# THE HIGHEST PRAISE FOR JANET GLEESON'S *THE ARCANUM*

"Gleeson handles this historical account with the cool, flawless elegance of her star material. She also blends in magnificent portrayals of porcelain masterpieces, proving herself a verbal alchemist."
—*Entertainment Weekly* ("A" rating)

"An account . . . as exquisite as the 2,200-piece services that graced the royal tables."
—*Dallas Morning News*

"Delightful. . . . Who would have thought that the story of porcelain would be such a rousing tale of wealth, intrigue, and outrageous greed and gluttony?"
—*Publishers Weekly*

"Simply delightful and most engrossing. . . . Gleeson's narrative is related with all the flair of adventure fiction, yet it is bedded in fact."
—**King Features Syndicate**

"Often exciting and always absorbing. . . . Gleeson does a marvelous job of relating court intrigue, decadence, and chicanery; but her descriptions of a 2,200-piece dinner service and the lavish banquets on tables decorated by porcelain finery, including an eight-foot-high model of the Piazza Navona with running rosewater, steal the show."
—*Kirkus Reviews* (starred review)

*more . . .*

# THE ARCANUM

*The Extraordinary True Story*

# Janet Gleeson

**WARNER BOOKS**

A Time Warner Company

 A Time Warner Company

Printed in the United States of America
First Trade Printing: January 2000
10  9  8  7  6  5  4  3  2  1

**The Library of Congress has cataloged the hardcover edition as follows:**

Gleeson, Janet.
     The arcanum : the extraordinary true story / Janet Gleeson.
         p. cm.
     Includes index.
     ISBN 0-446-52499-9
     1. Meissen porcelain. 2. Porcelain, European. 3. Böttger, Johann
Friedrich, 1682-1719. 4. Höroldt, Johann Gregor, 1696-1775.
5. Kändler, Johann Joachim, 1706-1775. I. Title.
NK4380.G59   1999
738'.092'243214—DC21                                          98-29494
                                                                                CIP

ISBN 0-446-67484-2 (pbk.)

*Book design and composition by L&G McRee*

*Cover design by Carolyn Lechter*

*For Paul, Lucy,*
*Annabel and James*

# Contents

················································

❧❧❧

# Introduction

Let me tell you further that in this province, in a
city called Tinju, they make bowls of porcelain,
large and small, of incomparable beauty. They are
made nowhere else except in this city; from here
they are exported all over the world. These dishes
are made of a crumbly earth or clay which is dug
as though from a mine and stacked in huge
mounds and then left for thirty or forty years ex-
posed to wind, rain, and sun. By this time the
earth is so refined that dishes made of it are of an
azure tint with a very brilliant sheen. You must
understand that when a man makes a mound of
this earth he does so for his children.

MARCO POLO, *Description of the World*

$\mathcal{I}$t all began with gold. Three centuries ago when this story begins there were two great secrets to which men of learning longed to find the key. The first was almost as old as civilization itself: the quest for the arcanum or secret formula for the philosopher's stone, a mysterious substance believed to have the power to turn base metal into gold and make men immortal. The second, less esoteric but no less desired, was the arcanum for making porcelain—one of the most coveted and costly forms of art—gold in the form of clay.

When the first steady trickle of Oriental porcelain began to reach Europe in the cargoes of Portuguese traders, kings and connoisseurs were instantly mesmerized by its translucent brilliance. As glossy as the richly colored silks with which the ships were laden, as flawlessly white as the spray which broke over their bows on their long treacherous journeys, this magical substance was so eggshell fine that you could hold it to the sun and see daylight through it, so perfect that if you tapped it a musical note would resound. Nothing made in Europe could compare.

Porcelain rapidly metamorphosed into an irresistible symbol of prestige, power and good taste. It was sold by jewelers and goldsmiths, who adorned it with mounts exquisitely fashioned from gold or silver and studded with precious jewels, to be displayed in every well-appointed palace and mansion. Everywhere, china mania ruled. While the demand for the precious cargo inexorably mushroomed, so too did the prices for prime pieces. The money spent on acquiring porcelain

multiplied alarmingly, fortunes were squandered, families ruined, and China became Europe's bleeding bowl. Gradually it dawned on sundry ambitious princelings and entrepreneurs that if they could only find a way to make true porcelain themselves this massive flow of cash to the Far East could be diverted to their coffers and they would be preeminent among their peers. So the hunt began.

Samples of clays were gathered, travelers' tales of how Chinese porcelain was supposedly made were dissected and analyzed. Ground glass was added in an effort to produce translucence; sand, bones, shells and even talcum powder were mixed in to give pure whiteness, myriad different recipes for pastes and glazes tested. All was to no avail until, in 1708, after lengthy experiments in a squalid dungeon, a disgraced young alchemist who thought he could make gold discovered the formula for porcelain, and Europe's first porcelain factory, at Meissen, was born.

As in some enthralling fairy tale, the manufacture of porcelain was spawned by the age-old superstition that it was possible to find a magical way to create gold, but it was also, ironically, a technological breakthrough that represented one of the first major successes of analytical chemistry and the start of one of the earliest great manufacturing industries of Europe. Even the Chinese were eventually obliged to acknowledge Meissen's ascendancy and began copying its designs. It remains to this day the most outstanding ceramic manufacturer of all time.

This is the incredible but true story of the lives of

the three men who solved one of the great mysteries of their day and made porcelain to outshine that of the Orient: Johann Frederick Böttger, the alchemist who searched for gold and found porcelain, but ultimately paid for the discovery with his life; Johann Gregor Herold, the relentlessly ambitious artist who developed colors and patterns of unparalleled brilliance, exploiting numerous talented underlings as he did so; and Johann Joachim Kaendler, the virtuoso sculptor who used the porcelain Meissen made to invent a new form of art. It is also the story of the unimaginable treachery and greed that this discovery engendered; of a ruthlessly ambitious, spendthrift king, whose appetite for sensual pleasure included an insatiable desire for porcelain; and of the cutthroat industrial espionage, eighteenth-century style, that threatened the security of the arcanum.

Nearly three centuries later, porcelain no longer rules the hearts and minds of leading scientists, potentates and philosophers. For most of us china does not represent a peerless treasure but something easily bought from a department store, given as a wedding present or casually admired in a shop window: a familiar accoutrement of everyday life. These days, as we lay our tables for dinner, raise a cup of coffee to our lips or rearrange the figures on a mantelpiece, it is scarcely remembered that virtually every piece of china in some way owes a debt to the endeavors of these extraordinary men—or that porcelain was once more precious than gold.

# Part One

## The Arcanist

# Chapter One

......................................

*The Fugitive*

*What better in all the world than that divine stone of the Chymists, yet men in the achieving of it, doe commonly hazard both their braines and subsistence, and in case they come neer an end, it is a very good escape their glasses bee not melted or broken, or evill spirits, as Flamell admonishes, does not through envy blinde their eys, and spoile all the worke.*

JOHN HALL, *Paradoxes of Nature,* 1650

*E*scape was the only alternative. He had failed to fulfill his promise to the king and his life now hung in the balance. On June 21, 1703, a dark-haired twenty-one-year-old prisoner gave the slip to his unsuspecting guards, stole from the confines of his castle prison and

found his way to the meeting place, where his accomplice waited with a horse ready harnessed for a journey to freedom.

With a hastily murmured farewell and scarcely a backward glance, the fugitive mounted his horse and fled speedily through Dresden's narrow medieval streets. Passing through the fortified city gates and across the bridge traversing the wide span of the river Elbe, he hastened through the town's jumbled, dilapidated suburbs and then out onto the fertile plains surrounding Saxony's capital city. Only once before had he glimpsed the lush panorama of fields filled with grain, flax, tobacco and hops, and the vineyards laden with ripening grapes. That had been nearly two years before on his heavily guarded journey to captivity. Ever since, he had been haunted by the fear that he would never be free to see it again.

As he rode southward the terrain became increasingly contoured and the roads more perilous. Rutted by spring rains and the wheels of heavy wagons, the route wended its way toward a precipitous mountain pass skirting narrow ravines. But still the fugitive sped on, spurred by the certainty that as soon as his disappearance was noticed a search party of soldiers would be dispatched to recapture him. One did not escape the king easily, and success depended on the lead he could gain before they followed. If he was recaptured the penalty would almost certainly be torture and death.

The name of this daredevil fugitive was Johann Frederick Böttger. At the time of his desperate escape he had

been held as a prisoner of Augustus II, King of Poland and Elector of Saxony, for nearly two years. The cause of his incarceration was neither murder, nor theft, nor treason, merely his proclaimed belief that he was close to discovering the secret that virtually every European monarch craved: the formula or arcanum for the philosopher's stone, the magical compound that would turn base metal into gold. Augustus yearned to be the first to find someone who could unlock that mystery, and he was not about to let a man who had promised to supply him with limitless wealth escape his clutches. Böttger had vowed to make gold and had failed to provide it. He could not expect to be shown mercy.

Viewed from our comfortably superior twentieth-century perspective, the notion that, by means of little more than the simplest laboratory equipment, some assorted ingredients and a few mystical words, any base metal might be transmuted into gold seems unquestionably absurd. We now know that the only way one element can be changed into another is by harnessing the might of nuclear technology and showering it with neutrons in a nuclear reactor. Even then the amount of gold that could be produced in such a way would be infinitesimal compared with the energy and cost expended. But however far-fetched such a concept now seems, transmutation—the ability to change one metal into another more valuable one—still obsessed men of learning and power in the Europe of Augustus's day.

The elusive philosopher's stone had been the holy grail of alchemists since the birth of the art in the ancient civilizations of Mesopotamia, India, China and Egypt. It had subsequently flourished in ancient Greece and in the Arabic-speaking world; Arabic texts were in turn translated into Latin, and by the Middle Ages belief in alchemy had pervaded the whole of Europe.

By the late seventeenth century, despite the dawning age of enlightenment and the huge advances being made in scientific discovery, the theory of the philosopher's stone remained by and large undimmed. Far from being seen as a remnant of medieval superstition, it was still viewed seriously even by the fathers of modern scientific theory: Robert Boyle, the first chemist to collect gases and formulate a law governing their pressure and mass, and Sir Isaac Newton, the founder of modern physics, were both fascinated by alchemy.

The theory was rooted in the way early thinkers believed that the world functioned. According to Aristotle, on whose theories much European alchemy was based, all earthly matter was composed of four elements—air, water, fire and earth. Arabic alchemists, whose word *alkimia* christened the art, thought that metals were composed of various combinations of sulfur and mercury. The yellower the metal the more sulfur it must contain; hence, they reasoned, gold must be laden with sulfur, while silver would contain mainly mercury.

Mysticism and religion were also intertwined with this vision of the physical world. Astrology provided the link between the universe and man's existence and it was logical that it too should hold sway over alchemical study; all metals were thus linked to a heavenly body: gold was associated with the sun, silver with the moon, copper with Venus and so on. It was also believed that everything in the universe was alive, and depended on God, or the power of planetary influence, in order to function. Rocks and metals, like plants and animals, were believed to grow spontaneously. While an animal grew in the womb of its mother or a plant blossomed from the soil, minerals were born from seeds of metal deep within the earth and grew with the assistance of natural forces into large nuggets and seams.

Of all the minerals that the earth was able to produce spontaneously, gold to these early experimenters was the most sought after. The philosopher's stone, *lapis philosophorum* or red tincture, was, they believed, a substance contained in the earth through which metal traveled in order to transmute into gold. Thus, by finding or fabricating this compound, harnessing nature with the help of planetary or divine assistance, and speeding up the usual growth process in their laboratory, any metal might be transmuted into gold.

This goal was a secret to which the baffling writings of ancient philosophers were believed to hold the key. Hence it was not only with mixing potions but also with attempting to decipher and understand an-

cient teachings that most alchemists occupied themselves. They in turn mirrored the cryptic texts they interpreted by recording their own experimental processes in terms that were shrouded in mystery. Their spidery scripts and mysterious diagrams spoke of ruby lions, of black ravens, of lily virgins and golden mantles. Their ingredients, mixtures of horse dung, children's urine, saltpeter, sulfur, mercury, arsenic and lead, were given deliberately obscure symbolic names and their findings recorded in equally esoteric language.

Concealment and camouflage were paramount to ensure that any successful experiment remain safe from avaricious outsiders who failed to fully understand the significance of their quest. For it was not the wealth gold represented that motivated the true alchemists but its unique perfection and resistance to decay—for therein lay the key to immortality itself.

Unfortunately, as Johann Böttger had already found to his cost, his intrinsically noble ambition was more often than not lost on those wealthy enough to sponsor such gold-making experiments. All Augustus and his royal counterparts elsewhere in Europe were really interested in was their own pecuniary gain. But in this quest they encouraged alchemists in scientific research that extended the understanding of the world around them, in order to improve technology, boost trade and add to their wealth and prestige. So alchemists developed laboratory equipment, experimental techniques and manufacturing processes such as glassmaking and

the fabrication of imitation gems, and thus laid the foundation for the development of modern industrial chemistry.

Augustus was only too aware that sponsoring the search for the arcanum was not without its attendant dangers. Credulous monarchs were easy game for the numerous charlatans and tricksters who toured the courts of Europe trying to dupe them into parting with real gold by means of little more than a promise that they would repay such investments thousandfold. The cost to those found guilty of such sharp practices was high; the penalty was likely to involve inquisition, torture and ignominious death—usually on a gallows decorated with gold tinsel. But there were many who thought the risk worth taking.

Was Böttger a fraudster? Clearly until now the king had thought not, for over the period that he had held Böttger captive he had lavished considerable sums of money on equipping a laboratory, as well as providing him with assistants and all the materials he could need. This escape attempt, however, could not fail to make him think twice.

This sobering thought must have preoccupied the fugitive alchemist as he fled through the night, stopping only when he needed to rest his horse. For four days he journeyed southward. Crossing the border into Austria and heading for Prague he rested on his way in the town of Enns. Here, in the anonymity of the bustling streets, he could temporarily cover his tracks before continuing his journey.

But the tentacles of Augustus's power were not so easily evaded. His soldiers refused to give up the chase. On June 26, 1703, their tenacity finally paid off when they traced Böttger to an inconspicuous inn where he had taken lodgings. He was summarily arrested and brought back to Dresden under close guard. The soldiers, recognizing his depression, did not let their vigilance slip and there were no more chances of escape. There was, however, plenty of time to wonder how the king would punish him for his audacity.

Back in Dresden, Augustus, now forced to consider what action to take in the light of Böttger's waywardness, called for the advice of the two men he had appointed as his prisoner's supervisors: Pabst von Ohain, manager of the royal silver mine at Freiberg, and Michael Nehmitz, royal privy secretary.

A highly trained scientist with a particular interest in mineralogy, von Ohain had been an appropriate choice of overseer, and had helped Böttger in his experiment by providing the necessary raw materials. Nehmitz, by contrast, had taken an instant dislike to the brash, overconfident alchemist and made his feelings clear from the start; he probably would not have cared less if the recaptured prisoner had been put to death.

Fortunately, however, von Ohain was still impressed by his troublesome charge. He put in a strong plea for clemency, begging the king to spare the alchemist's life. Böttger was not a charlatan, of that the supervisor felt sure; "something out of the ordinary

and strange lay concealed within him." Böttger, realizing the danger he was in, also implored Augustus to spare him and gave a written undertaking never to try to escape again. From now on, he vowed, he would do nothing but pursue his gold-making for the king.

Augustus considered his options. He had already invested about 40,000 thalers, a great deal of money even by *his* extravagant standards, in equipping Böttger's laboratory and paying for his assistant.* Böttger seemed as confident as ever of his ability to find the arcanum, as well as suitably repentant. Von Ohain, whom the king held in great respect, believed in him. Despite his escape attempt Augustus still trusted him; his knowledge of science was formidable, his brilliance undeniable. After protracted discussions with his advisors the king at last decided to spare Böttger's neck, but ordered that he be kept under closer guard than before. Sooner or later Böttger would find a way of making gold, Augustus remained utterly convinced of it.

---

*A thaler was worth roughly 5 shillings (25 pence) in the eighteenth century, so Augustus's expenditure was equivalent to £10,000—in modern terms something like £650,000 (given that a pound sterling today is worth roughly sixty-five times more).

# Chapter Two

........................................

❦

## *Transmutation or Illusion*

*If I had known then what I know now I would not
have let the boy go. I would have manacled him to
a heavy iron chain and not released him until he
had changed the whole chain to gold.*

FREDERICK ZORN TO HEINRICH LINCK,
December 28, 1701

*I*n the colorful life of Johann Frederick Böttger, such
daredevil escapades form a recurring theme and this
breakout was far from being his first. He had been born
on February 4, 1682, in the central German city of
Schleiz. Both his parents were natives of Magdeburg,
and both sides of the family had traditionally been em-
ployed with gold in one way or another. Böttger's pa-
ternal grandfather was a master goldsmith; his father,
Johann Adam, was a mint worker who, some say, also

dabbled in gold-making, and his mother, Ursula, was the daughter of Christoph Pflug, the master of the Magdeburg mint. Johann Frederick Böttger was Johann Adam and Ursula's third child, born two years after his father had taken up work in the city of Schleiz as head of a newly founded mint.

Johann Adam's career in Schleiz was sadly short-lived. Somewhat ironically, bearing in mind his son's later pursuits, the coins produced by the mint contained less pure gold and silver than was standard and the public refused to accept them. The mint was forced to close before the baby's first birthday and Böttger's father lost his job. The family had little option but to return to their native city of Magdeburg, where Johann Adam fell suddenly ill. He died later the same year, a few weeks before the birth of his fourth child.

To Böttger's mother, Ursula, suddenly finding herself a young widow with four small children to care for and no means of financial support, the prospect must have looked extremely bleak. Remarriage would give her the only realistic chance of enjoying a reasonably comfortable life in the future, but finding a husband who was prepared to take on such a burden would not be easy.

Magdeburg had been devastated in the Thirty Years' War (1618–1648) and its population had fallen from thirty thousand to a mere five thousand or so. The impoverished city had, however, recently amalgamated with Prussian territory, and at the time of the Böttger family's return the city thronged with

Prussian officials, many of whom were engaged in the work of reconstruction. Among them was Johann Frederick Tiemann, a fortifications expert in charge of rebuilding the ramparts. A widower, Tiemann had been left with a son and a daughter to look after, and remarriage was therefore a necessity for him too. Fortunately, Ursula, still comely despite all she had endured, caught his eye. Educated in both architecture and engineering and with a stable career, to her he must have seemed an extremely eligible suitor. He was sympathetic to her plight and, having children of his own, kindly disposed toward her young infants. His proposal of marriage, made a year after her husband's death, gave Ursula the chance of renewed security for her family, and she accepted with alacrity. In 1683 the widow Ursula Böttger and the widower Johann Frederick Tiemann were married.

Böttger's new stepfather took an active role in the upbringing of his wife's young son, who coincidentally shared his Christian names. As the child matured his natural intelligence became increasingly apparent. By the age of eight he could read and write fluently and his stepfather encouraged his education, assisting him in the study of Latin, which he quickly mastered, as well as geometry and mathematics. But, though he was interested in all these subjects, from an early age Böttger showed a marked preference for the study of chemistry. One of his great childhood friends was Johann Christoph Schräder, the son of the local apothecary, and as he learned more of the subject from his

friend his interest and skill became increasingly apparent. It was obvious to his parents that this would be his preferred career, and Tiemann, ever keen to nurture Böttger's talents, managed to apprentice the boy, now aged fourteen, to a leading apothecary in Berlin named Frederick Zorn.

Industrious and intuitively gifted, Böttger settled down to learn all he could from his master. He studied zealously in the pharmacist's shop in Neumarkt, working hard in the day and poring over books late into the night. His unusual dedication to his studies was ridiculed by the other apprentices in Zorn's shop, but their teasing did nothing to lessen his hunger for knowledge. Through his passion for chemistry he met and was befriended by leading scientists working in Berlin at the time, among them a famous elderly chemist named Johann Kunckel. Kunckel had worked as alchemist at the court of Saxony in the 1670s but had so convinced the elector that he knew how to transmute metals into gold that his employer had refused to pay him a salary, saying that he surely did not need money if he could make it himself. To escape imminent arrest by greedy courtiers who were keen to extract the secret from him, he had been forced to move to the University of Wittenberg. From there he was lured to Prussia by Frederick William, the Great Elector of Brandenburg, with the promise of a proper salary and the title of court chemist.

Kunckel was interested in alchemy in its broadest sense, and his research had led to the development of a

ruby-glassmaking industry. He became deeply impressed by the young apprentice's flair for chemistry. Encouraged by this statesmanlike figure, Böttger carefully studied Kunckel's influential scientific treatise, *The Complete Art of Glassmaking,* which contained a wealth of detailed information on the manufacture of glass, enamel and ceramics. Kunckel became something of a mentor to the young Böttger, inviting him to stay at his country estate and stimulating his growing fascination with analytical experimentation. Scientific discovery, said Kunckel, was founded on practical experimentation, and this was the path that Böttger should follow.

But as Böttger's grasp of chemistry expanded, he became increasingly captivated by the idea of finding the arcanum for the philosopher's stone. His conviction that such a discovery was possible was probably fueled by his acquaintance with a mystical Greek monk by the name of Laskaris, who, it was said, knew the secret of transmutation. Böttger nurtured his relationship with Laskaris and eventually persuaded him to part with a quantity of a mystery powder that Laskaris led him to believe was the philosopher's stone.

With this mysterious substance and a few vague instructions on how to make more of it Böttger felt confident that he was now close to a breakthrough and began performing his own experiments in transmutation. At first the surreptitious trials took place in Zorn's laboratory by night, when the rest of the apprentices were asleep or out enjoying themselves. But

when Zorn discovered what Böttger was doing he warned him in no uncertain terms of the perils of pursuing such a route, and forbade him to continue. Alchemists had searched for the philosopher's stone for centuries without success; those who pretended to hold powers they did not possess ran the risk of severe punishment. Böttger was wasting his time; he would do better to concentrate on the preparation of the curatives that would provide him with a sound means to prosper in the future.

Böttger, considering the prospect of grinding pills a poor substitute for the excitements of alchemy, found this chastisement difficult to accept. Egged on by various sponsors and friends, including a local grocer by the name of Röber who financed some of his research, he continued to experiment in various secret locations and absconded several times from his lodgings in his master's house, sometimes disappearing for weeks on end. After each of these truancies he would return hungry, penniless and repentant, asking to be taken back. And each time, despite his assurances to the contrary, he would continue to experiment clandestinely.

In 1701, after serving five years of apprenticeship with Zorn, the nineteen-year-old Böttger began to hold occasional secret demonstrations for his immediate circle of friends, during which he convinced them that he could transmute various metals into small amounts of gold. All who were invited to witness these experiments were first required to pledge their secrecy, but once they had observed Böttger in

action they were so impressed that few of them found it possible to remain silent. The rumors enabled Böttger to raise money for increasingly impressive experiments with little more than the assurance that he would repay any advances many times over with the large quantities of gold he would soon be able to make.

By now he had even convinced himself that he knew the secret arcanum and he sent his mother coins assuring her that she would never go hungry again. In the light of this great breakthrough he implored her to come to Berlin and persuade Zorn to release him from his apprenticeship. Frau Tiemann seems to have believed her son and her intervention convinced Zorn that he was ready to become a journeyman. (A qualified tradesman; halfway between an apprentice and a master, a journeyman was able to earn wages but not to employ others.) Despite his pupil's obstinacy and his continuing infatuation with alchemy, and despite Böttger's dislike of criticism, the two seem to have retained a peculiar trust in one another. It was not to last much longer.

A few weeks after he had qualified as a journeyman, on October 1, 1701, Böttger decided he was ready to prove beyond doubt that transmutation was possible by inviting Zorn and his wife to witness and assist in a most important experiment. It would take place after dinner. Zorn, though still incredulous, agreed to attend, and two friends who were staying in the house were invited to help.

When his guests arrived at the appointed time and

place, Böttger began the proceedings dramatically by taking an empty crucible and placing it on the fire. The flames were fed and the bellows worked until the crucible glowed incandescent. One witness took a handful of fifteen silver coins, which he was instructed to drop into the pot, allowing them to melt in the by now searing vessel. Meanwhile a wrapped paper containing a mystery powder was handed by Böttger to the other witness, who was told to add it to the molten metal. Then the crucible was covered and the substances were allowed to mingle, fuse and, if Böttger were to be believed, transmute. As the tension in the dingy room mounted and smoke billowed from the crucible, Böttger removed it from the heat and poured the still white-hot contents into a mold for the audience to examine.

Before their very eyes, the river of silvery white liquid that had flowed out of the blackened pot cooled to a brilliant gold.

The next day, when the molten metal had hardened to an ingot, it was subjected to rigorous examination and testing. Against everyone's expectations—except Böttger's—the resulting metal turned out to be gold of the very purest quality.

In order to accomplish such an illusion Böttger must at some stage have substituted gold for the silver coins or the hardened metal that was tested. But exactly how the trick was done, and where he had acquired the necessary gold to do it, remains a mystery. What is quite clear, however, is that all the witnesses, including the skeptical Zorn, were completely taken in.

Incorrigible show-off though he was, Böttger was not an out-and-out charlatan, and he genuinely believed that transmutation was possible. He also knew how dangerous games such as this could be. As soon as he had staged his demonstration the foolhardiness of such an escapade must have dawned on him and he begged Zorn and his friends never to speak of what they had seen. But, like his earlier witnesses, they were so bewitched by Böttger's manifest skill that they could not prevent themselves from mentioning it to one or two select colleagues and acquaintances, and thus, inevitably, the news spread.

Zorn was so impressed that he wrote to a colleague in Leipzig to tell him what he had witnessed. "This is to inform [you] that my former apprentice made the finest gold weighing 3 loth in my presence. . . . The gold stood up to all tests." Interestingly, this letter ended up in the secret files of Augustus the Strong. The story of the experiment also reached the ears of the famously respected philosopher and mathematician Gottfried Wilhelm Leibniz. A little more than a month after it took place he wrote to the wife of the Prince Elector of Hanover: "They say that the philosopher's stone has suddenly appeared here. . . . I am reluctant to believe just anything but I dare not refute so many witnesses." Before long even foreign newspapers were referring to the incredible transmutation that had happened in Berlin.

Meanwhile the news had also traveled the few streets from the apothecary's shop to the Prussian

court. Newly accorded the title of King of Prussia, Frederick I was every bit as avaricious and ambitious as his Saxon counterpart Augustus II and, like him, desperate for gold to finance an extravagant lifestyle. A man who could make gold would neatly solve his financial problems and make him the envy of all Germany. As soon as he heard of these developments he summoned the apothecary Zorn, ordering him to bring with him the gold Böttger had manufactured. Frederick questioned Zorn closely about the experiment he had witnessed and, evidently impressed by this firsthand account, instructed him to return the next day with his pupil. In the meantime he would take charge of the gold.

When Böttger learned that the king wanted to see him he realized that luck and time had run out. Frederick was renowned for his ruthlessness if crossed, and since Böttger knew that his experiment would be impossible to repeat in circumstances that he could not control, he had every reason to expect that he would be tortured and put to death as soon as his sham was exposed. With no wish to precipitate such an unpleasant end Böttger decided on a characteristically dramatic and audacious plan. Instead of preparing himself to meet his king (and his maker), he waited for nightfall and crept from his lodgings. For the next two days he found sanctuary nearby in the secluded house of his grocer friend Röber, while he sent word to Kunckel begging for assistance.

At the Prussian court, meanwhile, Frederick had

quickly realized that something was amiss and sent out search parties of soldiers to look for the alchemist who had failed to present himself as ordered. Throughout the city proclamations were read aloud and bills posted stating that the king was prepared to pay a reward of 1,000 thalers for Böttger's capture alive. Böttger knew that, with such a price on his head, if he stayed in Berlin his chances of avoiding arrest would be minimal, and presumably Röber must also have been keen to get rid of such a dangerous house-guest. Escape from the country was the only solution. On the third night of hiding, Böttger persuaded a sympathetic relative of Röber's to allow him to hide in his covered wagon while it was driven out of Prussia. For this dangerous assistance he paid two ducats with the usual promise of a sack of gold in addition—as soon as he had time to make it.

Cowering in the bottom of the wagon, Böttger was spirited across the Prussian border to the comparative safety of the medieval Saxon town of Wittenberg. Once settled there he lay low and enrolled at the university medical school as a student. Kunckel still had contacts within the university from his time as head of the College of Chemical Experimentation, and Böttger had faithfully promised that he would pursue his studies there diligently.

But somehow news of the successful getaway reached the royal court, where Frederick, unaccustomed to such a blatant flouting of his royal will, was more determined than ever to capture the fugitive. He

summoned one of his most trusted men, a Lieutenant Mentzel, and dispatched him, together with a detachment of a dozen troops, to find Böttger and bring him back at all costs.

It was not hard for Mentzel to trace his quarry. Saxony, whose border lay a mere thirty miles to the southwest, was the obvious escape route. However, the diplomatic relationship between Prussia and Saxony, although currently peaceful, was always sensitive, and once Böttger had been located by the Prussian lieutenant, protocol demanded that the permission of the king's representative in Wittenberg be obtained before he could make an arrest. Leaving his soldiers camped outside the town walls the lieutenant requested an audience with Johann von Ryssell, the local court official, from whom he begged formal permission to apprehend, "for certain important reasons," a fugitive from Prussian justice.

Such requests were clearly not run-of-the-mill, and von Ryssell was immediately suspicious. Why should a common fugitive warrant a detachment of a dozen Prussian soldiers? The matter clearly needed investigating further before he could comply with such a demand.

Placing Böttger under a precautionary Saxon guard, von Ryssell made a few more inquiries. Unfortunately for Böttger, the magistrate somehow managed to come across Röber, who happened to be visiting Wittenberg at the time. Terrified for his own safety, Röber did not need much persuasion to reveal the real reason the

Prussians wanted to recapture the fugitive: he knew the arcanum for making gold.

On hearing this account of events von Ryssell realized the potential sensitivity of such a matter, and word was sent immediately to the king in Dresden. Meanwhile, aware that the net was closing around him, and deciding that his chances of survival with Augustus of Saxony were probably marginally better than with Frederick, Böttger also sent a letter to the king begging for royal protection from the Prussians. The king was not, however, in Dresden but in Poland, and a messenger was duly sent to Warsaw, a journey of several more days.

While days and then weeks passed, Frederick of Prussia and Lieutenant Mentzel grew increasingly impatient. There was nothing mysterious about the prisoner, Mentzel assured von Ryssell; he was a straightforward murderer, a man with a long criminal record, a dangerous prisoner. From Berlin, Frederick threatened military intervention if von Ryssell did not comply; full-scale war would be the result of this petty obstinacy. Von Ryssell; however, remained unperturbed by these blusterings and stood his ground. Prussia would have to wait patiently for the response of the ruler of Saxony. Until it was received no further action would be authorized.

At the time, Augustus was caught up in a lengthy and costly war with Sweden, in which he was losing all the major battles. Gold was urgently needed to replenish his coffers, and when he heard that a man who

could make it had appeared on the scene it must have seemed like a gift from God. The drawback was that he had no desire to embroil himself in a dispute with Prussia; if he was not careful the situation could easily escalate into a major diplomatic incident. He decided, therefore, to play for time. Almost two months after Böttger had first arrived in Wittenberg, instructions were at last sent to von Ryssell and the Prussian envoy decreeing that any requests for the extradition of the fugitive were to be sent directly to the king, who would organize his own inquiry before giving the matter his personal consideration. The fate of the nineteen-year-old fugitive, whose only crime had been to stage an entertaining illusion or two, had now become a matter of international significance.

Meanwhile, desperate to find some justification for his refusal to hand Böttger back to the Prussians, Augustus decided that his birth in Schleiz gave him a useful piece of ammunition. Schleiz was not part of Prussia but of Augustus's dominion, Reussia. Thus, Augustus claimed, Böttger belonged not to Frederick but to him. But even in the face of this forceful argument the Prussians remained unflinching in their determination to secure Böttger's return, refusing to withdraw from Wittenberg without him. The only solution, Augustus decided, was to spirit the alchemist away to safer custody in Dresden before the Prussians realized what was happening. The governor of Saxony, Prince Egon von Fürstenberg, also a keen believer in alchemy, was therefore given royal instructions to es-

cort Böttger back to Dresden under close guard, and on no account to let him slip into Prussian hands.

Judging by the cloak-and-dagger way in which the transfer was accomplished, von Fürstenberg must have considered that the Prussians posed a very real threat. Frederick's troops were most likely to try to seize the prisoner en route to Dresden. To avoid this possibility, Böttger was awoken at four in the morning of November 24, 1701, bundled into a waiting carriage and driven along obscure back ways rather than by the main roads. He was given a cavalry escort of sixteen men, and an advance party went ahead to check for signs of Prussian soldiers. In order to hoodwink the Prussians into believing that Böttger was still in Wittenberg, Saxon soldiers continued to stand guard outside his rooms as they had for the past weeks, and for the next two days food was carried into his rooms as usual.

By the time the Prussians realized they had been outwitted, Böttger was safely beyond their reach. He arrived in Dresden four days later, on November 28, and was imprisoned in the Goldhouse, a part of the royal castle that was already equipped as a laboratory. From now on, Augustus decreed, Böttger would remain a prisoner of Saxony. He would never walk free unless he first revealed the arcanum for making gold.

# Chapter Three

·····································

## The Royal Captor

*The king is a ruler, whose genial and good-na-
tured address captivates the hearts of all who come
to know him. . . . Ambition and a lust for
pleasure are his chief qualities, though the latter
has the supremacy. Often his ambition is curbed by
his lust for pleasure, never the latter by his ambi-
tion. . . . He needs money in order to give the rein
to his generosity, to gratify his wishes and satisfy
his lust for pleasure, and thus he values those who
procure him money, lower than those who content
his ambition and desires. . . . He does not require
that money be furnished him by unlawful means,
but if it be so furnished, its acceptance causes him
no discomfort, and if he can put the blame of it on
another he feels himself free of all reproach.*

    Count Jakob von Fleming,
    Character sketch of Augustus the Strong, 1722

*E*ven in an age not known for its moderation, Augustus the Strong, the king into whose clutches Böttger had now fallen, was among the most excessive of rulers. Augustus had inherited the title Elector of Saxony on the death of his brother John George IV in 1693. But ruling over one of the largest and most important states in Germany, a country divided into hundreds of minor princedoms, in no way satisfied his relentless ambition. He craved absolute kingship of the kind enjoyed by Louis XIV of France, and dreamed of outshining the Sun King by establishing himself as the most powerful ruler in Germany.

The obvious way of boosting his position in the hierarchy of Europe was to increase his dominions, and three years after becoming elector his hunger for power drove him to enter the election for the kingdom of Poland. To tip the balance in his favor he renounced the Protestant religion of his forebears and adopted the Catholic faith, a move he had few qualms about despite the fact that both his Saxon subjects and his wife were Protestant and deeply suspicious of his motives. With a combination of Russian support and massive bribery, Augustus beat his opponents and was crowned King of Poland in 1697.

At the time of Böttger's incarceration in Dresden, Augustus was less successfully engaged in trying to expand his Polish kingdom. In an attempt to conquer Livonia, a province of Sweden that had once been part of Poland, he had formed an alliance with Russia and

Denmark against the Swedish King Charles XII and invaded. So began the Northern War (1700–1721), a conflict that proved disastrous for the fortunes of Poland and its Saxon king, and would lead in 1706 to Augustus's temporary abdication.

The king's nickname, Augustus the Strong, was a reflection partly of his great physical strength but mainly of his legendary prowess with women. A man of immense energy and charisma, tall and compellingly handsome, he was a compulsive collector of beautiful women who used his "favorites" to bolster his image of regal potency. Although the presence of royal mistresses was very much an accepted part of court life of the day, in Augustus's case they were so many and varied that a year after the king's death, one of his courtiers, Baron von Poellnitz, was able to write a book entitled *La Saxe Galante* entirely devoted to Augustus's sexual liaisons. The publication enjoyed enormous success and became a popular topic of conversation in Europe.

As a young man Augustus had traveled Europe incognito, wooing aristocratic ladies as he went. On his return to Dresden he married the Princess Eberhardine of Bayreuth, but this union proved only a minor hiccup in a pattern of repeated infidelity. The political unease between Saxony and Poland was alleviated by taking to heart counsel given by one of his courtiers, who suggested that "As your Majesty has two courts, one in Saxony and the other at Warsaw, you ought to be a compleat Monarch, and in Justice, keep a Mistress

at each Court. This will conduct undoubtedly to the Satisfaction of both Nations."

Whether slave girls or princesses—and Augustus had mistresses from all walks of life—the objects of his desire were typically showered with gem-studded dresses, lavished with priceless jewels and enticed with sumptuous entertainments until, sooner or later, they invariably succumbed. It was not unusual for the king to attend state functions in the company of several mistresses. The Queen of Prussia thought his behavior charming when he brought an entourage of five beauties to one of her evening soirées. Such was his sexual prowess that, in addition to his only legitimate child, he was said to have sired a different child for every day of the year, although only nine of his illegitimate offspring by five different mistresses were acknowledged by their wayward father.

The king's most notorious paramour was Constantia, Countess of Cozelle, the erstwhile wife of the king's chief minister of state, de Hoyhm. She became the king's mistress after a drunken wager on the subject of her peerless beauty.

The king together with Prince von Fürstenberg pledged 1,000 thalers that de Hoyhm's paragon of a wife would not appear so striking if seen surrounded by all the other beauties of the court. Madame de Hoyhm was duly summoned and the king introduced. Before him he saw a woman with "features most delicate; the Beauty of her Face, when laughing, was unparalleled and capable of captivating the most

insensible Heart. Her Hair was black, her Breasts could not but raise any Person's Admiration. . . ." In short the king was predictably smitten.

Lady Mary Wortley Montagu, an intrepid early-eighteenth-century traveler, made a visit to the court in 1716 en route to the embassy in Constantinople where her husband was ambassador, and recorded details of the liaison, which was clearly still the subject of some gossip at court. Lady Mary noted how the king had reportedly revealed his passion for Madame de Hoyhm by "bringing in one hand a bag of a hundred thousand crowns, and the other a horseshoe, which he snapped asunder before her face." The inference was clear: not only was his majesty physically potent, he was also generous with those he desired. Lady Mary continued, "I do not know which charmed her; but she consented to leave her husband and give herself up to him entirely."

Augustus gave Constantia the title of Countess of Cozelle after her expedient divorce from her bemused husband. She was ensconced by the king in the grand Taschenberg Palace, linked by a covered passage to the royal residence, and he also bought her the Schloss Pillnitz, a beautiful country estate on the banks of the Elbe. For some years she dominated the king, holding sway at court, generally giving herself "the airs of a queen" and becoming fabulously rich in the process, but also earning the hatred of many of Augustus's key advisors.

Eventually she fell from favor and was forced into

exile. In 1713 she escaped to Prussia, but having been bartered for Prussian prisoners of war was brought back to Saxony and imprisoned in "a melancholy castle," the fortress prison of Steulpen, where she died after fifty years in captivity in 1765.

If the image of a monarch of unparalleled power was reflected in Augustus's possession of as many women as he pleased, he reinforced the message by displaying the pomp and privilege of kingship at every available opportunity. He lavished untold sums on magnificent ceremonies and spectacular entertainments. Fine clothes, precious jewels and exquisite works of art were also a passion. One of his most extravagant commissions, made in 1702 by Johann Melchior Dinglinger, was an extraordinary centerpiece measuring a square meter in size and entitled *The Birthday of Grand Mogul.* This priceless confection of gold, silver, enamels, pearls and gems depicted an Oriental palace populated by 130 exquisitely modeled exotic figures bringing gifts for the emperor's birthday.

When Böttger arrived in Saxony, the court at Dresden was one of the largest and most sophisticated in Germany. During his travels as a young man, Augustus had stayed at Versailles and been deeply impressed by all he had witnessed. Under his rule Dresden metamorphosed into his own version of Louis XIV's splendid court. A massive city program of building and embellishment was undertaken. Dresden had been badly damaged in a fire in 1685, and the royal palace had suffered from another catastrophic

blaze in 1701. New grandiose buildings mushroomed, and the bridge spanning the Elbe and joining the new and old city was rebuilt in stone. Matthäus Daniel Pöppelmann, a leading Baroque architect, was employed by the king to build next to the royal palace the Zwinger, a stylish arena circled with classical galleries and pavilions, which provided the elegant backdrop to many of the most opulent of Augustus's spectacles, entertainments and sports. The aim was to construct a city to outshine anything else in Germany and thus highlight its sovereign's unequalled might.

At court, protocol and formality also mirrored that of the Sun King. An incredibly complex hierarchy evolved in which royal officials were divided into more than ninety different echelons. There was a retinue of physicians, artists, historians, architects, gardeners, horse trainers, soldiers, lackeys, chefs and pages, along with sundry grades of personal and administrative staff. Apart from their practical duties, the higher ranking officials were also expected to amuse the king by joining in the constant stream of musical and theatrical extravaganzas that took place when the king was in residence. The role of numerous staff was simply to provide the entertainments for the court: there were dwarfs and buffoons to amuse him with their physical deformity and mental agility; there was an operatic company, a court ballet, a troupe of sixty dancers and a company of actresses; and there were also several orchestras. One way or another the vast majority of the city's population was there to service the

court, and virtually all the city's social and cultural activity revolved around the king and his family.

But there was far more to Augustus's character than mere love of display and sexual self-indulgence. In France he had also noted the mercantile policy introduced by Louis's chief minister, Colbert, and, in common with many other German rulers, he aimed to put similar policies into practice in his own kingdom. Saxony in the early years of the seventeenth century had enjoyed one of the most affluent economies in Germany. Her fertile lands, rich mineral deposits and temperate climate had enabled the population to prosper and agriculture and industry to flourish. But now the country suffered from the devastating after-effects of the Thirty Years' War. Farms were run-down, peasants exploited by their estate owners and industry by and large demolished. Augustus hoped that by following the French example of encouraging home trade and local mining, and developing science and manufacturing, he would restore his land to its former prosperity and in so doing reinforce his regal authority and replenish his financial resources.

A nobleman named Ehrenfried Walter von Tschirnhaus was employed by the king as a councillor of court to locate mineral deposits in the kingdom and develop new manufacturing techniques. An associate of the philosopher Leibniz, Tschirnhaus had made lengthy studies of mathematics, science and philosophy at the University of Leiden in Holland and the Academy of Sciences in Paris. In Saxony, he set up three glass fac-

tories and a dyeing manufactory. He also developed huge burning glasses, based on those he had seen in Paris, that could concentrate the sun's rays and generate far greater heat than could be achieved using more conventional methods. There was one industry, however, in which more than any other Tschirnhaus longed to succeed—the manufacture of porcelain.

Augustus's appetite for beautiful porcelain was every bit as compulsive as his desire for beautiful women, and his royal ascendancy allowed him a similarly free rein to indulge himself. If Tschirnhaus could find a way of making this highly prized material he would not only satisfy the king's desire to develop local resources; he might also stem the flow of untold sums of revenue to the Orient. So while the young Böttger was trying to turn lead into gold in Berlin, as he languished under arrest in Wittenberg, and as he now pursued his alchemical experiments as a prisoner in Dresden, Tschirnhaus was searching equally fervently for what appeared to be a no less elusive arcanum—the formula for turning clay into porcelain.

# Chapter Four

.....................................

## The China Mystery

*We are not thorowly resolved concerning Porcellane or Chyna dishes, that according to common beliefe they are made of earth which lyeth in preparation about an hundred yeeres underground, for the relations thereof are not only divers, but contrary, and Authors agree not herein. Guido Pancirollus will have them made of Egge shells, Lobster shells, and Gypsum layed up in the earth the space of eighty yeeres: of the same affirmation is Scaliger, and the common opinion of most. Ramuzius in his Navigations is of a contrary assertion, that they are made out of earth, not laid under ground, but hardened in the Sunne and winde, the space of fourty yeeres.*

THOMAS BROWNE, *Vulgar Errors*, 1646

𝒰nder orders from Augustus, the captive Böttger was to be supervised in his search for gold by two trusted courtiers, Michael Nehmitz and Pabst von Ohain, and helped by three assistants. Apart from these five men he was allowed to talk to no one, there was no contact with the outside world, and even the windows were shuttered against Prussian spies who, it was still feared, might attempt to kidnap him.

In Warsaw the king was impatient for evidence of his new captive's skill. Instructions were sent to von Fürstenberg to bring a sample of the philosopher's stone as quickly as possible. Böttger was reluctantly obliged to pack a traveling casket with his mysterious powder, some quicksilver (mercury) and various other ingredients and pieces of equipment and to brief von Fürstenberg on how to carry out the experiment. According to some accounts, when von Fürstenberg arrived in Warsaw on December 14, 1701, the king's dog knocked the casket containing these precious ingredients on the floor and some of the fragile vials broke. The lost ingredients were replaced and then, two weeks later, in a secret room in the Warsaw palace, the experiment finally went ahead under cover of darkness. By flickering candlelight the king and von Fürstenberg donned leather aprons before lighting the fire and following Böttger's instructions as closely as they could remember them. Predictably, after hours of boiling, mixing, stoking and bellowing the experiment yielded nothing but a hard metallic mass that

was certainly nothing like gold. Discouraging though this must have been, Augustus was undaunted and ordered that the young alchemist be forced to continue his research.

The restrictions of confinement and enforced labor at the Goldhouse rapidly took their toll on Böttger's mental well-being. His life with Zorn had accustomed him to having the liberty to pursue, albeit covertly, his own research—and to set up his miraculous transmutations. Now secrecy, privacy and liberty of any kind were denied and the threat of death was never far away. He grew fearful, depressed and prone to occasional fits of hysteria during which, according to colorful contemporary reports, he would drink to excess and bellow like a bull, grind his teeth, bang his head against the cell walls, cry and tremble uncontrollably. Convinced that these scenes were nothing but a sham to avoid having to hand over the arcanum, Augustus tried dispatching him to the bleak cliff top fortress prison of Königstein, in the hope that isolation would shock him out of his histrionics. But this severe treatment in fact had the very opposite effect and Böttger's mental state deteriorated still further. His jailer reported back to Dresden that the prisoner was at times uncontrollable, needing two guards to restrain him. During these seizures his jailers found that satisfying his apparently unquenchable thirst for wine and beer was one of the few ways of calming him down, and as they fed his craving Böttger discovered that alcoholic oblivion was the most effective means of numbing the

misery of his confinement and obliterating the fear of execution.

Realizing from the guards' reports that even if Böttger was not already mad, keeping him in such intolerable conditions was likely to drive him to insanity before he produced any useful results, Augustus permitted the conditions of Böttger's imprisonment to be improved. He was recalled from Königstein and allowed two comfortable rooms in part of the royal palace with a view of the gardens, and for the first time, he was allowed to have limited access to outsiders.

The slightly more relaxed regime made Böttger's job of convincing Augustus that he was on the brink of a major breakthrough much easier. In June 1703 he made his most ridiculous promise so far, writing to the king, "At last, by faithfulness and diligence I have come to the point of being able to produce for Your Majesty by next Peter and Paul Day a sum of 300,000 thalers and thereafter 100,000 thalers monthly." Augustus was so convinced that vast quantities of gold were imminent that he appointed Böttger master of the mint. It was Böttger's sheer terror of the repercussions of his failure to deliver this sum that led to his desperate escape to Bohemia.

At some stage during these experiments, perhaps even before he ran away and was recaptured, Tschirnhaus was introduced to the renegade alchemist and they dined together in Prince von Fürstenberg's castle. Böttger, engrossed in trying to discover the recipe for

gold, impressed the older scientist with his profound knowledge of chemistry and they must have discussed Tschirnhaus's own work. The two men established a rapport and over the next months of Böttger's imprisonment Tschirnhaus regularly visited the captive alchemist and began to tell him in more detail of his quest for the secret of porcelain.

At the beginning of the eighteenth century, true porcelain was only made in the Far East, primarily in China and Japan. Silk, lacquer and spices had been imported to Europe since the Middle Ages via the great Silk Road, the overland route from Asia to the West, but porcelain was too fragile to be transported in such a way and the few pieces that arrived in the West were mostly shipped through the Gulf of Arabia or the Red Sea by Arab traders. There was no large-scale organized trade until after Vasco da Gama's voyage of discovery in 1497 opened a sea route to China.

From the first, porcelain was regarded by the Western world as one of the most coveted rarities of the Orient, whose mysterious allure it encapsulated by its seemingly impossible combination of extraordinary fragility, coupled with glittering hardness. Modern science tells us that this strange substance made by these ancient potters is in fact so hard that ordinary steel cannot cut it.

The scarce early pieces that survive were often given to rulers as papal or diplomatic gifts, and their preciousness in Western eyes is reinforced by the way in

which they were meticulously adorned with intricately wrought handles, lids and stands made from solid gold and silver and often studded with gems. Such rare and costly items are found in numerous royal treasuries. In the fifteenth century the powerful doges of Venice were presented with Ming porcelain by visiting sultans from Egypt, who also gave it to Charles VII of France and Lorenzo de Medici. Among the treasures listed in Henry VIII's inventory were "A cup of Purselaine glasse fation with two handles garnisshid with siluer and guilt, the Couer garnished with iij Camewe heddes and thre garnettes," which he had probably been given by the King of France.

As a matchless symbol of artistic perfection, worthy of only the most formidable potentates, porcelain appears from time to time in the work of Renaissance painters as an exotic attribute of the gods of the Christian and pagan worlds. When Mantegna painted the *Adoration of the Magi* that now hangs in the Uffizi, the gifts the three kings reverently presented to the Savior were enclosed in a vessel resembling Oriental porcelain. When the Venetian artist Giovanni Bellini set to work in 1512 to paint a *Feast of the Gods* for Alfonso d'Este's Alabaster Chamber in the castle of Ferrara, the banquet served to Bacchus and his fellows by the assembled satyrs and nymphs was presented upon Ming porcelain bowls, identical to some in the Topkapi Palace, Istanbul, which Bellini is known to have visited. Thus, slowly but surely, porcelain inveigled its

way into public consciousness as a symbol of sacred beauty of the most mysterious and elusive kind.

After Portuguese merchants established a sea route to China and Japan in the sixteenth century, trade in porcelain steadily grew as Oriental potters massively boosted their output (often at the expense of quality). By the middle of the century Portuguese carracks weighed down with dishes, vases, bowls and a myriad other porcelain items plied the seas between Macao and Lisbon. Later the Dutch East India Company also joined in the lucrative trade, and literally hundreds of thousands of pieces flooded into Dutch ports to feed the West's apparently unquenchable appetite for such exotica.

Throughout the later seventeenth century, porcelain of widely varying standards was imported in ever larger quantities, much of it a useful and lucrative ballast in the parts of the merchantmen where other luxury cargoes such as tea and spices, lacquer and silk could not be stowed because of the threat from water damage. The fashion quickly spread from mainland Europe across the Channel to England, where, according to Daniel Defoe, it was introduced by Queen Mary, who, he lamented, had given royal sanction to "the custom or humour, as I may call it, of furnishing houses with chinaware, which increased to a strange degree afterwards, piling their china upon the tops of cabinets, scrutores, and every chimney-piece, to the tops of the ceilings, and even setting up shelves for

their chinaware, where they wanted such places, till it became a grievance in the expense of it, and even injurious to their families and estates."

In fact, though she certainly exemplifies the trend for china mania, Mary did not establish it in England; the fashion was well entrenched before she ascended the throne in 1689. Queen Elizabeth I had encouraged her maverick naval captains to appropriate Spanish ships laden with treasure from the East whenever possible. One such vessel, the *Madre de Dios,* captured in 1592, was filled with, among other things: "elephants teeth, porcellan vessels of China, coconuts, ebenwood as black as jet, bedstead of the same cloth of the rinds of trees very strange." A decade before Mary became queen, when William Wycherley's immoral comic play *The Country Wife* was performed in c. 1675, English society was already in the throes of an orgy of collecting. "China," as porcelain was popularly known, had become such an alluring, exotic, tantalizingly elusive prize that Wycherley used the word as a euphemism for the act of sex. In the play, the lodgings of a libertine, aptly named Mr. Horner, are described as "the china house" and provide the setting for marital infidelity. When Horner appears on stage with the married Lady Fiddler, he is confronted with a second eager admirer who entreats him: ". . . don't think to give other people china, and me none; come in with me too." To this admonition Lady Fiddler replies, "What d'ye think if he had had any left, I would not have had it too? for we women of quality never think

we have china enough." The exhausted Horner, however, has to disappoint her with the words, "Do not take ill, I cannot make china for you all, but I will have a roll-wagon for you too, another time." A roll-wagon in seventeenth-century parlance was a slender phallically shaped Chinese vase. To the informed audience of Wycherley's day, the sexual allusion would have been abundantly clear.

But not all the porcelain that found its way to Europe was of a quality suited to the bawdiness of the London playhouse. By the early eighteenth century, as Böttger languished in his Dresden prison, the heavily laden ships that plied the treacherous pirate-ridden seas between Canton and Amsterdam carried porcelain wares of unparalleled beauty and refinement, and these were the treasures that Augustus craved. The so-called Nanking cargo, which aroused a furor among porcelain collectors when it was salvaged from its watery grave and auctioned in the 1980s, was, though of a later date, typical of the objects exported to the West.

The sale comprised more than 100,000 pieces of Chinese porcelain stowed aboard a Dutch merchantman, the *Geldermalsen,* which in 1752 struck an uncharted reef in the South China Sea on her return journey from Canton to Holland. Most were unrefined kitchen wares but some were vases around which long-tailed, multiclawed dragons curled, from which pinnacled pagodas rose, or luscious many-petaled peonies blossomed. There were plates bedecked with pools full

of rippling fantailed fish, branches populated with exotically plumed birds set in gardens of bamboo and craggy rock-studded landscapes. To Augustus, such exquisitely decorated objects offered him glimpses of a fantasy landscape, a porcelain world of compelling fascination, of whose beauty, unlike that of his mistresses, he never tired.

So Saxony's extravagant ruler became a keen buyer for the most costly porcelain items, sponsoring representatives to buy on his behalf wherever a large collection came onto the market or a newly arrived ship's cargo was to be auctioned at the dockside. In the first year of his reign alone he is said to have spent 100,000 thalers on the acquisition of porcelain for the royal collection. Writing to his general field marshal, Augustus confessed, "It is the same with porcelain as with oranges; if you have a longing for the one or the other, you will never have enough." It is little wonder then that Tschirnhaus described China as "the bleeding bowl of Saxony."

The Oriental porcelain for which Augustus constantly hungered had been made in the northern regions of China in the Hebei province since the sixth century. It was not a sudden invention of the kind that Tschirnhaus sought, but the outcome of slowly evolving methods born from the high-fired white pottery produced in the region.

The West's fascination with imported porcelain had spurred numerous travelers to China to try to find out

how this mysterious substance was made. But the process was a closely guarded secret and the descriptions published in early accounts were often fundamentally inaccurate and highly misleading. Marco Polo described how "They collect a certain kind of earth, as it were from a mine, and laying it in a great heap, suffer it to be exposed to the wind, the rain and the sun, for thirty or forty years, during which time it is never disturbed. By this it became refined and fit for being wrought into the vessels." Gonzales de Mendoza, an emissary of Philip II of Spain, came closer to the answer when he found that porcelain was made of "a Chalky eaerth, which beaten and steeped in water, affoordeth a cream or fatness on the top, and a grosse subsidence at the bottome; out of the cream or superfluitance, the finest dishes . . . are made."

Other writers accounted for porcelain's fineness more imaginatively by saying that it was made from shells of lobsters or eggs pounded into dust or that the clay had to be buried for a century or so. No one from Europe grasped that the secret of making it was to mix two basic ingredients: kaolin or china clay and a feldspathic rock known as china stone or petuntse, and to fire them at such a high temperature that the feldspar melted and vitrified, infusing the pores of the clay and creating in the process microscopically fine crystalline structures known as mullite needles that are unique to porcelain. The Chinese call the clay the bones and the feldspar the flesh of the porcelain.

The result was a flawless material, far harder than

any other known ceramic and through which daylight would penetrate if you held it to the light. Brilliant and durable, no wonder it looked to Western eyes like shell. The word "porcellane," first used by Marco Polo, is derived from the Portuguese term *porcellana,* meaning a pig or a type of vaguely pig-shaped cowrie shell that was used as currency in parts of the Orient.

Tschirnhaus was by no means the first European to try his hand at porcelain-making. There had been numerous earlier attempts to discover its secret. The Venetians, who, thanks to their trade links with the Far East, had probably seen more early pieces of porcelain than anyone else in Europe, tried to make it in the sixteenth century, but succeeded only in producing cloudy glass. In Florence, also in the sixteenth century, the Grand Duke Francesco de Medici had slightly better luck. He assumed, like the Venetians, that the translucence of porcelain meant that it was in some way similar to glass, and included sand, glass and powdered rock crystal along with clay to his recipe. The resulting material was fine but a long way from the brilliance of the real thing. Few pieces survived the firing process and his factory turned out to be little more than an expensive folly. It closed on his death after only a decade and its rare products had little lasting impact on the development of European porcelain.

In the meantime superstitions about the magical properties of porcelain abounded. If you drank from a porcelain cup, it was said, you would be protected

both from poisons such as arsenic, aconite and mercury and from heat, since "they [porcelain cups] will grow hot no higher than the liquor in them ariseth." But despite the reverence in which it was held, almost a century was to pass before anyone tried seriously again to make porcelain. Then in the 1660s, in London, John Dwight of Fulham took out a patent on a porcelain formula—there are no records to show that anything ever came of it, but recently discovered shards containing mullite suggest that he found limited success. Elsewhere in London the Duke of Buckingham, England's richest man and the owner of various glass factories, also dabbled in porcelain-making. Two small vases survive at Burghley House and there is a similar pair in the Royal Collection at Windsor, but again no industry was able to prosper.

In France at around the same time factories were founded in Rouen and St. Cloud near Paris. The St. Cloud porcelain factory, which Tschirnhaus went to see, fared better. Potters there had formulated a recipe similar to that used in Italy: a combination of white clay, glass, chalk and lime. The result is now known as "soft paste porcelain" or *pâte tendre,* but though it was semitranslucent and far finer than anything else that had so far been made, it was grayish in tone and peppered with black flaws; in other words still lacking the perfection of true porcelain.

As part of his investigations Tschirnhaus also went to visit other European pottery centers. He saw the makers of faience in Nevers in France and delft in Hol-

land. Their pottery was made from a heavy earthen-ware body covered in a white tin glaze and painted in patterns derived from the Orient. He observed that even though these objects were often crude imitations of Chinese art, and heavily potted—nothing like the real thing in fact—the fashion for "chinoiserie" was such that the exotic designs alone were enough for them to sell as "porcelain."

Tschirnhaus's studies, coupled with his knowledge of glassmaking and his observation of the porcelain in Augustus's collection, persuaded him, like the potters in Italy and France, that true porcelain must be a mixture of clay and glass melded together. On his return to Saxony he began experiments of his own, using his massive burning glasses to melt samples of Saxon clay with glass to see if in this way he could find the formula.

In his laboratory prison, meanwhile, Böttger kept his word to the king and continued diligently, but with little obvious progress, to try to find the arcanum for the philosopher's stone.

Augustus, however, was not a man of unlimited forbearance, and when political events in Poland allowed him to return to Dresden he grew increasingly impatient with Böttger. The war with Sweden was proving disastrous and money to fund it was urgently needed. By the spring of 1705, more than three years after his arrival in Dresden, the realization finally dawned that Böttger was no closer to making gold than he had been

when he first arrived. Augustus, more incensed than ever with Böttger's endless lame excuses, forced him to make a definite pledge as to when results would be forthcoming.

By way of response Böttger produced a twenty-two-page document witnessed by von Fürstenberg, Tschirnhaus and von Ohain and signed by the king. In it he promised to produce quantities of gold within sixteen weeks, and two tons of it within a further eight days, "with Gods help." But divine intervention was not forthcoming and the king's hopes were dashed yet again. Should Böttger now pay the ultimate price for his failed promises and be executed? wondered Augustus. The dilemma was that among his courtiers such an act might also be interpreted as a sign of his misjudgment in believing and financing the man for so long.

Fortunately for Böttger, when Augustus's quick temper seemed ready to spill over into something more menacing, Tschirnhaus was on hand to point to Böttger's profound knowledge of chemistry and his scientific brilliance. Tschirnhaus was growing old, and his experiments with porcelain-making were still far from successful. Böttger would be the perfect person to continue this work, as well as continue his research into gold-making.

Perhaps relieved to find there might still be a way of saving face and justifying the enormous expense of keeping Böttger for so long, the king agreed—porcelain would be a prize every bit as precious as gold.

New, larger laboratories and kilns were deemed to be necessary for such developments and, as space in Dresden's Goldhouse was limited, in September 1705 Böttger, still a prisoner, was transported to the Albrechtsburg, the royal castle that towers over the quaint medieval town of Meissen, some fifteen kilometers northwest of Dresden.

# Chapter Five

............................................

*Refuge in Despair*

*The Invention of it is owing to an Alchymist, or one that pretended to be such; who had persuaded a great many People he cou'd make gold. The King of Poland believ'd it as well as others, and to make sure of his Person, caus'd him to be committed to the Castle of Königstein three miles from Dresden. There, instead of making gold, that solid precious Metal, which puts Mankind on committing so many Follies, he invented brittle Porcellane; by which in one sense he made Gold, because the great vend of that ware brings a great deal of Money into the country.*

BARON CARL LUDWIG VON POELLNITZ,
*Memoirs,* 1737

*T*he Albrechtsburg towers precariously on the rocky slopes of the Burgberg surrounded by river on three sides. Originally a wooden fortress founded in A.D. 926, the royal *Schloss* at Meissen had been rebuilt by Arnold of Westphalia in the fifteenth century as a princely Renaissance palace with money earned from recently discovered local silver deposits. Popularly known as the Saxon Acropolis, this is the quintessential fairy-tale palace, its six mullioned, gargoyled and crocketed stories linked by a fantastical rapierlike exterior staircase that sprouts improbably from the cathedral courtyard.

To approach the castle one crossed the gateway bridge guarding the entrance to the cathedral courtyard and arrived in a vast enclosure bordered by the stone walls of the castle, the cathedral itself and a cluster of medieval stone houses. Inside, Gothic fantasy gave way abruptly to barren solemnity, for the Albrechtsburg in Böttger's time had long been deserted. Almost as soon as it was built Saxony's rulers had moved camp to Dresden, and during the Thirty Years' War rampaging Swedish soldiers had laid waste to its exquisite interiors. So Böttger arrived to find Arnold's strikingly romantic palace no more than a shell concealing grand halls and honeycomb-vaulted chambers of resounding emptiness.

This spartan new home seemed a poor substitute for the comforts Böttger had left behind in Dresden. Thanks to the intervention of Tschirnhaus, his accom-

modations had latterly been made as pleasant as the constraints of custody allowed. The rooms he had occupied had been comfortably appointed, he had been plied with food served on silver dishes—according to one report the allowance for his table included large quantities of beef, fish, butter, cheese, sweetmeats, eggs and veal—and supplies of wine, beer and spirits were similarly plentiful. In addition he had been permitted to enjoy strolls in the exquisitely tended gardens; to sit on cool afternoons in a sun-drenched orangery; even occasionally to visit a small menagerie where he was amused by the antics of various exotic animals.

As a prisoner in Dresden, Böttger had also been allowed access to his intellectual peers. He was permitted to entertain guests for dinner and exchange ideas with the leading scientists and philosophers of the Saxon court. Such eminent figures might have poured scorn on the captive alchemist but instead, following Tschirnhaus's lead, they discussed his ideas with respect.

All in all, the prison Augustus had provided had been one of such beguiling comfort that at times Böttger could almost forget the desperation that had driven him to escape two years earlier. His arrival at the Albrechtsburg vividly reminded him of the vulnerability of life as a captive. The king, once again exasperated by the lack of progress, had ceased to consider his comfort and mental and physical wellbeing a matter of priority. Böttger's uncomfortable

confinement was now being used as a means of ensuring his complete concentration on the task ahead of him.

His only companions at the Albrechtsburg were five assistants appointed by the king, among them two smelters and mineworkers who became key players in subsequent events: Paul Wildenstein, who kept a fascinating record of progress, and Samuel Stölzel, later to become one of the most influential employees at Meissen. He was to be supervised by three men: Michael Nehmitz, who continued to be unsympathetic and hostile; his old ally Pabst von Ohain; and the ebullient court physician Dr. Bartholmäi. All were to pay regular visits to monitor progress.

Activities at the laboratory were to be strictly confidential. There was to be no discussion of the work with outsiders, no unauthorized persons were allowed in the castle's confines and the windows were bricked up so that no casual onlookers could gather an inkling of what was going on. Twenty-four furnaces were built for Böttger's use, and on the king's special order every clay pit in the land was ordered to deliver sixty-five-pound samples of earth to the castle laboratory to be tested.

Böttger and his assistants—who were treated as little better than prisoners though they had committed no crime—were locked into the laboratory to work in tandem on the development of gold and porcelain.

Reluctant though he was to give up his obsessive

quest for the arcanum for gold-making, Böttger reasoned that any breakthrough discovery he made with regard to ceramics would buy him time from the king. Gold remained uppermost in his mind, but porcelain provided an additional challenge, a way of proving once and for all that he was not a fraud. It was a test that, to his own surprise, he found increasingly compelling.

As the weeks passed, Böttger followed a course of steady and careful analysis of the properties of the minerals and clays at his disposal. Tschirnhaus was a regular visitor, monitoring progress and sharing with Böttger the findings of his own research. Tschirnhaus had already succeeded in producing small beads of a ceramic material that he considered to be porcelain, although in fact it was probably no more than what is now termed opaque or milk glass, and he had made an artificial hard stone resembling agate.

One of the fundamental differences between the ceramics such as faience, stoneware and soft paste porcelain that were already made in Europe and the true hard paste porcelain that Böttger sought was the temperature at which the latter was fired. Faience or delftware, the most popular type of European earthenware pottery, needed only to be fired at a relatively low temperature and the porous body required a glaze to make it watertight. But Böttger knew that the fineness and brilliance of true porcelain would never be rivaled by such crude earthenwares. Stoneware, made in Germany since medieval times, needed firing at a temperature of

1200–1400° C to vitrify the clay. But here too the resulting material, although nonporous, was not translucent and lacked the refinement of porcelain.

From his travels in France Tschirnhaus had also probably learned how to produce soft paste porcelain, which uses glass ingredients fused with clay at a temperature of 1100° C to achieve a nonporous body. He also knew that despite the charms of soft paste it had many drawbacks. It was prone to collapse in the kiln, granular in texture, and lacked the crystalline hardness of Oriental porcelain. The formula for *pâte tendre,* both Böttger and Tschirnhaus realized, was not the arcanum for which they searched.

Already familiar with glassmaking processes from his friendship in Berlin with the glassmaker Johann Kunckel, and well versed in the effects of heat on minerals from his gold-making pursuits, Böttger seems to have realized from Tschirnhaus's experiments that firing at temperatures far higher than those used elsewhere was a key element necessary to change the clay into a vitrified glassy body. In this sense he approached the problem of porcelain-making both as a "modern" scientist and as a medieval alchemist. In order to achieve the nonporous vitrified quality of true porcelain you did not need glass, he reasoned, but to melt rock to transmute it into an entirely different form, in the same way, he believed, as lead could transmute into gold. But to discover the necessary ingredients you needed the systematic experimental approach of modern science.

Characteristically confident in his own ability to solve a problem no one else could fathom, he chose with intuitive brilliance to follow a totally different route from all the earlier would-be porcelain-makers. Ignoring porcelain's superficial similarities to glass, he embarked on a series of carefully conducted experiments in which he mixed various combinations of the clays and rocks available and fired them at temperatures far higher than had ever been attempted before.

A year after his arrival at Meissen, Böttger, still deeply involved in systematically testing the materials available to him, succeeded in making small sample slabs of a fine red stoneware, a completely new ceramic material. Vitrified and hard as rock, this richly colored brick-red material was far finer in texture than the stoneware produced in other German potteries, and resembled closely a material made in the Yixing region of China, but it was not translucent and it was not porcelain.

Before he had time to develop this red substance more fully or even to fashion and fire it into anything other than a test slab, political events irrevocably interrupted progress.

Tschirnhaus arrived unexpectedly from Dresden accompanied by Prince von Fürstenberg's bailiff. He brought worrying news: the war with Sweden was proving even more disastrous than anyone had feared. Charles XII of Sweden had triumphed over Augustus in Poland and was now marching through Saxony and advancing on Dresden. The king, though fraught with

anguish, was not too preoccupied to be able to spare a thought for the safety of his most valued possessions. His manuscripts, jewels and precious works of art were all to be sent to Saxony's most impregnable fortress, Königstein.

After more than four years of captivity Böttger had produced little of any value, but Augustus still considered him an immensely important possession on a par with his gold and his jewels, and he too therefore needed safeguarding. The Swedish king was known to share Augustus's fascination with alchemy. He had spared the life of one of his generals by the name of Paykhull, who had been convicted of treason and sentenced to death, because he had promised to make alchemically a million crowns of gold. If Böttger were left at Meissen and fell into enemy hands, it was almost certain that Charles would seize him and force him to work for the Swedish cause. To avoid such a disastrous eventuality it was imperative that Böttger be taken to Königstein.

In the meantime the laboratory would have to be closed and those assistants not accompanying the alchemist (only three were permitted to attend him) must make their own arrangements to avoid capture. With little time to spare, Böttger's chosen companions packed a handful of their master's belongings and the precious notebooks which he refused absolutely to leave behind and prepared for the unexpected journey. The hard-won fruits of the last year's labor, the successful samples, the laboratory equipment and all their

other personal possessions were to be sealed up in two secret rooms in the Albrechtsburg. No one knew if they would ever be seen again or when work might be resumed.

To Böttger this sudden change in circumstance seemed catastrophic. He already felt within sight of the arcanum for porcelain, and the prospect of an indefinite delay coupled with the thought of a renewed period of imprisonment at Königstein must have aroused feelings of profound unease. There was no possibility, however, that a direct order of Augustus the Strong could be overruled, and soon after the arrival of Tschirnhaus and his party, Böttger and three assistants were bundled into a waiting carriage and given a military escort to their bleak prison. The others went to Freiberg and waited.

Even in this remote and impregnable place Böttger's presence was treated with obsessive secrecy. As a precaution against his falling into enemy's hands his little party was identified in the castle's records only as an anonymous "gentlemen" and three servants—whose duties included ensuring that he spoke to none of the castle's other occupants.

For the indefatigable young Böttger, the next year seemed interminable. There were no laboratory facilities and no substitute occupation with which to pass the endless days and nights; even books, paper and ink were denied him. As the months crept by, conditions improved only marginally. Driven almost mad by the enforced inertia Böttger managed, with his usual in-

genuity, to find a way of having limited contact with some of the castle's other involuntary residents—the vigilance of his guards was no match for the determination of Böttger when challenged. The other prisoners—mainly political detainees—feared for their lives and were frantic to find a way to escape.

Unable to resist the temptation of positive action after months of boredom, Böttger joined the conspiracy and helped plan a breakout—this was a field in which he was doubtless regarded as something of an expert. But at the final moment, perhaps remembering his promise to the king and fearing the consequences of angering him further, he dropped out of the attempt.

From then on the emotionally fragile Böttger descended into increasingly severe depression, emerging from bouts of despair only to write frantic letters to the king—having finally been granted the luxury of paper and ink—pleading for his release and begging to be allowed to resume his work. As he waited helplessly for Augustus's response to bring this purgatory to an end his penchant for wine probably gained further hold, providing temporary respite from the misery of incarceration.

A year after Böttger had been brought to Königstein the political turmoil in which Saxony had become embroiled was resolved, temporarily at least. Augustus had been forced to abdicate as King of Poland and the Swedes withdrew from Saxony. As soon as the situation

in Dresden became more settled Augustus's mind turned once again to gold and porcelain. With Poland lost, Augustus had little need now to absent himself from the city, but the war had been costly and money was needed more urgently than ever. As far as he was concerned, Böttger was now going to prove his worth.

In the meantime the despairing Böttger's letters to the king begging him "in the name of heaven" to give him an audience included a new promise: "It is my great hope, that with the help of Herr von Tschirnhaus, I can within two months present something great." Augustus's appetite was immediately whetted and he summoned the alchemist to be brought to Dresden for a secret meeting. At five in the morning on June 8, 1707, Böttger met the king and elaborated on his plans. He was positive that, given the right equipment, he would quickly make a breakthrough and find the arcanum for porcelain—and porcelain would be as effective as gold in solving the king's financial problems.

Augustus was easily convinced. While Böttger returned temporarily to Königstein he gave orders for a new laboratory to be prepared, this time not in Meissen but in Dresden, where he could keep a close eye on developments. Three months later the preparations were well under way and Böttger, finally recalled from Königstein, visited his new prison for the first time.

The laboratory was constructed in the Jungfernbastei, the Maiden's Bastion, in the dank maze of mal-

odorous vaulted fortifications bordering the Elbe beneath the eastern city walls. Mere mention of the name Maiden's Bastion was enough to strike fear in the hearts of Dresden citizens, for it was said that the place was so called because one of the gloomy cavernous tunnels contained a bizarre machine in the form of a steel woman with rotating arms of razor-sharp swords. Those who fell from favor in the court were forced to walk blindfolded toward the machine until they were sliced to shreds and a trapdoor in the floor opened allowing the still twitching body to sink without a trace into the river Elbe.

Despite the fearsome surroundings, the move to Dresden and the chance to resume his work came as a profound relief. Böttger knew that once again his life was on the line, but work would bring respite from the monotonous tedium of the last year and he was confident of rapid progress.

A new kiln, larger and capable of higher temperatures than those at the Albrechtsburg, had yet to be constructed. In the meantime he resumed research using Tschirnhaus's burning glasses. The glare reflected by these massive lenses was so intense that many of those involved in the experiments irreparably damaged their eyesight. Böttger's assistant Wildenstein wrote later, "Köhler and I had to stand nearly every day by the large burning glass to test the minerals. There I ruined my eyes, so that I now can perceive very little at a distance."

Soon after Böttger's new laboratory was more or less

functional the king paid him a visit. Gold was still an overriding priority, he said, and this time he would not listen to any excuses: failure would cost Böttger his life.

Bearing in mind the king's interest in porcelain, Böttger decided that his chances of once again cheating death would be improved if he ignored these threats and concentrated on ceramics rather than gold. Within a few weeks his experiments succeeded in producing again the red stoneware and he began making inroads into white porcelain production, rigorously testing combinations of clays and minerals fired at varying temperatures for various lengths of time. More materials were urgently needed, and Böttger was exceptionally given permission for some of the assistants to leave the prison temporarily in order to collect them.

The component on which Böttger soon focused was kaolin, or china clay, a fine grayish earth that had been acquired from a mine in Colditz but which takes its name from the Chinese word *kao-ling,* denoting the high mountains where the Chinese deposits of clay were found. Kaolin is termed by geologists a decomposed feldspathic product; it is the substance that results when granite has decayed after being subjected to the prolonged effects of weathering. The clay's principal component is kaolinite, a hydrated aluminum silicate that consists of numerous microscopic flakes that can move against one another and gives the clay its plasticity, making it ideal for modeling. The other

factor that made kaolin attractive was that when fired at high temperature it turned pure white—a key characteristic of Oriental porcelain.

But while kaolin softens at high temperature it does not melt. Thus it cannot alone create the translucent, pure white, nonporous body that defines Oriental porcelain. Another fusible substance to fill in the pores of the clay and give the body its glassy quality was clearly needed. Among the minerals Böttger tried mixing with the clay were various types of alabaster, a calcareous material. Tests were encouraging; alabaster from Nordhausen, Böttger found, responded especially favorably.

As autumn yielded to winter his now compulsive quest for the porcelain arcanum continued apace, with increasingly encouraging results. Even the king was infected by the mounting excitement and kept closely in touch with progress.

The turning point came as the new year of 1708 dawned. A handwritten sheet in Böttger's eccentric mixture of Latin and German, dated January 15, 1708, recorded a list of seven recipes:

N 1 clay only
N 2 clay and alabaster in the ratio of 4:1
N 3 clay and alabaster in the ratio of 5:1
N 4 clay and alabaster in the ratio of 6:1
N 5 clay and alabaster in the ratio of 7:1
N 6 clay and alabaster in the ratio of 8:1
N 7 clay and alabaster in the ratio of 9:1

The results of the test firings were more startling than even he had dared hope. After five hours in the kiln, Böttger records, the first sample had a white appearance; the second and third had collapsed; the fourth remained in shape but looked discolored. The last three held him spellbound.

These small, insignificant-looking plaques had withstood the searing heat of the kiln; they had remained in shape and intact. More important they were *"album et pellucidatum"*—white and translucent. In the dank, squalid laboratory the twenty-seven-year-old Böttger had succeeded where everyone else had failed. The arcanum for porcelain for which all Europe had searched now lay within his grasp.

## Chapter Six

···············································

# The Threshold of Discovery

Allons à cette porcelaine,
Sa beauté m'invite, m'entraine.
Elle vient du monde nouveau,
L'on ne peut rien voir de plus beau.
Qu'elle a d'attraits, qu'elle est fine!
Elle est native de la Chine.

Embarras de la Foire de Beaucaire
en vers burlesque, 1716

*B*öttger viewed his great discovery with ambivalence. On the one hand there was the undoubted satisfaction of having solved the elusive porcelain mystery, on the other a sense of failure that the arcanum for gold still eluded him, and that his scientific brilliance should be wasted on such mundane research. In a char-

acteristically self-mocking moment he scratched above the door to his laboratory: "God the Creator has made a potter from a gold-maker." The words, though no longer visible, have remained in popular legend as ironic testimony to his momentous discovery ever since.

Once the gratifying sense of success had passed he also realized that his achievement posed as many questions as it answered, and marked no more than the starting point in a laborious journey of discovery. Was the substance he had created stable enough to be fashioned into works of art as fine as those of the Orient? Could a glaze of sufficient brilliancy be found?

Through the spring and summer of 1708 Böttger persisted with his testings of mixtures of clays and other minerals, rigorously observing and recording the effects of heat on the various substances. By June, experimentation with various pottery and stoneware recipes was so successful that Tschirnhaus was able to found a manufactory where earthenware pottery or faience, in the manner of the potters of Delft, was to be made. This factory, based in the Neustadt district of Dresden, was to be run by two potters from Brunswick: Christoph Ruhle and his stepson Gerhard von Malcem, under the direction of Tschirnhaus and Böttger. The idea behind its foundation was partly to demonstrate the commercial value of Böttger's work, but, equally important, to give him access to skilled craftsmen: potters, glazers and decorators who would be essential in order to establish a porcelain business.

Tragically, however, as success beckoned, the health of Böttger's staunchest ally failed. Tschirnhaus, the older scientist who had kindled respect and affection in the captive Böttger, his assistants and even the king, fell gravely ill with dysentery, presumably contracted from infected water or food. His worsening condition placed an added strain on the already severely taxed Böttger and his colleagues. While experiments continued during the day, Böttger passed nights in silent vigil at the bedside of Tschirnhaus. Augustus was also deeply moved by the news of Tschirnhaus's illness and asked to be kept informed of events, sending Bartholmäi, the court physician, to visit him with his most effective remedies. But despite these efforts, at midnight on October 11, 1708, Tschirnhaus died.

Even Augustus mourned his passing. This statesmanlike scientist had helped the king to realize his dream of encouraging Saxon industry as well as being responsible for introducing to Dresden some of the most advanced philosophical and scientific theories of his age. To Böttger, Tschirnhaus had been a father figure, mentor and friend, offering crucial protection from the king's wrath on more than one occasion. Now that even this slender defense had fallen Böttger was more vulnerable than ever to the royal whim. His research provided both solace from grief and the only way of now keeping Augustus at bay. So work continued.

The rudimentary kilns constructed in the Jungfernbastei had proved incapable of producing the heat nec-

essary to fire anything larger than simple tiles of porcelain. The new bigger one was now ready for use, but this too was problematic. Wildenstein recorded: "We couldn't manage to make a strong fire in the new kiln; all our toil was fruitless and the fire remained weak. While it was burning, we had to make the fire walls sometimes higher, sometimes lower, but it was no use until we finally discovered the fault in the casing. The coals wouldn't burn all the way down, so we had to pull them out every thirty minutes."

For six days and nights he and the other men worked "like cattle" despite the subhuman conditions in which they remained incarcerated. The vaulted chambers of the laboratories were poorly ventilated by small windows—as a defense in medieval times against enemy incursions—and despite the chimneys into which the furnaces were built the heat in the room became so stiflingly intense that the men's hair was scorched. Shoes offered scant protection against the searingly hot stone floor that blistered their feet. Wildenstein recalled that as the furnace continued to rage the very fabric of the vault that contained it threatened to collapse. Lumps of rendering and plaster turned silver in the heat and began falling from the ceilings in large molten fragments. Stones loosened from the rendering exploded like bullets into the vault and littered the floor. Smoke from the furnace mingled with the moisture-laden atmosphere, filling the rooms with noxious fumes. It was barely possible to breathe, and the sweat pouring from the brows of the men con-

gealed the soot and dirt staining their faces and fell into their eyes, partially blinding them.

Böttger, sensing success and perhaps numbed by sorrow after Tschirnhaus's death, seemed impervious to mere physical discomfort. Demonically he drove his assistants on. As the days and nights passed and the furnace continued to gorge itself on fuel, the heat within it rose. Pungent gray smoke belched out of the inadequately ventilated kiln. The whole smoldering building looked as if it might break into flames at any moment. City officials became increasingly concerned at the threat to nearby buildings. The laboratory was beneath a wooden pleasure pavilion and orangery. It would be scandalous if everything went up in flames as an entertainment for the Saxon court was in progress. The Dresden guards were put on standby, hosing down the exterior walls, while inside the men still fed the flames and the furnace burned on.

The king had told Böttger that he wanted to see for himself the progress at the laboratory as soon as the kiln had reached the correct temperature. As the wood in the kiln began to burn more steadily word was sent to the palace that the time was auspicious.

Arriving at the vaults with Prince von Fürstenberg, Augustus entered a hellish scene. The heat in the room was unbearable, but before they could turn back, Böttger, his face and clothes blackened with soot and sweat, greeted them and led them to the kiln. According to Wildenstein's colorful account, "The Baron

[Böttger] ordered that we stop the fire for a time and open the kiln, whereupon the Prince repeatedly said 'O Jesus,' but the King laughed and said to him, 'Indeed it is not purgatory.' Then as the kiln was opened and everything glowed white so that one could not see anything, the King looked inside and called to the Prince saying, 'Look, Egon, they say that porcelain is in there!'" At first neither could see beyond the glare of the blaze, but with the door of the kiln open the heat within subsided slightly and began to glow red. Now the royal party could just pick out the fire clay boxes known as saggers in which the porcelain was cased before firing to protect it from the flames of the furnace. Wildenstein was ordered to show a sample of the contents to the king. He removed a sagger and opened it to reveal a small teapot still glowing red with the heat of the furnace. Böttger quickly stepped forward, picked up the pot with a pair of tongs and threw it into a nearby bucket of water. According to Wildenstein's account, the exposure to such extremes of temperature caused the submerged pot to effervesce and a loud explosion reverberated through the vault. "It's broken," said Augustus, but Böttger replied, "No, Your Majesty, it must stand this test." He then rolled up his sleeves, removed the pot from the water and handed it to the king. Astonishingly, the pot had remained intact although the glaze was imperfect. The king, suitably impressed by what he saw, ordered Böttger to put the pot back in the kiln and instructed that until firing was complete and the kiln perfectly

cool no one should open it. He wanted to be the first to witness the results of this firing and would attend the opening himself.

A few days later Augustus returned and the kiln was opened for examination. Inside were several pieces of white unglazed porcelain and red stoneware, which Böttger and his associates called red porcelain. The king took away with him the teapot he had seen in mid-firing. Satisfied with the progress made so far, he became suddenly more concerned at the plight of Böttger and the others and, turning to Böttger, commented on the appalling conditions in which the men worked.

"My men will do anything for Your Majesty," Böttger said with feeling, probably wondering as he did so if this was the appropriate moment to ask for his freedom.

"Then they shall have my blessing and their livelihood." The king was well satisfied with Böttger's achievement and in an unusually munificent frame of mind. Soon after, a consignment of new clothes was delivered to the vault to replace the charred, unwashed rags in which the alchemist and his helpers had slept and worked for months. From now on each was paid a modest salary, but apart from these small concessions working conditions remained as dire as before.

Böttger's experiments continued for another year, and it was not until March 28, 1709, that he felt confident enough to write to the king declaring himself able to make "fine white porcelain together with the

very finest glaze and painting as good as that of the Chinese, if not better." He was ready to go into full-scale production. Porcelain, he suggested, was itself a form of gold, and since he had found a way of making such a priceless treasure for the benefit of the king, he had fulfilled his promises and should be granted his freedom.

Böttger's assertion was characteristically optimistic and, as usual, economical with the truth. Although by now he had undoubtedly discovered the arcanum for a fine porcelain body, he was still nowhere close to surpassing the porcelain of the Chinese. A large proportion of the pieces fired did not withstand the intense heat and were lost. His glazes were still far from the brilliancy and clarity of Chinese porcelain, while underglaze blue and colored enamels were as yet undeveloped. To Böttger, however, these seemed minor difficulties, easily overcome compared with those he had already surmounted. Given time, enough skilled workmen and enough investment, he would solve them.

But the king was not to be easily steamrolled into financing a porcelain factory, or into granting Böttger his freedom. He had already spent a fortune on his gold-making experiments, and so far had seen nothing in return. In response to the request for freedom, Augustus therefore replied that the alchemist would not be free until he found the formula for gold. Starting from December 1, 1709, he expected to be paid 50 ducats a month, until the 60 million thalers in gold

Böttger had once promised was repaid. Until then he would remain a prisoner of the king.

In the meantime Augustus pondered on how best to capitalize on the alchemist's invention of porcelain. Though always lavish in his spending on personal luxuries, Augustus was often surprisingly cautious when it came to investing in the industries that he wanted to restore Saxon fortunes. Developments in porcelain-making so far had pleased him, it was true, but he was not convinced that Böttger was ready to start a full-scale manufactory, which would doubtless require yet more investment from the royal purse. Before he would sanction such an enterprise he wanted to know more about its viability. Where would the clay come from? How would it be transported? Would Böttger's porcelain be more expensive than that of the East? What sort of pieces would he make? And above all, how would they ensure that the arcanum remained secret?

Without Tschirnhaus the king lacked a reliable and well-informed advisor whom he trusted and who could understand the practicalities of porcelain-making. To resolve the matter, therefore, Augustus appointed a commission of five expert investigators to advise him: among them were the unsympathetic Michael Nehmitz and Böttger's old ally Pabst von Ohain.

Böttger meticulously explained his vision. The red clay he needed for the red porcelain or stoneware was from Zwickau or Nuremberg; it would be mixed with

clay from Plauen. The paste for the porcelain would be made by mixing alabaster from Nordhausen with white clay from Colditz. He envisaged a central administration with control over various different branches. Each of the processes—the mixing, the modeling, the firing and the decorating—could be conducted in a different place, thereby safeguarding the secret, for it would be difficult for any one worker to gain insight into anything outside his own specialty.

As for the question of what he would make from his newly invented substance: Böttger always regarded porcelain as a precious material on a par with gold or silver, having little in common with other forms of ceramics, which were essentially utilitarian. In a document submitted to the commission he explained his idea of what would make these objects desirable: "Firstly beauty, secondly rarity, and thirdly the usefulness that is bound to both of these. These three qualities make an object agreeable, valuable and needed." To Böttger, porcelain objects were to be first and foremost works of art of supreme and exclusive beauty; function was a minor detail, a foil for the intrinsic beauty of the object.

Böttger's staunch outward enthusiasm for the porcelain venture belied his wildly vacillating state of mind. Although optimistic in his dealings with the commission, at times he was overwhelmed with despair at the king's demands for gold. He had abandoned gold-making in the hope that porcelain would

satisfy Augustus and earn him his freedom, but the king clearly would not let the matter drop.

There were worrying tales of the gruesome fate of a fellow alchemist in Berlin. After Böttger's escape, the Prussian King Frederick, realizing that the chances of recapturing the fugitive were slender, had employed a Neapolitan alchemist by the name of Domenicho Manuel Caetano who had made a lucrative if perilous career out of demonstrating transmutations in many of the courts of Europe. Unbeknownst to Frederick, Caetano had mysteriously disappeared from Brussels after having been advanced 60,000 gulden against his promise of multiplying that sum in gold. From there he had gone on to Vienna and then to Berlin, where he assured the Prussian king that he had found a cache of manuscripts belonging to an unknown alchemist which included details of how to make the philosopher's stone. In return for Caetano's promise to make gold within sixty days, Frederick advanced generous amounts of money, presents and privileges. Predictably, when the sixty days of good living were drawing to a close, Caetano tried to escape—this time to Hamburg—but Frederick sent soldiers after him and he was captured, brought back to Prussia and imprisoned. In August 1709, having finally exposed Caetano beyond a doubt as a charlatan, Frederick ordered that, as an example to all would-be fraudsters, he be dressed in a robe of gaudily woven golden thread and hanged on the city's gallows, especially decorated for the occasion with gilded spangles and tinsel. As a final

reminder Frederick gave instructions that a gold medal be struck to commemorate the event.

Although, like Augustus, Böttger remained convinced that an arcanum for gold could be found, he must have known that he was not much closer to finding it than he had been ten years earlier while an apprentice in Berlin. The realization cast him into severe depressive fits, in which the threat of a death as ignominious as Caetano's constantly held over him seemed unbearable. It would be preferable to admit defeat and end it all.

In December 1709, Böttger, in a fit of gloom, wrote to the king enclosing an emotional poem in which he confessed that he was still incapable of providing gold. In return for his failure he offered his life to the king:

> *The King will yearn for golden fruit,*
> *Which the feeble hand yet cannot present.*
> *On this account it proffers now but crystals of*
> *    porphyry and borax*
> *Before the King's throne in place of those*
> *    sacrifices.*
> *Yes, the hand extends even the heart in vessels of*
> *    porcelain*
> *And as an offering here tenders both.*

Fortunately for Böttger, however, political events once again preoccupied the king. The Russian army under Peter the Great had defeated Charles XII of

Sweden at Poltava in July 1709. Augustus, seeing his way clear to regain the crown of Poland, had broken the peace treaty of Altranstädt whereby he had agreed to recognize Stanislas Leszcynski as Polish ruler, and reclaimed the throne for himself, forming an alliance with Prussia and Russia against Sweden. With the king reinstated in Warsaw, the problem of what to do with the miserable Böttger seemed less pressing than it had a few months earlier. If the alchemist could not make gold, he had at least proved himself a capable inventor of porcelain, and if, as he promised, this could be commercially successful, all Europe would look to Saxony with awe and admiration. With true porcelain to sell, Augustus could even attempt to rival the artistic preeminence of the French.

But wars are inevitably costly and Augustus, though eager to profit from Böttger's invention, remained chronically short of money and reluctant to incur any further unnecessary expense by setting up a new porcelain factory. He decided that if he could attract outside investors his risk would be minimized; he would stand only to gain, both in terms of prestige and financially. On January 23, 1710, therefore, a royal proclamation written in four languages was posted to the door of every church in Saxony. In it Augustus announced the forthcoming foundation of his new royal porcelain manufactory. The announcement sought investors for what the king promised would be a highly profitable financial venture. Anyone willing to put up money was offered shares in the company and 6 percent interest on

his money over two years plus an additional dividend. Shareholders could receive added bonuses by taking repayment of their capital in the form of porcelain, which would be priced at 25 percent below its market value.

But the cautious merchants of Saxony remained skeptical about the chances of such a business working. Nothing like it had ever been attempted before, and Augustus's announcement failed to attract the enthusiastic response he hoped for. In the end no one offered to invest in the porcelain factory and Augustus was obliged, with great reluctance, yet again to sponsor Böttger from the royal purse.

While the king waited for a response to the announcement and letters were dispatched to and fro between Dresden and Warsaw, Böttger continued diligently with his experiments into the best recipe for porcelain. There were constant developments. He had recently been given a new sample of pure white kaolin that had come from a mine belonging to a wealthy landowner, Hans Schnorr von Carolsfeld, of Aue, a town in a province of Saxony called Voigtland. Schnorr had come across the clay while mining for iron and had been using it successfully as an ingredient in his cobalt factory. Pabst von Ohain, as the Saxon inspector of mines, had a paid visit to Schnorr in 1708 and, noticing the incredibly fine powdery white clay, immediately sent a sample to Dresden.

In tests Böttger discovered that Schnorr's clay was far superior to that of Colditz, on which he had previ-

ously relied, in two important respects. It was easier to model, and because it contained fewer traces of iron oxide it fired whiter. Despite this improvement, Böttger continued to use alabaster as a fluxing agent and this caused him constant problems. Alabaster can only be used as a flux within a very limited temperature band, and the unreliability of the kilns meant that the precise temperature was impossible to regulate and there were still huge losses in the firing.

Having given the porcelain factory the go-ahead, Augustus was anxious that a careful control should be kept on Böttger, whom he continued to plague from time to time with demands for gold. A directorate of crown officials who would monitor his work was appointed by the king. Against Böttger's wishes the hostile Michael Nehmitz was appointed director, a position that allowed him continually to undermine Böttger's relationship with the king. More positive from Böttger's point of view was the selection of Bartholmäi, the affable royal physician, who was put in charge of hiring staff; and Johann Melchior Steinbrück, a fair-minded teacher, who was made factory supervisor. Böttger himself was appointed chief factory administrator.

While still perfecting the formula for white porcelain, Böttger now began commercial production of his red stoneware, but progress was far from smooth. A larger, more efficient kiln had been built in the Jungfernbastei in Dresden but there was a further unexpectedly serious difficulty: an acute shortage of

skilled workmen. In order for Böttger's business to succeed he needed specialists capable of turning the material he had invented into objects of beauty. But no one with the necessary experience, it seemed, wanted to take a gamble on such a risky project and join Böttger's team. Advertisements for potters were displayed prominently on the door of Dresden's town hall, but to no avail: not a single inquiry was forthcoming. Eventually, in desperation and fearing that his business would never get off the ground, Böttger pulled strings with contacts at the court and managed to entice the court potter, Fischer, to work for him making objects from the red porcelain. But Fischer could hardly fail to be aware of the shortage of skilled labor, and was not about to miss an opportunity to take advantage of it. He charged an exorbitant price for his work. Böttger, with no suitable alternative, was powerless to refuse.

Within weeks production was so well established that wares were mounting up and lack of storage space became another problem. Dr. Bartholmäi allowed spare rooms at his house to be used as a store, but this was a short-term measure only. As stocks of the new material were accumulated the important consideration of how to sell such a product had also to be resolved. The Easter trade fair in Leipzig was an annual event at which the rich routinely gathered to buy the newest luxury items. It was clearly the perfect place for Böttger's red stoneware to make its commercial debut, and the directorate organized an impressive stand at

which objects made from this miraculous new material as well as examples from the faience factory were on offer. White porcelain, the greatest achievement of all, was also exhibited but not for sale.

The stand attracted considerable attention and according to newspaper reports was heavily visited by spectators who marveled at the "extraordinary beauty" of the goods on offer. The Leipzig paper of May 14, 1710, gave detailed descriptions of the exhibits, mentioning with awe "jugs, teacups, Turkish coffee pots, bottles and other items suitable for use and for adorning the table. . . . Some because of their extraordinary hardness resemble jasper. . . . They are cut in angular shapes or in facets and are of a wonderful lustre. . . . There is a sort of red vessel that has been lacquered like the most beautiful pieces of Japanese work."

But, as Böttger painfully discovered, fashions in porcelain, as with other forms of art, take time to establish. The first public showing of the revolutionary red and white porcelain was far from the instant success for which he had hoped. Few pieces were sold, orders were fewer than he had expected and the whole venture resulted in a considerable loss.

Nonetheless the directorate persisted in its attempt to market the wares, and salesmen were employed to sell at several other large European fairs and in neighboring German states. In June the porcelain was displayed in the Peter and Paul Fair in Naumburg. Unable to resist the temptation to reveal Böttger's achievement to Prussia, the directorate also dispatched

a salesman to Berlin, laden with choice items. One can scarcely imagine the reaction of the Prussian court as they realized that the exquisitely wrought vases, bowls, cups and figurines were the direct result of the king's persecution of the talented young alchemist a decade earlier.

As production grew, it became clear that more space would have to be found before white porcelain could go into full production. The question was where to set up this new factory so as to ensure that the precious arcanum would remain safe. The Albrechtsburg, strategically perched on its impregnable cliff top and still vacant since Böttger had been temporarily housed there in 1705, seemed the ideal solution. The castle's position would ensure that the factory's activities could be easily safeguarded, and the river beneath it allowed for easy access by boat—an important consideration since constant deliveries of wood were needed to fuel the kilns. In June 1710 the new porcelain factory was moved to Meissen. Böttger, however, on strict instructions from Augustus, remained a prisoner in Dresden.

# Chapter Seven

........................................

*The Flames of Chance*

*In order to preserve this art as much as possible a secret, the fabric at Meissen . . . is rendered impenetrable to any but those who are immediately employed about the work, and the secret of mixing and preparing the metal is known to very few of them. They are all confined as prisoners, and subject to be arrested if they go without the walls; and consequently a chapel and everything necessary is provided within.*

JONAS HANWAY, *An Historical Account of the British Trade over the Caspian Sea*, 1752

$S$uccess did not come easily despite the royal fanfare. In the first years after the move to the Albrechtsburg, Böttger was beset by a seemingly endless string

of difficulties as the factory's survival teetered precariously in the balance.

Money was a constant source of worry. Böttger, as factory administrator, had to shoulder personal responsibility for the factory's debts. Although a talented chemist, he was hopelessly disorganized when it came to financial matters; no proper factory accounts were kept and his muddled personal debts became irretrievably intertwined with those of the factory. The king was supposed to pay him a salary to cover living expenses and costs, but this seems to have been paid in full only sporadically. Subsequent biographers unsympathetic to Böttger's cause have accused him of fiddling the books for his own ends, but it seems more probable that the discrepancies were simply the result of Böttger's financial naïveté and chaotic administrative skills, and the duplicity of those like Nehmitz who were quick to take advantage of his failings.

The king was often away for months at a time in Warsaw and the wages of his other factory employees frequently went unpaid. Even when he did deign to send instructions to his chancellor in Dresden to meet outstanding debts, money was still often withheld because the king's finances too were in desperate disarray. The nonpayment of wages caused obvious hardship and unrest among the hard-driven staff, who were still kept as virtual prisoners in the Meissen precincts and officially forbidden to come and go as they pleased. Forced to work for weeks, sometimes months, on end for no pay, they became audacious and lawless. On one occasion they

ignored the usual restrictions and abandoned their jobs at Meissen, marched to Dresden and confronted the king during his leisurely morning ride. On this occasion their wages were paid but they were not always so lucky.

Michael Nehmitz, the head of the commission appointed by Augustus to monitor progress, was a continual source of irritation and one of the chief causes of the factory financial concerns. By failing to pass on Böttger's letters or to relay messages, by endlessly criticizing him to the king with exaggerated accounts of his drunkenness and his mismanagement of the factory, he caused damaging friction between Augustus and Böttger and further distrust among the workers. It was later to emerge that much of the money that he claimed Böttger had misappropriated had in fact gone to line his own pocket.

Although Böttger had been appointed the factory administrator, he was still forcibly held in Dresden, because the king still expected him to find the formula for gold. Separation from the factory meant that he was unable properly to monitor its day-to-day running or the training of staff. In all he is known to have made only five visits to Meissen, obviously a hopelessly inadequate state of affairs for the smooth running of a still nascent industry. His first visit took place in July 1710, a month after the factory's inception; the second was a year later in the autumn of 1711 when Böttger, by now accustomed to a relatively comfortable life in Dresden, brought with him a decorator to improve the spartan interiors at the Albrechtsburg.

From the start at Meissen there were also serious problems with production. A new, larger kilnhouse had been promised in vacant rooms that once had been occupied by the local magistrates' court. Dr. Bartholmäi had made detailed studies of foreign kilns in order to improve on the inefficient design of the ones at the Jungfernbastei in Dresden, which were still far too small for full-scale commercial production as well as being impossible to regulate with any accuracy. The difficulties of this hit-and-miss method, without any form of accurate temperature gauge, in which heat was regulated by the supply of oxygen to the furnace, had led Tschirnhaus to christen the Dresden kilns "the bowl of chance." Here too, however, shortage of money hampered progress, and by 1711 the position had gotten so bad that building of the new kiln at Meissen had been stopped altogether.

There were also endless irritating delays caused by arguments with the cathedral chapter. The cathedral of Meissen was enclosed within the same fortifications as the castle and shared the same entrance and large courtyard. The Protestant clergy from the start were highly suspicious of the Catholic king's new venture and probably wondered if there was more to it than met the eye. Certainly they became increasingly disgruntled at what they considered the inappropriateness of having a factory in the building adjacent to them.

Despite all these complications, somehow Böttger managed to start production in limited quantities.

The red stoneware that he had invented was far simpler to make and more stable in firing than white porcelain and in these early days he relied on it to provide extra cash to make up the shortfall from the king and finance further experiments into white porcelain, which still needed perfecting.

Although the red stoneware could be reliably made and fired, its incredible hardness and striking color meant that the usual ceramic shapes and methods of decoration were by and large useless. The material was too fine, too hard and too completely different to be treated like a normal ceramic. So new shapes had to be found to show it to advantage, new techniques developed to decorate it, and above all new craftsmen employed who were capable of such innovative tasks. The potters at the faience factory helped, but they were not skilled enough for what Böttger had in mind.

The substance was immensely versatile, and from the outset Böttger ensured that it was used to make objects of beauty and refinement. Under his direction craftsmen developed a novel range of decorative techniques. They mixed red clay of slightly differing compositions together to create the streaky, marbled effect of natural stone; they embellished surfaces with leaves and blossoms in the style of Chinese porcelain and further adorned it with painting or even studding the surface with gems. Correctly fired, the stoneware was nonporous and therefore did not need glazing; instead it could be treated like marble and simply polished to

a fine sheen. Added richness could be achieved by polishing certain areas while leaving others dull, thus creating a striking contrast between matte and gleaming surfaces within a single object.

But the success of this multiplicity of decorative techniques relied on the skills of a wealth of specialist craftsmen, and such people had to be found, tested, employed and given further training and direction. Freelance sculptors were hired to model the fine details that were applied to the surface after a pot was thrown. Craftsmen in Bohemia, famed for their lapidary and glass-engraving skills, finished the red porcelain by cutting, engraving and polishing until it resembled finely burnished marble. Much of this work was done at a new polishing works set up outside Dresden on the Weisseritz, a tributary of the Elbe, and Böttger's research led to the development of new grinding mills, which were also used to work agate and other semiprecious stones.

Still Böttger remained unsatisfied, seeking more innovation and ever more visually appealing shapes. But, as a technician rather than an artist, he needed help to realize the inspirational designs he envisaged. A turning point in the design of stoneware came in 1711 when Böttger met the court silversmith Jacob Irminger. Impressed by the silversmith's work, Böttger showed enormous trust by exceptionally permitting him to make a tour of the Meissen factory—and allowing him to take away for trial modeling quantities of the best clay available.

Irminger was such a success that the king, with Böttger's approval, quickly appointed him artistic director, with instructions to develop a range of items that would appeal to the luxury market, to the less affluent middle-market buyer and to a foreign clientele. Like Böttger, Irminger remained based in Dresden, where from his studio he dreamed up new forms for the factory to manufacture, fashioning them from copper before dispatching them to Meissen or to the Dresden factory to be cast in clay. Every few months, far more regularly than Böttger, he made a trip to the Meissen factory and spent several days at a stretch there, keeping an eye on production and teaching new staff how to achieve the effects he wanted.

As the workers at the factory became increasingly adept, Böttger strove to offer an ever larger repertoire of objects. By 1712 he had perfected several larger forms and, typically overoptimistic, announced to Steinbrück, the factory's supervisor, that he would now be able to produce "stoves, fireplaces, cabinets, table tops, columns and pillars, door-posts, small coffins, antique urns, slabs for covering floors, jewel boxes, chimes, pastry boxes and chess sets." In short, Böttger was saying (as usual not entirely truthfully) that almost anything could be made from his remarkable invention.

By far the most numerous and successful of all the objects made from Böttger's revolutionary red stoneware were vessels for the three drinks that had been introduced to Europe in the seventeenth century

and become entrenched in the social habits of fashionable society: coffee, chocolate and tea.

In the absence of proper sanitation, water posed a huge health risk to those who dared drink it in its unadulterated state. Boiling made it safer (although the existence of bacteria had yet to be discovered), but there was a great need for something to be added that would disguise its tainted taste. Tea, coffee and chocolate not only had flavor, they also contained a mild stimulant: those who sipped these drinks received a gentle boost, with none of the less dignified side effects of alcohol.

Coffee had been introduced from Arab countries, where it was enjoyed from the fourteenth century. Cocoa had been discovered by the Spanish in Mexico following its conquest by Cortés. Tea, like porcelain, originated from China, where it had been a favorite drink for centuries. The drink, known in Cantonese as *cha,* had been discovered in Canton by the Portuguese traders who were already importing it from China to Lisbon in 1580. In 1613 Samuel Purchas, on a visit to China, noted how in greeting a friend the locals "offer him Chia to drinke, which is the water of a certain herbe of great price, and may not be omitted with other junkets." A century later tea, like so many other Oriental products, had become fashionable throughout Europe.

By Böttger's day, although these drinks had become one of the established conventions of polite society, the question of how they were to be served had yet to be

satisfactorily answered. One of the very earliest examples of a complete service for tea and coffee was made between 1697 and 1701 by Augustus's imaginative court jeweler, Dinglinger, to celebrate the king's accession to the Polish throne. Presented on a massive layered pyramid stand of gold, with a diminutive teapot perched at the apex like some holy relic, the service is decked with sumptuous golden sugar bowls, exquisitely carved ivory figurines and delicately engraved crystal vases, the whole studded with thousands of diamonds and precious gems. But perhaps the most remarkable thing about this extraordinary and priceless object is that the cups are made from solid gold enameled in imitation of Oriental porcelain. For despite his apparently limitless resources—quantities of gold and gems, amazing skills and brilliant craftsmen—the unavoidable truth was that Dinglinger, like every other royal craftsman in the land, was unable to provide his king with a genuine Saxon-made porcelain cup for his tea.

Clearly such an extravagance was never intended to be used for anything other than a ceremonial showpiece. Indeed, had it been made for regular use Dinglinger's dilemma would have been even more awkward. To drink tea and coffee hot you needed a material that would be strong enough to withstand the heat of boiling water but would also provide insulation so that the person who was drinking it could sip the liquid while it was hot without burning themselves. Silver was all very well for coffee, tea and chocolate

pots but as a conductor of heat was clearly unsuited to use for cups, and the same could be said of any other metal.

Ceramics were clearly ideal for such a function, for clay is an insulator rather than a conductor of heat. So the prolific potters of Delft began making pots and cups in response to the snowballing fashion for these beverages. But here too there were drawbacks. The porous nature of the earthenware body meant that if there were the slightest chip—and lead glaze is extremely easily chipped—the body would not be watertight.

In the Far East tea was brewed in a kettle and served cooled in small handleless porcelain cups. Purchas noted how tea was brewed in the Orient and wrote in 1613 "they put as much as a Walnut-shell may containe, into a dish of Porcelane, and drinke it with hot water." Noting that the unenlightened Europeans preferred to serve their exotic product from a pot, the Chinese saw the potential for yet another lucrative Western market, and began making pots for export from their own Yixing red stoneware, probably based on shapes copied from silver or delftware pots made in Europe.

When China's copies of European forms were seen by Böttger, he borrowed them back, realizing that his material was even finer than Chinese stoneware and equally well able to withstand the rigors of boiling water. Thus the circle of fashion revolved in a curious cross-pollination of ideas and customs: a design from

Europe was transported to China and then welcomed back to Europe again.

Augustus was a great admirer of his new factory's imitations of exotic Chinese stoneware—he already had a vast collection. He was even more delighted when Böttger presented him with "a very fine red vessel, which in every way equals the so-called red porcelain of the East Indies, surpassing marble and porphyry in its hardness and beauty." And as with so many luxuries, his appetite for red porcelain grew voraciously. While output steadily increased, alarming quantities were appropriated by the king. Augustus, ever a lover of ostentation, ordered Böttger to make extra large pieces for his palaces; vases sixty centimeters high and dishes half a meter in diameter were produced as royal commissions. In all some eight hundred pieces were acquired for Augustus's own collection and in addition large quantities were given away to visiting princes and dignitaries by the king—ever eager to show off the peerless products of his new factory.

As patron of the factory Augustus could buy porcelain and stoneware at vastly discounted prices. Despite this advantage he rarely troubled to pay anything for his acquisitions, regarding them as one of the justifiable perks of his investment. The outstanding sums compounded Böttger's financial problems even further. Increases in production had still not helped the factory to make a profit. A year and a half after the opening of the Meissen factory, even though nearly

thirteen thousand pieces of stoneware were stored in the stockroom ready for sale and a showroom had opened for visitors to come and buy the products, Steinbrück calculated that outgoings were 50 percent higher than earnings.

The chief reason for the losses, which Böttger, locked in Dresden, failed to perceive, was the corruption with which the factory was riddled from top to bottom. At the top of the tree, Michael Nehmitz, head of the commission, was almost certainly the worst culprit. He was prone to keeping for himself the money given by Augustus to help with the factory running costs, and was also not above selling prize pieces of stoneware at Leipzig and stealing the proceeds. The factory's accountant, Mathis, was similarly corrupt and he too was caught selling Meissen stoneware at Leipzig and pocketing the cash. Of the top directorate only Steinbrück the supervisor and Bartholmäi the physician were immune from such chicanery. Further down the chain of command there were similar tales of theft and double-dealing, some of which would have dire repercussions for the future of the factory.

The ingenuity of Böttger's inventions, so flamboyantly announced by the king, had aroused extraordinary jealousies in rivals throughout Europe. Even before porcelain was widely available there were numerous attempts to steal the secret formulas for both stoneware and porcelain. Dresden and the town of Meissen constantly thronged with spies loitering purposefully in the bustling market squares and inns in

the hope of overhearing conversations between factory workers that would allow them to glean enough knowledge to unravel the secrets of the formulas.

Augustus, alert to these dangers, inculcated the workmen with the fear that if they were discovered to have discussed what they knew with any outsiders they would suffer the severest punishments. Talking about porcelain-making was in Augustus's eyes tantamount to treason. As an added safeguard, following Böttger's original suggestion, each worker was deliberately kept ignorant of the processes carried out by others in the factory.

But these precautions were not enough to keep the secret safe. The first to capitalize on the value of his knowledge was Samuel Kempe, a kiln master and compounder at the Neustadt factory. Kempe had already been caught once with his hand in the till and been punished with two years' imprisonment. Midway through his sentence he had written an emotive letter to Böttger, imploring him to take pity on his plight. Feeling sorry for the man, whose predicament he could all too easily sympathize with, and mistakenly believing that Kempe had learned his lesson from the severity of the prison conditions he had experienced and would never try anything similar again, Böttger backed Kempe's application for a pardon. After his early release Böttger helped further by giving him back his job in the factory and letting him assist in the laboratory.

In this position of privilege Kempe was able to wit-

ness Böttger's experiments at first hand and gain crucial knowledge of his formula for the red stoneware. A few months later, without any apparent qualms of conscience, Kempe repaid Böttger's trust by not turning up for work one day. Immediately fearing the worst, Böttger dispatched a messenger to Kempe's lodgings. When it was found that he had disappeared without a trace, a quick search of the Dresden factory was carried out and revealed that he had taken with him a large lump of the red stoneware paste. Kempe, it emerged, had been lured to Prussia, as the old rivalry between Saxony and Prussia once again reared its head. The dishonest technician had been bribed with an offer of lucrative employment by a Prussian government official, privy councillor Görne, whom he helped set up a rival establishment making stoneware at Plaue in 1713.

In fact the Plaue products were never as good as those of Meissen. The paste was always coarser and the designs rather oddly proportioned. But the breach of security was enough to terrify the king and his administrators. The episode had proved beyond a doubt that the secret porcelain arcanum was in even greater jeopardy than they had feared.

# Chapter Eight

........................................

✺

## *White Gold*

*Ay; these look like the workmanship of Heaven,*
*This is the porcelain clay of human kind,*
*And therefore cast into these noble moulds.*

    JOHN DRYDEN, *Don Sebastian*, I.i., 1689

*I*n the tender spring sunshine of 1713 visitors to
the celebrated Leipzig Easter Fair could not fail to
pause as they strolled past the outstanding display put
on by the King of Poland's famous Meissen factory.
Modishly clad aristocrats, well-to-do merchants, ladies
in velvet-trimmed cloaks that billowed over their
silken dresses greeted one another, exchanged pleas-
antries and marveled aloud at the eye-catching spec-
tacle.

Accustomed though it was to striking arrange-
ments of luxury items—always a hallmark of the

Leipzig fair—this fashion-conscious audience's attention was nonetheless riveted by Meissen's extraordinary array. For here was something completely unprecedented: a dazzling hoard of dainty beakers, fragile tea bowls, delicate saucers, finely cast dishes, tea caddies and pipes, all made from glittering white porcelain the like of which had never before been produced in Europe.

Gently picking up the tiniest of tea bowls, they perhaps held them aloft to the sun's soft radiance, exclaiming in delight as the light penetrated the wonderfully fine translucent body. They lingered over small beakers applied with a trelliswork of naturalistic leaves and flowers, remarking admiringly to one another on their sparkling glazed surface. These pieces were highly priced, but, as the fair's sophisticated clientele would doubtless have recognized, in every sphere of art the most exquisite novelties command a premium. This, after all, was a historic occasion: the first time that true porcelain made in Europe had ever been openly offered for sale.

The Leipzig fair, a magnet for the most sophisticated of eighteenth-century audiences, was the natural place for Augustus's porcelain wares to make their debut. Its patrons—pleasure-loving royal princes, affluent aristocrats and the well-to-do—all came to acquire the latest in furniture, glass, metalwork, ceramics, textiles and much else besides. It was, said Lady Mary Wortley Montagu, "one of the most considerable [fairs] in Germany, and the resort of all the

people of quality, as well as the merchants." Her visit was used to stock up on essentials such as "pages' liveries, gold stuffs for myself, &c, all things of that kind."

At previous fairs these discerning customers might have glimpsed a handful of white porcelain pieces displayed alongside the red stoneware objects. These had been no more than exhibition curiosities, a tantalizing presage of things to come, not for sale. But now visitors could not only admire, they could also buy. They could take home with them a set of sparkling tea bowls and daintily sip tea, content in the knowledge that these superior vessels had been made in Saxony, at the factory belonging to the most illustrious king in Germany. The royal cachet of such objects significantly enhanced their appeal to the fashion-obsessed visitors at the fair. Little wonder then that the elegant shoppers found themselves unable to resist such novelties and, much to Böttger's delight, the orders and sales for his "white gold" began to flood in.

Böttger's first significant success at the Leipzig fair of 1713 had been a hard-won victory. In 1711, a little over a year after the factory's inauguration, Meissen's dire monetary problems had forced the king to set up yet another special commission at which Böttger was called on to explain the hopeless financial morass into which the factory had plummeted. Böttger found himself confronted by a largely unsympathetic panel, though he took courage from the fact that among his

inquisitors he recognized the friendly faces of the scrupulously fair-minded factory supervisor, Johann Melchior Steinbrück, and Dr. Bartholmäi, also a zealously committed supporter of the factory.

Böttger refused to be browbeaten and presented a strong case in his own defense. As far as he was concerned, the problems stemmed mainly from the king's erratic financing of the factory, which he had endorsed so publicly and with such pomp and ceremony only twelve months earlier. Large-scale porcelain production would never get under way unless the new kiln was built as had been promised. More to the point, the kiln could not be built until there was money to pay for it. In addition, the kilns could not be fired without a reliable supply of timber. At present fuel was only erratically delivered and ridiculously expensive. Moreover, the successful manufacture of white porcelain was entirely reliant on a plentiful supply of the necessary materials, in particular kaolin. Clay from Colditz was proving unpredictable; and Böttger urged Bartholmäi to establish a regular contract for delivery of Hans Schnorr's clay from Aue, which was far superior in quality and purity and performed far better in test firing. Furthermore, said Böttger, the factory could not be expected to make a profit when such vast quantities of stoneware and faience ordered by the king were never paid for. This constant sapping of resources was bleeding the factory to death. If the cost of staff wages and supplies of new materials could not be met, the factory would never get off the ground.

In future the king must guarantee payment for his orders, must promise that wages and supplies would always be paid for, and must invest on a more reliable basis in the development of the factory. Finally, said Böttger unequivocally, it was vital that he, as discoverer of the arcanum and administrator of the factory, had overall authority in its running. At present his instructions were constantly contradicted by the meddlesome Michael Nehmitz and his allies. This was a flawed system that would doom the factory to inevitable failure if it continued much longer.

The commission must have met such a display of impassioned bravado with incredulity. How dare an imprisoned alchemist, who had clearly proved that he had no idea how to run an important business, criticize their administration in such a manner and suggest such dramatic reforms? Furthermore, how could someone so disorganized and inept imagine that he would be suitable to have sole charge of such a prestigious royal enterprise?

But unlike Nehmitz and the other officials who were primarily concerned with their own personal gain, Steinbrück and Bartholmäi instantly sympathized with Böttger, recognizing that, in contrast to his critics, he spoke with the interests of the factory at heart. Here was a man who had his faults, it was true—Böttger's predilection for alcoholic binges was well established by now—but one in whom they believed nonetheless. Both therefore strongly upheld his arguments for change. Their influence forced the com-

mission to acknowledge that Böttger had justifiable cause for grievance and to pass on his complaints and suggested reforms to the king.

Despite his ongoing political preoccupations, Augustus's mania for porcelain was undimmed and his pride in his unique, if faltering, factory remained steadfast. The commission's report forced him to confront the issue of its survival. Clearly, unless financial security were guaranteed the venture would never work. It was time, even the king admitted, for change.

Money was made available for paying wages and completing the kiln. Böttger was also paid an allowance to cover living costs and expenses, though still under house arrest, and, in the most remarkable turnaround of all, was put in overall charge of production and sales. Finally, in an attempt to stem the flow of funds into the pockets of the corrupt officials, a separate intermediary wholesale company was established, which had the sole right to sell the products made by the Meissen factories.

The commission's power was thus for the time being dissolved, but Nehmitz managed to survive the reshuffle and remain in a position of authority, from which he continued to plague Böttger. In a characteristically wily maneuver he invested in the intermediary company, becoming one of the chief profiteers from Böttger's invention of porcelain, often at the unwitting and impoverished Böttger's expense.

A year later and the vital new kiln was at last complete. Although few details about the early furnaces

have come down to us, we know that the extremely high temperatures needed to make porcelain had forced Böttger to design a new type of kiln made from a totally unprecedented type of fireproof clay bricks, which he also, with typical ingenuity, developed. The early kilns were small and cylindrical in shape, just over half a meter long and only thirty centimeters wide, and allowed only small pieces of porcelain to be fired. Later versions were about ten times larger but functioned basically in the same way. It is a remarkable testimony to the genius of Böttger that until the early nineteenth century no one could improve on his design.

By now regular deliveries of the best white china clay from Schnorr's mine at Aue began to arrive in large shipments on ox-drawn wagons. In the long term the supply of clay was by no means reliable. Schnorr's son, Hans Enoch, was an extremely devious individual and it was not long before he began taking advantage of the Meissen factory's evident dependence on his clay whenever the opportunity arose. Over the decades that followed he caused endless worry to Böttger and the factory's subsequent administrators by arbitrarily raising the price of the clay whenever he thought he could get away with it. In the first decade alone the price nearly doubled, and an exorbitant charge for delivery was also introduced. At the slightest sign of dissatisfaction from Meissen, Schnorr made sure that no one forgot how vital his cooperation was by delaying deliveries at whim, dispatching clay that was of infe-

rior quality and therefore unworkable, and even supplying clay to rivals despite signing an agreement that he would not sell anywhere else. In 1712, however, deliveries seemed assured, and Böttger was at last able to start the long-awaited production of porcelain.

Steinbrück made regular tours of inspection in the increasingly busy Meissen factory. A highly sophisticated series of manufacturing processes had been instituted, all of which required his vigilant supervision. The first stage of the laborious process of turning raw clay and rock into objects of such unparalleled beauty that they would be worthy of a place in the most princely of palaces was the preparation of the ingredients. China clay in its raw state is a brittle crumbly substance, containing granules of feldspar, sand and other impurities, all of which, if not extracted, could ruin the even-textured appearance of the finished porcelain objects and tarnish the color of the body. The clay therefore had first to be purified and refined.

This process relied on a linked system of basis through which water flowed at a steady speed. When the clay was churned with running water in the first large vat, the heaviest, coarsest particles fell to the bottom while the finer-textured granules needed for potting were held suspended in the water and moved on with the liquid to the next basin. Once all the particles of sand and grit had been removed, the mixture was transformed back into a solid mass by passing it through filter presses that allowed the surplus water to soak away and retained only the fine particles of

kaolin. Meanwhile the solid alabaster flux was first pummeled into a gravelly texture with large wooden pestles and then ground between stone-crushing rollers to the consistency of powdery sugar.

The next stage, the compounding, was arguably the most critical part of the whole process. Carefully measured quantities of the two key ingredients, kaolin and alabaster, were stirred together using a broad paddle in vast open vats until, at length, a thoroughly mixed batter was produced. This creamy, soft paste was taken again to the filter presses where workers forced it once through layers of mesh to extract superfluous water. Next the firmed paste was transported by apprentices to the damp cellars of the Albrechtsburg, where, rather like pastry being left to become workable, it was allowed to rest for eight weeks to allow its "plasticity," or ability to be molded, to develop. Then it would be kneaded and pressed once more, to eliminate any residual air bubbles, before finally it was ready for delivery to the factory modelers. Simple hollow shapes were turned on a wheel; more complex objects were formed in sections in plaster of Paris molds and later assembled by the repairers, using liquid porcelain paste instead of glue.

Having thus been formed into recognizable objects, the porcelain was then left in a storage room for up to three months to air-dry. During this time each piece became 15 percent smaller due to the loss of moisture. It was vital that the process should take place slowly,

for if the paste dried too quickly the shrinkage caused by sudden water loss created cracks in its surface.

Now looking white and slightly powdery in appearance, the objects were given an initial firing at a temperature of 800° C to improve their strength and absorbency before glazing. Böttger's glaze was made from the same components as the porcelain body, with a higher proportion of alabaster, so that the process of vitrification which took place during firing of the paste mirrored the changes that took place in the glaze. Once glazed, each piece was stacked into cases of heat-resistant clay known as saggars, which would protect them from the flames, furnace debris and uneven heat. The fire was then lit and fed until a temperature of 1450° C was reached, at which point the flames were left gently to subside and the kiln was allowed slowly to cool. In the absence of thermometers, judging the temperature of the kiln required a high degree of skill: too much or too little heat and the kiln's precious contents would be ruined. By now Böttger had greatly improved the design of the kilns and Steinbrück mentions that after 1713 they were "a completely new and special invention . . . in which the air and fire join, and through an extreme draught it look more like fiery air than a proper fire which you would find in an oven." Steinbrück may not have understood how in the intense heat the glaze formed a transparent molten substance that fused with the vitrified porcelain beneath. Allowed to cool, this surface layer formed an extremely hard transparent surface

over the semitranslucent body beneath. But it was clear that the glaze Böttger had invented was thus quite literally a skin of molten rock over the flesh and bones of clay and rock beneath.

Unless deliberately tinted in some way, porcelain is, by its very essence, white. But within this uniform whiteness, porcelains made in varying ages, in disparate countries or in individual factories all have a distinctive tonality. If you gaze long and hard enough at a white glazed porcelain dish made by Böttger and compare it with a similar piece of plain white glazed porcelain made in China you will discern distinctive tinges within the whiteness of each. The subtle shades, whether pearly, or gray, or bluish or yellow, are created by the inevitable variations in the mineral content of the clay and other materials used in the production methods. As experts in wine can detect a characteristic vintage from the color, bouquet and taste of an anonymous flux of Bordeaux or Burgundy, so the nuances in shades of porcelain enable experts visually to identify its origins.

Oriental porcelain, as Böttger recognized, tends to have a slightly bluish hue—a characteristic caused partly by the fact that in China and Japan potters use a feldspathic rock called petuntse rather than alabaster as the flux. The porcelain Böttger had so far created using alabaster had in contrast a faintly discernible lemon tinge. To modern taste this brings a rather pleasant softness to the icy whiteness, but to Böttger

and to Augustus, who judged success against the achievements of Oriental potters, the aim was still to produce a whiter body, closer to that of the Chinese and Japanese. Measured against the yardstick of Oriental ceramics, the even more important hurdle that now confronted Böttger was the development of colored decoration.

Painting on ceramics can be achieved in three different ways. The easiest, most obvious method is to paint straight onto the glaze after the piece has been fired. This technique, called lacquering or cold enameling, was used, rather crudely, to adorn some of the white porcelain on sale at the Leipzig fair, but its big disadvantage was that any paint applied cold to a glaze has only the most tenuous hold and is easily worn away. It became quickly apparent to both Böttger and the king that the successful development of fired enameling was essential for the success of Meissen's revolutionary porcelain.

Enameling on any ceramic whether pottery or porcelain entails subjecting the colored decoration to heat. The colors, made from various metal oxide pigments mixed with glass, are applied to the glazed body after the main high temperature firing, and fired at low temperatures that allow the oxides to maintain their various shades and melt sufficiently to be absorbed into the transparent glaze beneath. The main problem with enameling, as far as Böttger was concerned, was that since every shade is comprised of a different compound, all of which have to be identified

and tested at different temperatures, each color posed a separate and formidable challenge.

A still more exacting way to decorate porcelain is to paint it under the glaze. Here the decoration is painted onto the porcelain body while it is in its unglazed "biscuit" state and the object is then glazed and fired in the usual way. Underglaze decoration is the most resilient of all ways to adorn porcelain, for however delicate and fragile the images of exotic gardens or elegantly clad courtiers may be, all are safely protected beneath an impenetrable layer of glaze which forms a window to the exquisite designs beneath.

But such a technique is beset with difficulty. The color used has to be incredibly resistant to temperature, for it will be exposed to the full force of the furnace (within its saggar). In such extreme conditions the metallic compound used to create the color must transmute to the shade required but also remain stable. One tiny mistake in the mixing or the temperature of firing and the color becomes unrecognizable or the decoration bleeds into the glaze and the sharpness of the design is lost.

Almost four centuries before Böttger began his experiments to find a way of achieving underglaze color, the potters of Jingdezhen in eastern China had discovered underglaze decoration using cobalt oxide, which produced a rich blue tone when fired. The technique spread also to Korea and Japan, where underglazed blue porcelain was produced in the Arita district of Kyushu island from the early seventeenth century. By

Böttger's day Oriental potters had achieved an extraordinary mastery of this technique, and were using it both alone, to create the characteristic blue and white color scheme, and in combination with overglaze enamels to create rich multicolored designs. Thus the vast majority of imported porcelain that Augustus admired and hankered after was adorned in this way.

As far as Augustus was concerned, Böttger's achievement in creating porcelain remained incomplete unless he could produce underglaze blue and enamels to decorate it. This, as it turned out, was to be a challenge almost as elusive as that of producing gold.

# Chapter Nine

·····························

## The Price of Freedom

*There's a joy without canker or cark,*
*There's a pleasure eternally new,*
*'Tis to gloat on the glaze and the mark*
*Of china that's ancient and blue.*
ANDREW LANG, *Ballade of Blue China*, 1880

*A*ll things, wrote Shelley, are subjects of fate, time, occasion, chance and change. An improbable configuration of unusual circumstance and extraordinary talent shaped Böttger's life and molded his personality, but in trying to define the essence of his character one is confronted by a tantalizingly contradictory picture: a man of chameleon temperament, an improbable mélange of moodiness, sentimentality, intellectual objectivity and grace. Dashingly brave on occasion, yet on others irresolute, wanton and weak; a graciously charming bon

vivant; a drunken dissolute wreck; but always a meticulous chemist of inspired ability.

Discrepancies in portraits and medallions of Böttger echo the contradictions within his character. The only known portrait made within his lifetime portrays him ill and close to death. He is shown creased with care in stern profile with jutting jaw, lips set in a determined grimace, eyes haunted by unfathomable fantasies. But in other, posthumous portraits his image presages the ultimate Byronic hero; he is a romantic libertine, a rakish figure with windswept curls, full-blooded sensual mouth and eyes ablaze with zealous spirit.

Ambivalence too is evoked by the written accounts of Böttger's personality. There are stories on the one hand of a man of great sensitivity, one who engendered enormous loyalty and dedication in those with whom he worked. Wildenstein, one of his earliest assistants, recalled that even during the most arduous moments of the experiments in Dresden "he spoke to the workers in such an unassuming manner that we would have worked day and night for him." It was, on more than one occasion, Böttger's misplaced sympathy for and trust in his workers that led to secrets being stolen. Yet Böttger was certainly no soft touch. On his order, workers at the Meissen factory were fined a week's wages if they dared miss a day's work.

Depression, engendered by years of lonely captivity, made Böttger prone to displays of maudlin self-pity, but throughout the long years of his imprisonment he

was certainly not treated as a common criminal. Even though he was constantly guarded and watched by soldiers, in the later years of his confinement he had comfortable rooms next to his laboratory in Dresden. The king's begrudging respect for him is reflected in the extraordinary range of privileges he was permitted. Böttger was titled baron by Augustus in 1711, and from then on he lived the life of an aristocratic gentleman, albeit a captive one. He entertained lavishly, freely discussing his ideas with the king and other leading scientists, philosophers and artists at the court, and enjoying bacchanalian bouts of drinking. He felt free enough to open his heart to the king, with little apparent restraint. Writing to the king of his achievements as he saw them, he said: "The works are, so to speak, my first-born children and I trust you will therefore not take it amiss when I say that, for myself, I love them tenderly."

So Baron Böttger was neither alone, nor deprived of comfort and intellectual stimulation. Yet one feels, from the pattern of his life, that anything that this impassioned soul lacked could easily become an overriding obsession, and the one thing missing after he had found the formula for porcelain was liberty. Augustus, however, had no intention of setting him free until he fulfilled his promise to produce gold. In 1713, the king, urged on by Nehmitz, began yet again to pressure Böttger to provide some concrete evidence of his skill. He was ordered to demonstrate a transmutation in the presence of the king, Prince von Fürsten-

berg and Nehmitz on March 20. If he failed, his fate would again hang in the balance. Yet again Böttger was forced to return to the illusions that had ultimately been responsible for the years of captivity. In front of the royal party he placed copper in one crucible and lead in another and placed them on the furnace. As before, when the metals were molten he added a mystery tincture and waited for the contents to mingle. When the crucibles were removed from the heat and uncovered, the copper was found to have transmuted into silver, the lead was now gold. Once again Böttger by clever sleight of hand had managed to cheat the executioner's axe.

But the strain of living as a prisoner under such constant threats had by now taken a serious toll on his health. Fondness for alcohol had caused irreparable physical damage. Contemporary reports stated that scarcely a day passed that Böttger was sober. His eyesight was failing, almost certainly as a result of the experiments he had carried out with Tschirnhaus's burning glasses. Most damaging of all, the prolonged exposure to the toxic fumes of chemicals—arsenic and mercury were commonly used ingredients in goldmaking experiments—had injured his lungs and poisoned him. Dr. Bartholmäi ministered to him with endless preparations but there was little to be done. By early 1714 Böttger was becoming severely ill with symptoms that included epileptic seizures and consumptive fever, and recurring depression was leading to increasing mental instability.

The king, hearing of the gravity of Böttger's condition, at last took mercy on his plight and on April 19, 1714, after twelve and a half years' imprisonment in Dresden, the thirty-two-year-old Böttger was granted his freedom, with the proviso that he should not leave Saxony for the rest of his life and should still continue his search for gold. Ill health now provided Böttger with a far harsher and more effective prison than the one in which Augustus had held him captive for so long, and when he was given the news that he was now a free man he burst into maniacal peals of laughter.

While his day-to-day life probably changed little, freedom, once he had recovered from his illness, allowed him a few extra pleasures he had long been denied. His stepfather, Tiemann, had died in 1713 and Böttger was now able to send for his mother and younger sister, who arrived together with his stepbrother. Böttger was able to introduce his sister to his friend Steinbrück, whom she married in 1716.

As a prisoner he almost certainly had little privacy and virtually no opportunity to enjoy romantic liaisons, a fact that can hardly have failed to compound his frustrations and unhappiness. One early biographer describes how in later years Böttger was permitted to enjoy the charms of several mistresses, like a nobleman, although there seems to be no concrete evidence for this claim. There are signs, however, that his housekeeper, Christine Elisabeth Klünger, was his mistress for several years, though this relationship does not seem to have been particularly happy. Steinbrück

recorded that she often took advantage of Böttger's dependence on her, but even though she pestered Böttger to marry her he never did.

The king's long-awaited gesture did little to dispel Böttger's concerns for the factory's survival. Despite his impressive arguments three years earlier, the improvements he had managed to engineer in the factory's financial fortunes proved as ephemeral as the king's fondness for his various mistresses. The impoverished Augustus had been forced by his treasury to fund his porcelain factory by borrowing money from private bankers. When the time came to repay the debts, instead of reimbursing them in gold as they expected, Augustus decided it was more expedient to settle his debts in porcelain—his precious white gold. Prestigious though the porcelain from the king's manufactory was, the commercially minded bankers of Dresden remained unconvinced that the deal was a fair one, and halted all future payments until the matter could be resolved to their satisfaction.

By 1715, a smart new shop selling Meissen porcelain had opened in Dresden, where the chic could browse for choice items. Sales were buoyant and production at the factory was increasing. But the storm clouds of discontent were gathering. The workers at the Meissen factory had not been paid for four months, as far as anyone knew no more payments were promised either from the treasury or the private financiers,

and the king, once again in Warsaw, was impossible to reach.

The workers became so disgruntled and frantic for payment that they put down their tools and invaded the counting house at the Albrechtsburg, refusing to return to work until such time as their demands were properly dealt with. Production was gravely threatened.

Such a desperate situation called for desperate measures. Böttger, temporarily recovered from his illness, remained firmly committed to the factory's survival. It was unthinkable that all he had labored to achieve should be lost for the want of cash that the king so readily squandered on himself and his mistresses. He embarked on a characteristically dramatic course of action.

Borrowing money at his own expense, he enlisted the services of a Dresden advocate, Vollhardt, and paid for him to go to court at Warsaw to petition the king for the much needed financial aid. Böttger never imagined that such a costly venture would go unnoticed, but the pleasure-loving Augustus was otherwise engaged, and he neglected to give an audience to Böttger's emissary. Vollhardt waited hopelessly at court for nearly two years, finally returning to Dresden without once having been given the chance to plead his case.

In the meantime, Böttger waited helplessly in Dresden. As his creditors demanded repayment for the

loans he had incurred, he was forced to pawn his luxurious furniture and borrow more money at ever higher rates of interest, on the understandable assumption that this was just a stopgap until the money from Augustus arrived. Eventually there was nothing left to pawn, nowhere else to turn to borrow, and Böttger's cash supply ran out altogether. Finding him unable to pay, his creditors took their case to the judiciary. Böttger was convicted of insolvency and thrown ignominiously into the debtors' prison.

News that the factory's chief administrator was locked up in jail for debts incurred on behalf of the king's factory eventually filtered through to the court and, finally, to the king himself. Augustus, outraged, demanded Böttger's freedom, promising personally to settle all his debts. Böttger was thus released, but despite Augustus's grandiose gesture little actually changed. Ignoring his pledge, the king never properly settled the outstanding debts. The physician Bartholmäi was left unpaid for decades and his bill was eventually settled "in kind" with vases, teacups and caddies. A lucky few received the odd consignment of porcelain in recompense for their outlay, but it was all very hit and miss. Böttger never received all the money he was owed. The king's chief response to the drama was yet again to order the factory commission to sort out the mess.

In the years following his release from captivity, Böttger's physical and mental fragility had begun increasingly to be reflected in his ability to run the factory. Even his amicable brother-in-law, the factory supervisor, Steinbrück, now complained to the com-

mission that Böttger's unreliability was proving damaging to the factory he had fought so hard to create. Perhaps recognizing a germ of truth in these criticisms, and with little strength left for a fight with his long-standing friend, Böttger responded, not with a forceful argument in his own defense as he had in 1711, but by confessing sadly to the king that many of the problems had occurred "as a result of the illness that has overtaken me."

On this note he unofficially relinquished the running of the factory, calling on Steinbrück, who was forced to abandon his job as a supervisor at Meissen, to come to Dresden to look after the work there. Böttger, meanwhile, locked himself in his laboratory, immersing himself in his experiments with colors, and returning once again to his quest for gold.

Genius, it is said, is only a greater aptitude for patience. In Böttger's case the tenacious genius that had fueled his early discoveries began gradually to elude him. The search for gold and for a formula for underglaze blue continued fitfully, and in the latter case probably because of his ill health, unsuccessfully.

Inspiration, though, had not totally deserted him, and he achieved modest success with enamel colors and gilding. In between sporadic bouts of illness he managed to produce a formula for fired gilding, which was far more hard-wearing and lustrous than the cold-painted variety used on early wares. He discovered ways of creating silver-fired decoration as well as de-

veloping a wonderfully rich pink luster that could be used to paint monochrome decorations or to adorn the inner surfaces of cups and tea bowls. He developed formulas for one or two rather dull-colored enamels, including a deep green and dark red, but these must still have seemed far from the brilliant clarity of tone for which he strove.

In other areas too Böttger had made technological advances. Turning his attentions to glassmaking, he had improved a recipe for ruby glass, also considered a much coveted rarity, first developed by Kunckel in the seventeenth century. The ruby glass made by Böttger incorporated powdered gold and its color only emerged as the mixture of glass and gold was exposed to heat. It seems likely therefore that the exquisite ruby vases that Augustus proudly displayed in his treasury were a by-product of research into enameling.

But still no successful recipe for underglaze blue had been found. Augustus had grown markedly more impatient at this failure since his addition of the most precious items yet to his collection of Oriental porcelain.

On visits to the Prussian palace of Charlottenburg Augustus had noted and deeply envied the priceless collection of porcelain vases acquired by the Prussian King Frederick I. But Frederick died in 1713 and his successor, Frederick William I, was a puritanical and militaristic leader, far more interested in collecting soldiers than in collecting china; under his rule the

Prussian army was to double in size to a deadly force of 83,000 men. Augustus, seeing an opportunity, therefore dispatched his agents to see if Frederick William would sell the collection. After lengthy negotiations a deal was struck. Augustus would get the vases along with over a hundred other pieces of porcelain in return for payment to Frederick William of six hundred dragoons from the mounted regiments of the Saxon army. The soldiers, regarded as little better than chattels, had no say in the matter.

Thus on April 19, 1717, a regiment of six hundred men from Poland, Russia, Bohemia and Silesia who had been enlisted in Augustus's army were the bargaining chips handed over to officials at Jüterbog. Saxon officials then proceeded to Charlottenburg, where the eighteen monumental vases, together with seven smaller covered vases, five beakers, twenty colored plates, thirty-seven large bowls, sixteen blue and white plates, and sundry blue and white dishes—151 pieces in all—were carefully packed and sent to Dresden, where they were impatiently awaited by the king. The dragoon vases, and much of the rest of the collection, remain in Dresden to this day.

The king's delight in this porcelain conquest heightened his disappointment in Böttger, for the dragoon vases were adorned with consummate perfection in dazzling underglaze blue. Meissen, despite Böttger's promises, could not hold a candle to such skill.

Sensing the king's dissatisfaction and feeling once

again mortified at his failure, Böttger wrote to him in an attempt to explain the difficulties and beg for his patience: "Who knows how long India [he meant China] manufactured porcelain before they were able to deliver those beautiful pieces to Your Majesty."

Augustus's response was to offer a reward of 1,000 thalers to anyone who could discover the successful recipe for underglaze blue. Other workers, attracted by the promise of such a prize, joined in the chase. Among them were Samuel Stölzel and David Köhler, both of whom had been among the first workers to join Böttger at the Meissen laboratory in 1705.

Köhler had by now risen to be an obsessively secretive but talented compounder. His refusal to collaborate with Stölzel slowed down the overall progress in the quest for underglaze blue decoration. Nonetheless, his dedication to the task in hand was the first to pay dividends. In 1717, Köhler managed to fire a piece decorated with a blue pigment that remained stable during firing. But rather than heralding imminent success, this seems to have been something of a lucky fluke. Either he had difficulty in reproducing the blue more than once or he remained unsatisfied with it, but at any rate he did not submit his claim for the prize for another two years, by which time Stölzel claimed that he too had played a part in the discovery and was also due a share of the reward.

True to form, Augustus was reluctant, when confronted with this inconvenient reminder of a pledge, to part with the cash. The dispute between the two men

provided him with the ideal excuse for wriggling out of his agreement. Disregarding his earlier offer, he promised that if both men would share their knowledge with each other and continue to develop their work a "just reward" would be theirs. The idea of collaboration was anathema to the taciturn Köhler and neither of them ever received the promised 1,000 thalers.

The spectacle of others' misfortunes has always been a compelling attraction for opportunists. As Böttger's health became increasingly fragile, the promise of easy pickings attracted the unscrupulous to his side. Among the most menacing of these insidious characters were Johann Georg Mehlhorn and Gottfried Meerheim, two so-called friends of Böttger's who inveigled their way into his inner circle and enticed him to trust them, only to betray his confidence at the first opportunity.

A trained cabinetmaker, Mehlhorn turned his back on marquetry, inlays and dovetails when he realized that porcelain promised to provide him with a far more lucrative trade. Though unable to either read or write, he was obviously a highly accomplished confidence trickster who managed to convince Böttger that he was an expert decorator and thus able to solve the underglaze blue problem. In response Böttger shared with Mehlhorn his discoveries so far. Too late the realization finally dawned on Böttger that Mehlhorn was not contributing anything to these discussions and had

no real knowledge of his own. By that time the damage was done. Mehlhorn had discovered enough to pretend that Böttger, while drunk, had given away vital secrets about the manufacture of porcelain. The directorate were, as Mehlhorn had intended, terrified that such information might be sold to a rival, and he managed to wheedle a job as vice-inspector for himself in the factory, with a salary of 300 thalers a year. Eventually Mehlhorn's duplicity found the perfect employment when he was sent to spy on Samuel Kempe, the defector who had set up a rival stoneware factory in Prussia.

Meerheim was a similarly unprincipled fraudster. He described himself as a metallurgist and also began working with Böttger on the quest for underglaze blue. Somehow Meerheim engendered such faith in Böttger that he recommended him as his successor, but the two soon quarreled and parted company. By then, however, Meerheim, despite being "all hot air and talk," was able to persuade the Meissen commission that he too knew enough to damage the factory and thus he was also able to extort a handsome salary for the next decade.

Meanwhile, despite the disappointments and difficulties, Augustus continued to champion his factory's showpiece products, using them as regal gifts to underline his country's, and thus his own, technological and artistic preeminence. But the more Augustus sounded the trumpet of his porcelain success story, the

more his political rivals throughout Europe became determined to pierce his conceit and share in the potential for lucrative financial reward. First, though, they had to discover the secret for themselves.

Thus Meissen's monopoly on the manufacture of true European porcelain was increasingly threatened by a deluge of secret agents and confidence tricksters. The problem of keeping the arcanum safe had never been more pressing, particularly in light of Böttger's ill health.

The dilemma, as everyone agreed, was that in order for the factory's future to be assured Böttger clearly had to tell others how porcelain was made, but with whom and how should such information be shared? Any single individual entrusted with such knowledge would inevitably become a target for the spies who were flocking to Meissen in ever-increasing numbers.

The arcanum involved knowledge not just of the composition of the paste, but also of the method of firing, the makeup of the glazes and the recipes for the enamels. Obviously the safest way to ensure that these secrets were secure was by sharing them among several trusted employees. Each would be taught part of the formula and no one, apart from Böttger himself, would fully understand, or be able to replicate, the entire process.

Böttger first divulged the secrets of his discovery to two men, who were dubbed "arcanists," in 1711. They were Dr. Wilhelm Nehmitz, a chemist and brother of

Böttger's enemy Michael Nehmitz, and Dr. Jacob Bartholmäi. Wilhelm Nehmitz was briefed on how the glaze for the porcelain was made, while Bartholmäi, who had long been privy to many of the secrets of Böttger's invention, was officially instructed on how to make the paste. He became adept himself at making porcelain, writing proudly: "In the first year, 1708, I acquired such skill . . . that the pieces made by myself could well be offered for sale."

Despite Böttger's assurances that "These are my men, who know how everything is done. I don't hold back anything," Augustus remained terrified that Böttger would deliberately withhold some vital detail in order to safeguard his own position, or that a spy would somehow manage to steal any written notes. To avoid such an eventuality Bartholmäi was instructed to "transpose everything that Böttger gives him into characters that nobody will be able to decipher."

But the poor working conditions and the sporadic payment of wages to workers remained largely unresolved, and their dissatisfaction, coupled with the continual presence of infiltrators eager to lure the Meissen staff away, fueled continual breaches in security. In 1718, Peter Eggebrecht, the leaseholder of the Dresden faience factory, was lured to Russia by Peter the Great to set up a porcelain factory in the style of Meissen. Nothing came of this attempt, presumably because Eggebrecht did not know enough about porcelain-making, and Peter then sent a Russian spy to

Meissen. He too failed to find the arcanum and returned empty-handed.

Much more serious was the defection in 1717 of Christoph Konrad Hunger, a skilled Meissen enameler and gilder, lured to Vienna by the Austrian war commissioner Claudius du Paquier, who was eager to start a rival porcelain factory. With his knowledge of the properties of gold, Hunger had managed to win Böttger's confidence and he too claimed that Böttger's indiscretions when drunk had given him access to knowledge of the arcanum. When du Paquier made him the lucrative offer of a handsome salary plus the opportunity of becoming a partner in a porcelain factory, it was clearly too tempting to turn down.

But as with so many of the other defectors, Hunger's claims to know how to make porcelain were proved false when his attempts at successful firing continually failed. Hunger knew that the problems lay both with the clay used for the paste and in the design of the kilns, but he could not find the correct solution. If he could tempt other Meissen workers with knowledge of the correct composition and firing techniques to join forces with him these difficulties could be overcome.

Hunger got in touch with the duplicitous Mehlhorn, offering him a share of profits plus 100 thalers to cover the cost of the move to Vienna if he would collaborate in the new factory. Mehlhorn responded encouragingly at first, but when the money arrived, perhaps bearing in mind the limitations of his

knowledge and the fact that he was already well provided for by the Meissen directorate, he pocketed the travel expenses and stayed in Meissen. For the time being, at least, success eluded Vienna.

# Part Two

........................................

*The Rivals*

# Chapter One

············································

Shadows of Death

*O cursed lust of gold! When for thy sake,*
*The fool throws up his interest in both worlds;*
*First starved in this, then damned in that to come.*
<div align="right">ROBERT BLAIR, <em>The Grave</em>, 1743</div>

Bouts of insanity, agonizing illness and forlorn experimentation punctuated the last sad year of Böttger's life. The king, unable to relinquish his hopes that Böttger might yet make gold, still goaded him into pursuing his hopeless dream. In response the increasingly frail Böttger, desperate to prove himself finally to Augustus, dabbled frenziedly with his mysterious liquids, powders and tinctures in his dimly lit laboratories. Long after it was clear to all who knew him that his mind was incapable of the analytical genius that had led him to his first great discoveries, he remained

pathetically fearful of spies and scrawled down the results of his last bizarre trials in meandering, illegible jargon that only he could decipher.

The futile and obsessive search continued until, finally, too weak even to leave his bedchamber, Böttger was forced to accept that the arcanum for gold would never be his to present to the king. As the new year of 1719 dawned, the thirty-seven-year-old Böttger's descent into final illness, a raging form of consumptive fever, was witnessed by the loyal Steinbrück, who visited him every day. In early March the epileptic spasms and cramps returned and were treated, at first successfully, with snake venom. A week later even this treatment failed.

On March 13, 1719, at about six in the evening, as the setting sun shimmered over the rippling waters of the Elbe, Böttger, the inventor of European porcelain, finally breathed his last, after coughing and writhing in agony for nine hours. He was buried ten days later in a quiet ceremony in Dresden's Alter Johannisfriedhof cemetery. Only a handful of mourners attended. The king, whose treatment of Böttger had led him to his early grave, was not among them. The cemetery along with Böttger's grave has since been replaced with the Dresden town hall and a park.

For the last five years of his life Böttger had officially been a free man, but the grip of Augustus and Meissen extended inexorably beyond the grave. As soon as the body had been removed from his apart-

ments, the rooms were sealed up until the papers and notebooks with which they were littered could be removed for safekeeping by Augustus's officials. The Meissen authorities presumed that among Böttger's belongings they would discover notes relating to the latest developments in the manufacture of porcelain, glazes and enamels. In fact, after careful examination of the documents, virtually nothing of use was discovered. Böttger's porcelain-making genius had, in effect, died along with him. It was, ironically, largely thanks to his indiscretions that the secrets of his later discoveries were passed on at all.

The full extent of Böttger's financial problems became clear only after his death. His debts, which included those he had incurred as the factory's administrator, amounted to over 20,000 thalers; his assets came to a paltry 700 thalers. Augustus's promise to settle Böttger's debts incurred on behalf of the factory had long been conveniently forgotten, and Böttger's modest and erratically paid salary, when set against his appetite for luxurious living, had been hopelessly inadequate to cover the enormous sums still outstanding. Valuables were either pawned or entailed; even his extravagant furniture and the silver plates from which he grandly dined were rented or unpaid for.

The ingenious inventor who had been deprived of his liberty and forced to devote virtually his entire working career to a discovery that was poised to bring

Augustus gold and prestige beyond his wildest expectations was found, in the final reckoning, to be penniless.

We do not know how Augustus responded when he heard the news of Böttger's death, but to judge from letters and reports it seems certain that over the years of frustration and achievement he had developed a genuine if sporadic affection for his brilliant arcanist.

As the king came slowly to terms with Böttger's loss and brooded over the problem of who would carry the factory forward into the future, he was also troubled by the worrying news from Meissen. Key staff were being lured to Vienna, where the events that would solve his most pressing problem—finding a successor to Böttger—were already unfolding in the Austrian capital.

Like Dresden, Vienna was a city rapidly expanding in response to its Hapsburg ruler's military and political successes. Since Austria had emerged triumphant from the Turkish Wars the city had been transformed from a dingy, unremarkable metropolis into one boasting ravishing Baroque palaces, glorious music, sophisticated theater and opera—and a society with an increasing appetite for luxury of every type. Thomas Nugent, an eighteenth-century British traveler, wrote glowingly of its charms: "There is no place in the world where people live more luxuriously than at Vienna. Their chief diversion is feasting and carousing, on which occasions they are extremely well served with

wine and eatables. People of fortune will have eighteen or twenty sorts of wines at their tables, and a note is laid on every plate mentioning every sort of wine that may be called for. Especially on court days one sees the greatest profusion and extravagance in this kind of pageantry, the servants being ready to sink under the weight of their liveries, bedawbed all over with gold and silver."

This was the city in which Claudius Innocentius du Paquier, a court official of Dutch origin, decided to try his luck at porcelain-making.

Du Paquier's French name, volatile Latin temperament and entrepreneurial and creative inclinations may reflect Huguenot origins, but though little is known of his family's background he was certainly a man of intellect, unbridled enthusiasm, steely determination and a keen eye for opportunity.

In common with Augustus the Strong and most other central European rulers, Emperor Charles VI of Austria espoused a mercantile policy modeled on that of France. New commercial ventures were offered advantageous terms for setting up in the Austrian capital, and doubtless part of the reason for du Paquier's interest in porcelain was his hope that such an enterprise would attract royal patronage. In such refined, moneyed surroundings there was clearly, he must have reasoned, a ready market for new luxury products. As a court official he was *au fait* with all the significant commercial developments of central Europe, and having remarked the announcement of Meissen's dis-

covery of porcelain a decade earlier he decided that here was a golden opportunity. Porcelain was the white gold for which all of Europe cried out, which only Meissen had, as yet, discovered. If he could found a porcelain factory in Vienna, there was no reason why it could not quickly outstrip the faltering progress of Meissen. Such a feat would not only make all concerned incredibly rich, it would also reinforce Austrian superiority in Europe. But it all depended on discovering the arcanum.

Du Paquier began his attempts at porcelain-making by following the observations of Père François Xavier d'Entrecolles, a Jesuit missionary who had visited central China in 1698. D'Entrecolles had written two letters explaining the processes involved in making Oriental porcelain as he understood them. The first of these accounts, published in Paris in 1717, was by far the most detailed and accurate description of Oriental porcelain manufacture to be available in the West at the time.

Du Paquier hoped that locally available clay had the same white-burning properties as the clay d'Entrecolles had described being used to make porcelain in China. But even after careful scrutiny of d'Entrecolles's descriptions and numerous painstaking trials, all his early attempts to make porcelain were dismally unsuccessful.

It became obvious to du Paquier that he would need experienced technical help of the sort which only Meissen could provide. As a first step he probably

made a reconnaissance trip to Meissen to see what information he could glean. Perhaps daunted by Augustus's impressive security arrangements, and not short of contacts in high places, he then approached Count von Virmont, Austria's ambassador at the court of Dresden, to ask him to help find someone who might be willing to assist in his new venture. Von Virmont's attentions focused on Konrad Hunger, a skilled gold-worker who had trained as an apprentice goldsmith and arrived in Dresden from Paris in 1717.

Aside from his lack of technical expertise, money, or rather the lack of it, was du Paquier's chief problem. Unlike the Meissen factory, where, however begrudgingly, cash was sporadically provided from the royal exchequer to pay wages and installation costs, du Paquier received nothing at all from Charles VI apart from a vague promise that he would patronize the factory generously—as soon as it could provide something for him to buy. As if to underline his determination not to get financially involved, in May 1718 the Austrian emperor signed a special privilege granting du Paquier a twenty-five-year monopoly on the production of porcelain in Austria and her territories, but also stipulating that the enterprise should not expect to obtain money from the emperor's purse or from the treasury coffers.

Forced therefore to look elsewhere for the wherewithal to start his business, du Paquier found Martin Becker, a Viennese merchant who seems to have been

thoroughly beguiled by du Paquier's infectious enthusiasm for porcelain-making. Becker agreed to give du Paquier a generous advance to cover the cost of the initial experiments and early production. In return he would be given a share of the business. The other partners were Peter Heinrich Zerder, a government minister, who probably helped secure the monopoly, and Hunger, the so-called arcanist.

Thus, with none of the pomp and ceremony that had marked the inauguration of Meissen, the Vienna factory was founded before it had been able to produce a single piece of porcelain.

The factory in its early days was set up in a modest house in a suburb known as Rossau, in what is now the Liechtensteinstrasse. There was just one faulty kiln and a workforce of ten. As soon as Hunger joined du Paquier, experiments continued using clay from Passau, near the Austrian frontier with Bavaria. Hunger, with little true knowledge of compounding, seems to have gone along with du Paquier's belief that the local clay had similar white-burning properties to that successfully used at Meissen. But, perhaps because of the inadequate firing temperature of the kiln, the Passau clay proved unworkable and Hunger's repeated attempts to glaze and fire porcelain constantly failed.

Eventually realizing that he could not indefinitely pass off his inability to fulfill the promises he had made to du Paquier, Hunger began to complain that the clay was at fault and not suited for use with the underglaze blue he claimed to have developed. After

more than a year of costly experiments and endlessly disappointing results, and with no visible progress whatsoever being made, du Paquier was forced to acknowledge that his investment in Hunger had been, to say the least, ill advised. So far the Meissen "arcanist" had produced nothing but a pile of useless shards.

In the meantime costs were mounting and no money was being made. Unless true technical expertise could be found du Paquier's factory would be doomed to failure before it had even begun.

Meissen's skilled workforce once again became the target for du Paquier's attentions. The key person, du Paquier knew, was obviously Böttger, the inventor of porcelain, but by that time Böttger was already in the throes of serious illness and in any case his long-standing allegiance to the king would clearly make a move to Vienna out of the question. Du Paquier next began to consider Böttger's family. Steinbrück, the factory inspector and Böttger's brother-in-law, had a reputation as a staunchly incorruptible man, but Böttger's disreputable stepbrother, Tiemann, was far less fastidious. Tiemann had come to Dresden with his mother and sister after his father's death, and had a post as a lieutenant in the guards. He was always getting into trouble for his violent behavior and caused Böttger endless worry.

Tiemann harbored a bitter resentment of his successful stepbrother, who enjoyed such favor with the king. There is no evidence to suggest he had worked with Böttger, but his family connection had given him

the chance to acquire some rudimentary knowledge of the firing processes and he had met people in Böttger's immediate circle of friends—including the unscrupulous Mehlhorn. When du Paquier got in touch with him he did not hesitate. In an unbelievably callous act of betrayal of his by now desperately ill stepbrother, Tiemann, with Mehlhorn's help, made plans and a papier-mâché model of a Meissen kiln and sent them to Vienna. Modifications in the kiln designs were duly made, but even with this help du Paquier's factory was still unable to fire porcelain successfully.

As the months passed and the costs continued to mount, the full realization of the complexities of porcelain manufacture began finally to strike home. Unless du Paquier could find a genuine expert to help him he would never stand a chance of success. This time, with no room for mistakes, he turned his back on the coterie of peripheral "arcanists" who pretended to have overheard the secret from Böttger while he was in his cups. He was only interested in finding a top Meissen employee, one who really knew what he was talking about.

Samuel Stölzel must have seemed an obvious choice. He was one of Meissen's most experienced workers, in charge of mixing the porcelain paste and firing the kilns, and had been with Böttger from the early days in the Albrechtsburg, a total of more than ten years. Now he was drained by the constant fights with his rival, Köhler, the poor wages he received—his salary was a paltry 150 thalers a year—and the restrictions on his freedom.

As if all this were not enough he had become embroiled in an embarrassing romantic entanglement. Steinbrück had found out that Stölzel had enjoyed a passionate liaison with a girl in the mining center of Freiberg. The girl involved had unfortunately become pregnant and her family was demanding reparation. The repercussions of the ill-fated affair meant that Stölzel was unable to marry a girl to whom he was betrothed in Meissen.

Just as this unhappy situation was becoming increasingly awkward, Stölzel received a letter from a desperate du Paquier making him a tempting offer. If he would come to Vienna and successfully produce porcelain with Hunger, du Paquier would pay him a salary of 1,000 thalers and provide free living accommodations and equipment. Harassed on every front, it is easy to see why Stölzel grasped this tempting solution to his problems.

This final and most fatal desertion came just as Böttger slid into his last painful illness.

Early in 1719, as the winter's chill descended and Böttger tossed and raved on his sickbed, du Paquier arrived in Meissen and sent word via a messenger to Stölzel at the Albrechtsburg. Somehow Stölzel was able to evade the guards at the castle entrance and rendezvous with du Paquier at his lodgings. Amid great secrecy the deal that was to seal the fate of the Meissen monopoly was finally agreed to.

Days later, accompanied by a musician lady friend named La France, and a billiard player named Lepin

whose precise relationship with him remains tantaliz-ingly unclear, Stölzel escaped from the Albrechtsburg and traveled post haste to Vienna before anyone at Meissen realized what was happening.

Böttger had lost one of his key workers, but by then he was far too ill to care.

Arriving in Vienna, Stölzel, highly experienced as he was in both mixing and firing porcelain, quickly real-ized that many of Vienna's problems were due to the clay being used. He may have brought with him a sample of the paste used at Meissen, but at all events, after trying local clays without success, he quickly sug-gested that the factory should try its luck with Schnorr's clay from Aue that Meissen used so success-fully. Du Paquier concurred—by this stage anything was worth a try.

The difficulty, as Stölzel well knew, was that Schnorr had been forced to promise Augustus that he would sell his clay only to Meissen. Undaunted, Stölzel enlisted the aid of the treacherous Meerheim in Dresden, who had close contacts with Schnorr, and asked him to arrange for the supply of a consignment of clay to Vienna in return for payment in cash. Schnorr was annoyed with the Meissen factory's ad-ministrators, who often kept him waiting months for payment, and had few qualms about breaking his agreement with Saxony. The promise of cash was too tempting to resist and he was easily persuaded to agree.

Officials on the Saxon border were supposed to be on the lookout for wagons laden with clay and other precious raw commodities. But they were slipshod in their search of a straggling procession of carts crossing the border in the spring of 1719. One or two drivers were stopped and turned back, but a considerable consignment got through and arrived in Vienna a few days later.

Stölzel now had everything he needed to make porcelain to rival that of Meissen, including replica kilns and the same raw materials. Within a matter of weeks of the clay's arrival, Stölzel proudly handed over to du Paquier the prize he had feared would never be his: visible proof that, unlike Hunger and all the other charlatans, he knew what he was doing.

The cherished object was a tall, two-handled chocolate cup and saucer. Decorated with incised decorations, engraved with the words "To God alone and to none other be the honour" and dated indistinctly May 3, 1719, this landmark object is probably the first successful piece of porcelain Stölzel made, and therefore the first piece of true European porcelain made outside Meissen. The cup now resides in glittering resplendence in Hamburg's Art and Industry Museum.

The remarkable success, however, did little to raise its creator's spirits. Almost from the beginning Stölzel seems to have regarded his move to Vienna with mixed feelings. Du Paquier, with his penchant for exaggeration, had painted a far rosier picture than the reality Stölzel found. The factory was cramped, the workers

were unskilled and money was in even more excrutiatingly short supply than it had been at Meissen. Hiring proper skilled craftsmen would be an impossibility in such circumstances, and the salary he had been promised was never reliably paid. Stölzel became increasingly unhappy with his move.

His predicament, however, seemed insoluble, for he had little alternative but to endure it. Defection from Meissen and divulging the secrets of porcelain-making were, he well knew, treasonable offenses that could cost him his life if he ever showed his face in Saxony.

In Dresden, Augustus, though devastated at Stölzel's defection and longing to take action to recapture him, also found himself in an awkward diplomatic predicament. Stölzel's flight had coincided with delicate negotiations being conducted to arrange the marriage of his son and only legitimate child, Frederick Augustus (1696–1763, later Augustus III), and the emperor's niece Maria Josepha. The union, which was politically extremely advantageous to Augustus since it allied his family with that of the powerful Hapsburg emperors of the Holy Roman Empire, was due to take place the same year. Augustus could not possibly risk causing offense to Charles VI and thus jeopardize the match. So, though he did not give up his hopes of apprehending Stölzel, he was forced to adopt the more subtle tactics of diplomacy to get him back.

Augustus's ambassador in Vienna, Christian Anacker, was instructed to monitor closely develop-

ments at the du Paquier establishment, and report at regular intervals directly to the king. Anacker, a diligent and skilled negotiator, immediately got in touch with the renegade Stölzel, and set about earning his confidence—not a particularly arduous task as it turned out. Finding the sympathetic Anacker apparently concerned for his well-being, Stölzel quickly confessed both his regrets and his fears of reprisal should he dare return to Dresden.

Meanwhile porcelain-making at Vienna enjoyed modest success. Hunger now began to develop colored enamels far superior to those the Meissen factory had so far managed. With an increasingly varied palette at its disposal it became evident that the factory would need to employ artists capable of skilled painting, and Hunger began to look around for suitable recruits. At some stage he made the acquaintance of a twenty-three-year-old artist who was working as a painter in Vienna. His name, later to be immortalized in the annals of porcelain-making history, was Johann Gregor Herold.

Little is known of Herold's family background or formative years, but the sparse information we do have paints a somewhat improbable picture of the origins of a man who was to revolutionize the applied arts of his age. Herold was the youngest son of a master tailor, born in Jena on August 6, 1696. Realizing early on that he had little inclination for following his father's modest trade in fashioning elegant costumes for the wealthy, he decided to break with family tradition, put

to use his natural flair for drawing and pursue a career as a decorative artist. Having worked for a time as a painter in Strasbourg, Herold came to Vienna around the time that du Paquier was setting up his new porcelain factory.

From the earliest days of his career the exotic images of the Far East fired Herold's artistic imagination. He visually devoured the outlandish scenes he saw depicted on imported lacquer, textiles and topographical prints, as well as on porcelain. These patterns and pictures were translated into his own pastiche version of Oriental imagery, sometimes fusing exotic and European themes. By the time Hunger was introduced to him, Herold was already known by the fashion-conscious Viennese as an accomplished painter of stylish chinoiserie murals.

Young and inexperienced though he was, Herold's innate confidence in his own ability and persuasive charms invariably enabled him to convince others of his superior talent. Hunger was immediately certain that here was a man of great artistic aptitude, one who would be a huge asset to the Vienna porcelain factory. Herold, it was true, knew nothing of the art of painting on ceramics, but to Hunger this raw talent was well worth taking the trouble to school. Herold was offered a job as a junior decorator, a position that, quickly grasping the potential of such an opportunity, he accepted.

Herold's decision to change the direction of his career so dramatically reflects his extremely shrewd business sense as well as his all-consuming ambition. The

elegant pagoda- and peony-laden landscapes he had until now passed his time so painstakingly creating were little more than a backdrop for the priceless pieces of ornate porcelain that every fashionable house contained. In Vienna as in Dresden collecting porcelain was the passion of the affluent, and the ambitious Herold can hardly have failed to conclude that here was the potential for making a fortune, and the means of bringing his artistic genius from the background to the center stage it so richly deserved.

At first he was probably employed by Hunger piecemeal to decorate occasional pieces with the new colors he was developing. No porcelain from this time decorated by Herold has ever been identified and the genesis of his early technique remains a mystery. From the outset, however, the young artist's talent was unquestionable and the Vienna factory made incredibly rapid progress in the art of painting on porcelain. After just one year of production, Vienna had accomplished the unimaginable. It had not only discovered the secret arcanum for porcelain, it was already gaining ground on Meissen.

But just as full-scale production looked increasingly feasible, financial problems once again threatened the factory's existence. Becker, the merchant whose initial investment had made the venture possible, now found himself in straitened financial circumstances and had to stop subsidizing the factory. Desperate for cash to pay wages and secure supplies of materials, du Paquier was forced to turn elsewhere for help, and a merchant

named Balde now became a major investor and partner in the business, buying out Becker's share.

Stölzel, in the meantime, had reached the end of his tether with du Paquier's unreliability and failure to pay him the money he had been promised. In a frantic attempt to clear his way to returning to Meissen, Stölzel vowed to Anacker that he had not in fact divulged any of the secrets of the porcelain arcanum: the compounding he had done was always carried out in secret. If, therefore, he was offered a pardon and allowed to return to Dresden, the Vienna factory would certainly collapse without him.

This largely misleading confession prompted Anacker to write to Augustus recommending that Stölzel be taken back into the Meissen fold. Augustus delightedly agreed, assuring Stölzel that his life would be spared if he returned to Saxony. There were no promises of a job at Meissen but neither was such a possibility ruled out.

In the spring of 1720, Stölzel, having been paid 50 thalers to cover the cost of his journey by Anacker, was once again on the run, this time in the opposite direction—fleeing Vienna to seek refuge in Saxony. As added proof that he now had Meissen's best interests at heart, he resolved to take with him as traveling companion the most talented workman Vienna could offer. Meissen, he well knew, was still being held back by lack of artistic expertise, and the man whom he invited to accompany him was the gifted young decorator Johann Gregor Herold.

Even with Herold as his traveling companion Stölzel was still beset by guilt over what he had done and terrified that Augustus might not keep his word and try to arrest and punish him. The strain of the last year's events had taken a toll on his health and he now fell seriously ill. Instead of returning directly to Dresden, therefore, he went to the Freiberg home of his old colleague and friend Pabst von Ohain. Here he recuperated slowly from his illness and waited to see what action Meissen and Augustus would take. Meanwhile Herold, with a letter of introduction from Stölzel, journeyed on to Meissen to offer his services as a decorator.

On the night of his flight from Vienna, Stölzel had resolved to make one last grand gesture, to prove to Meissen beyond a doubt that he was genuinely repentant, to ensure that Vienna would be unable to compete in future with Meissen and to hammer home to du Paquier the full extent of his disillusionment.

Under cover of darkness, when he knew the factory premises would be deserted, Stölzel crept back into the silent, shadowy building. The turner and modeler's benches lay bare, ready for the next morning's work. Paste lay ready mixed in a cellar. The molds stood neatly ranged on open shelves, while elsewhere porcelain was being air-dried, ready for firing in the kiln.

In an act of unmitigated vandalism Stölzel contaminated the porcelain paste he had compounded, rendering it unusable. Moving on to the modeling rooms

where the beautifully fashioned molds awaited the next day's production, he hurled each one to the floor. Continuing unchecked he turned his attention to the demolition of the kilns. By the time he had finished this orgy of destruction virtually all the hard-earned materials and equipment of the Vienna factory were reduced to nothing but fragments of rubble and lumps of useless clay strewn across a workroom floor.

Before finally taking leave of du Paquier's factory, Stölzel concluded his visit by taking with him as many samples of Viennese porcelain as he could manage, together with all the precious colored enamels that Hunger had invented. Meissen was still having problems perfecting fired enamels and here was another useful bargaining tool.

As far as Stölzel was concerned the Vienna factory was now annihilated. It was as if the last year had never existed.

One can barely imagine the effect Stölzel's savagery had on the bewildered du Paquier when he confronted it the next day and realized that along with his stock and equipment he had also lost two key members of staff. Ruin must have seemed inevitable, for the damage was estimated at 15,000 thalers.

As Stölzel had hoped, Vienna's production came to a complete standstill.

## Chapter Two

........................................

❧

# *The Porcelain Palace*

*No handycraft can with our art compare*
*For pots are made of what we potters are.*
Potter's motto, anonymous, 18<sup>th</sup> century

*T*he fireworks that carved open the night sky pro-
claimed a royal marriage to the citizens of Dresden. The
formal nuptials of the Saxon heir apparent, Frederick
Augustus, and the emperor's niece, Maria Josepha, had
taken place at the Favorita Palace, Vienna, in 1719,
after which the newly wed couple, accompanied by a
vast and splendidly uniformed entourage, was escorted
to Dresden.

With characteristic ostentation Augustus was de-
termined that the entertainments he staged in the
couple's honor would completely eclipse those Austria
had put on. The festivities went on for weeks: orches-

tras played their most ravishing arrangements, operatic extravaganzas dazzled, theatrical performances were unrivaled, horse races thrilled vast audiences; citizens watched spellbound as the court arrived turbaned and clad in Oriental costume for a feast held in Augustus's exotic Turkish Palace; and a crowd of thousands were entertained by the spectacle of an animal fight in which bulls, boars and stallions ripped one another to pieces. But among the seemingly endless program of balls, banquets, masquerades and tournaments, the undoubted pièce de résistance was the extraordinary series of events Augustus staged in honor of seven planetary gods, beginning with the Festival of the Sun.

Augustus arranged this magnificent ceremony a week after the arrival of the happy couple in Dresden, on September 10, 1719.

The setting was not his primary official residence—the royal castle in the heart of old Dresden—but a far more spectacular and newly acquired royal palace. For while Böttger had lain at death's door, while Herold had busied himself mastering the art of painting on porcelain, and while Stölzel pondered longingly on how best to extricate himself from Vienna and return to Meissen, Augustus had been busy dreaming up plans for the most flamboyant porcelain extravaganza the world had yet seen: a palace made of porcelain.

The European mania for collecting Oriental porcelain had spawned an extraordinary and fantastical fashion

for porcelain rooms. In such cabinets a veritable confusion of porcelain objects was stuck to the walls, caked upon mirrors, crammed over door frames and layered over chimney pieces to create a dazzlingly elaborate multipatterned effect.

The fad for porcelain rooms had found particular favor in the luxury-loving courts of Germany. Augustus's much prized dragoon vases had been housed in a famously elaborate example at Charlottenburg, the Prussian king's summer palace. Another equally renowned and extravagant porcelain room at the Oranienburg, near Berlin, had columns encrusted with porcelain cups, plate-studded walls, cornices crammed with row upon row of Oriental vases; and still more choice examples scattered about the room on wall brackets, shelves, tables and mantelpieces.

Augustus had seen these displays, and the arrival in Dresden of the dragoon vases had fired him with the aim of creating an even more glorious setting for them. It was his extraordinary ambition, therefore, to devise not just a room but an entire palace made of and filled with porcelain. This, the ultimate fantasy showcase of the undisputed porcelain king of Europe, would far surpass the grandest porcelain rooms of Prussia and provide a suitable eye-catching backdrop for the products of his own porcelain factory.

In 1717, therefore, he bought the so-called Dutch Palace from his chief minister Count von Fleming. The elegant Baroque palace was situated in the Neustadt district of Dresden on the banks of the Elbe,

with stunning views toward Dresden and the fertile hills beyond. Augustus immediately began extending the palace with the help of a panel of leading architects including Matthäus Daniel Pöpplemann, who turned the riverside gardens into a version of the Grand Canal in Venice, even designing a small harbor where gondolas could tie up.

On the day of the marriage celebrations, the princess arrived at the Dutch Palace at three in the afternoon. She was greeted by the king, who ushered her inside to show off the palace's amazing porcelain-garnished interiors, which already boasted over 25,000 individual pieces. One wonders whether the princess was quite as riveted by the interminable collages of plates and vases as her father-in-law, but even if she stifled a discreet yawn during her tour of the king's collection she can hardly have failed to be roused by what happened next.

With suitable pomp, the royal party walked slowly to the riverside gardens and settled themselves on sumptuously padded throne seats on a stage beneath a red velvet canopy trimmed with gold. The rest of the royal household sat on green benches, the lower orders probably stood. The evening began with music and drama. As an orchestra hidden behind rosebushes struck up, seven eunuchs, each dressed as a different planet, appeared before the assembled audience in clouds of smoke and announced a series of festivals during the following days. Tonight, a Sunday, was to be the Festival of the Sun.

After these lengthy proclamations the royal party drifted indoors to enjoy a banquet laid out at long tables behind which Augustus's priceless porcelain glittered in the candlelight. As evening fell the guests rose and stood by the palace windows overlooking the river where Sol, the eunuch dressed as the sun, had announced that the highlight of the evening, a pyrotechnic display, would take place. The fireworks, representing Jason's battle for the Golden Fleece, emerged from a specially constructed temple, framed by ranks of trumpeters and drummers who played a rousing musical accompaniment. Meanwhile eight hundred musketeers and two infantry regiments blasted cannon salutes as innumerable flares and endless fountainlike rockets climbed into the night sky, illuminating the ranks of gondolas bridging the river. Augustus must have reflected that the event incontestably proved both the dynastic importance of his son's wedding and his own porcellaneous supremacy. Even by his standards it was an unforgettable night.

Arriving at the Meissen factory a few months after Augustus's flamboyant display, the young Johann Gregor Herold immediately began trying to ingratiate himself with the directorate and key courtiers in the hope that they would ignore his somewhat dubious record—a fugitive painter from Vienna can hardly have appeared a hugely attractive potential employee—and give him work.

The Meissen factory was still a hotbed of conspiracy, scheming and infighting and Herold soon realized that in such a place success depended as much on powerful allies as on formidable talents. He emerged as a master in the art of sycophancy, social climbing and shrewd negotiation. But beneath a politely deferential, enthusiastic facade, Herold concealed a firm intention to become the most powerful man at Meissen.

The authorities failed to perceive this worrying trait and were spellbound by his self-confidence, his pleasant manners and above all by his incredible artistic prowess. He quickly won numerous powerful supporters among Augustus's courtiers and key members of the directorate, including Chladni, the court administrator, and Fleuter, a powerful member of the new Meissen commission. Steinbrück reflected the prevailing opinion when he wrote in his notebook, "On 3 June there came to Meissen an artist who is able to paint on porcelain in a particularly fine way; Herold is his name."

As proof of his expertise Herold had brought with him to Meissen some of the precious enamels that Stölzel had stolen from Vienna, as well as fourteen samples of porcelain he had decorated for du Paquier. This assortment of bowls, chocolate cups and teacups was carefully examined by the Meissen inspectorate, who were so impressed that they admitted privately to themselves that Herold's work was as fine as, if not finer than, anything any Meissen decorator had so far

achieved. The samples were good enough to be deemed worthy of royal attention and duly sent on to the king in Warsaw, who was also impressed. Herold, meanwhile, was put to the test by being asked to decorate one or two pieces of Meissen porcelain. Steinbrück recorded this significant moment in his notebooks: "the first service from him, which he had painted red, was fired on 19 July 1720 and taken to Dresden."

Obviously Herold passed with flying colors and within months of his arrival he had secured regular work as a freelance decorator. He set up his decorator's studio and living quarters in the house of Nohr, the town clerk, in the cathedral square. His rooms were conveniently positioned opposite the Meissen factory, but outside its precincts. He had managed to get the commission to agree to extremely favorable terms whereby he would be paid piecemeal for every object he decorated and his fee would be calculated according to his own assessment of the complexity of the design involved.

In the year since Böttger's death the haphazard Meissen factory administration had been dramatically improved as a newly appointed commission of advisors, brought in to solve the financial mess, had overhauled the old management structure. They found that the continual losses were largely a result of a top-heavy and dishonest management, many of whose members were expendable. As a result the troublesome

and devious Michael Nehmitz, who had so blighted Böttger's career, had fallen from his exalted position, as had Meerheim and various other corrupt and superfluous members of the directorate. Steinbrück, a deserving beneficiary of the reorganization, was now promoted to the position of overall administrator of the factory. Other much needed improvements included modest increases in wages, the construction of three new kilns, and the sorting of wares into three separate categories according to their quality so that inferior pieces did not reach the open market.

Almost immediately, this more efficient and streamlined arrangement boosted morale. Production rose and this in turn staunched the flow of losses. At the Leipzig Easter Fair of 1720 so much porcelain was sold and so many orders were taken that royal subsidies became a thing of the past. While not yet greatly profitable, the factory was at long last able to pay its own way, and with the talented Herold to decorate the porcelain there seemed no end to the advances Meissen would be making.

Herold's painting meanwhile was developing in an increasingly distinctive style. He became adept at painting whimsical, jewel-like chinoiseries framed within elaborately shaped cartouches. There are strange landscapes dotted with pagodas and bizarre vegetation in which coolie-hatted, mustached Chinese clad in rich brocaded robes smoke, take tea, dance or grow rice. The skies in these imaginary visions of the

Orient are speckled with giant mosquitolike insects or fluttering swallows, and the gilded frames that draw the spectator's eye inexorably to their magical contents are swagged with flowers and garlanded scrolls.

Augustus, long fascinated by such exotic themes, was predictably captivated by the sheer fantasy and opulence of Herold's style, and the orders for pieces for the royal collection flooded in. After less than a year Herold's income increased tenfold. The huge acclaim that he quickly earned forced the Meissen management to consider how the porcelain itself could be adapted to highlight his skill. Gradually shapes were simplified and the purity of the translucent surface became the perfect foil for the complexities of his designs.

Color was a key element in Herold's new style, and the pressure was more intense than ever to develop a wider palette of enamels. Köhler, the arcanist whose obsessive secrecy and intrigues had originally played a part in driving Stölzel from Meissen, had long immersed himself in this task. He had by now developed a fairly reliable recipe for underglaze blue and managed to make some improvements to the range of enamel colors. But with manic secrecy he refused to divulge the formulas to anyone on the commission for fear this would weaken his position. Instead he recorded his findings in a special arcanum book that he kept securely locked up in a secret cupboard set into the wall of his bedchamber.

The suave, persuasive Herold, realizing that Köhler's

cooperation would be crucial to his own career, managed somehow to charm this fanatical man, though even he could not weaken his resolve to keep his formulas secret. But as Herold's output grew, a still greater number of colors were needed, more than Köhler was able or willing to provide, and another compounder capable of such complex work was urgently needed.

The management recognized that Stölzel, Herold's fugitive colleague, had invaluable experience in this area. Having been left to spend several uneasy months of exile and illness at Freiberg wondering what would become of him, he was finally recalled to Meissen, forgiven his misdemeanors and set to work supplying his former accomplice with colors.

Less than a year after his arrival at Meissen, Herold's decorating business in Nohr's house was doing so well that he was able to take on his first apprentice, Johann Georg Heintze. Before long several more workers from the Dresden faience factory were also employed and, as his business grew, a very different aspect of Herold's personality came to light. For while Meissen's star painter was invariably charm personified to those on whose favor he depended, his employees were treated in a far less sympathetic manner.

Herold's staff found their master to be a hard-hearted, unpredictable and often extremely unpleasant employer. His apprentices' lives were particularly miserable since they were housed and fed in his apartments and had little respite from his demands. Hours

of work were long and arduous for both trained artists and novices; in summer staff were expected to work from before six in the morning till eight at night, in winter the usual hours were from dawn until nine. A short break was allowed at midday but it was not long enough to allow those who lived in the town to go home for a meal. For this grueling regime the rewards were meager. Pay was set at pathetically low rates, and it was almost impossible for the artists to earn enough to support their families. Apprenticeships lasted for six years, during which time, although an apprentice's expertise inevitably grew, virtually no rise in pay was provided to reflect his increasing skill.

Anyone who dared to question the paltry pay or the severity of the conditions was severely punished as a warning to others. Herold had no qualms about using his network of powerful contacts to ensure that dissatisfied employees he had dismissed could not find employment elsewhere in Meissen and were forced into destitution or to leave the district.

Even with this stranglehold over an already hugely profitable workshop Herold remained dissatisfied. He had no intention of remaining a mere porcelain decorator for the rest of his days; his plan was gradually to inveigle his way into a more powerful position at Meissen. To fulfill this ambition, he realized, he would have to make himself indispensable to Meissen—and to do that he would need to gain knowledge of the arcanum.

# Chapter Three

## Deception

*The manufacture of Porcelane surpasses that of China because of the beauty of the paintings, in which there is great order and proportion. The gold is used with great taste, and the painters are such as excel in their profession, being chosen by the king, to whom the fabric belongs.*

THOMAS NUGENT, *The Grand Tour,* 1749

The most effective way of discovering the secret processes involved in porcelain-making, Herold decided, would be by stealth. The problem was that his present situation gave him little chance to see or overhear anything. Living and working as he did in Nohr's house, outside the castle's precincts, his opportunities to casually come and go in the laboratories or the com-

pounding rooms were few. Armed guards stood on constant watch outside the castle monitoring all arrivals. Outsiders were only allowed in with special permission, and even then were not free to wander through the factory but were accompanied by a guard or member of staff at all times and permitted entry only to certain "safe" areas where none of the secret processes took place.

The obvious way to gain regular and relatively unrestricted admission to the factory was by joining the Meissen staff and having a studio inside the castle. But for financial reasons Herold was reluctant to give up his freelance status. He was still being paid piecemeal according to the volume of porcelain he decorated and this arrangement was proving extremely lucrative— his income was already considerable, and as he saw it his profits could only rise as his flourishing studio grew. His objective, therefore, was to persuade the Meissen authorities that it would be in their interests to allow him to move the studio into the factory while still remaining an independent decorator. With this in mind he compiled a forceful argument.

Giving him rooms inside the Albrechtsburg would, he pointed out, reduce the considerable number of breakages caused when the fragile porcelain was transported from the factory to his studio at Nohr's and back, over the rough cobbles. In addition the porcelain secret would remain more secure. At present there was a risk that outsiders might somehow gain access to his workshops and abscond with samples of enamels. If his

studio and assistants were under the same strict supervision as the rest of the Meissen employees this danger could be eliminated. At the same time there was no need for Meissen to incur extra costs by paying his and his staff's salaries. He was happy to go on as before, being paid according to his work and covering the costs of his workers himself.

The reasoning was evidently persuasive and the Meissen directorate, keen to attach the talented decorator as firmly as they could, agreed to let him retain his independence yet work inside the factory. In October 1722, not much more than two years after his arrival in Meissen, he was given a room within the castle walls for his own use. A fortnight later more space was found on the second floor, away from the rest of the Meissen workforce, and the whole studio, three workers and one apprentice, moved over before the winter's bitter chill descended on the town.

As part of the agreement, the Meissen authorities had undertaken to make sure that Herold's rooms were comfortably fitted out. Saxon winters were piercing and the Albrechtsburg, perched on top of a sheer cliff face, was constantly exposed to the worst extremes of weather. Herold, with characteristic attention to every detail, stipulated that his workroom had to be fitted with a new stove and that he would be guaranteed a good supply of firewood—all at Meissen's expense, even though he was not on the payroll. He was, it seems, always susceptible to cold, firewood was expensive and one cannot help suspecting that, with his

usual concern for studio efficiency and his own profit, this condition was also included because he realized that his craftsmen would paint their minutely detailed decorations better if their fingers were not numb.

As Christmas and the new year approached Herold must have reflected happily to himself that even though his workshop was isolated from the compounders he was inside the castle and therefore ideally poised to gain the knowledge he craved.

Stölzel and Köhler, on the other hand, were still incorrigibly envious of each other; Köhler remained obsessively worried that should he collaborate with anyone his position would be irrevocably weakened. He steadfastly refused to pass on any of his discoveries to the authorities or to work in a team with the other arcanists, and was increasingly unreliable about supplying colors to Herold's artists.

Stölzel, by contrast, seems from the outset to have cooperated quite willingly with Herold. The two had a long-standing alliance since their Vienna days. Stölzel had been severely shaken by the experience of his dramatic flight from Vienna and his fears about the fate that awaited him on his return to Saxony but, once pardoned, he had quickly reintegrated into the Meissen workforce and, to Herold's delight, was making significant advances in color compounding.

Since his return Stölzel had busied himself in developing ground colors—enamels that could be used to cover the main body leaving windows of white for Herold's decoration. By the early 1720s he had already

found recipes for black, brown and yellow, all of which were much admired by the king. Herold, realizing the importance of Stölzel's cooperation, treated him with the same delicacy he accorded to the most precious and fragile piece of porcelain. The two traveled together to Freiberg, the Saxon mining center, to inspect new mineral deposits—essential for developing new colors—and to arrange for supplies to Meissen. Herold almost certainly used the opportunity of this journey to glean as much information as he could from Stölzel.

But Köhler, who held the key to more colored enamels than anyone else, was far less easy to win around. His laboratory door remained firmly locked while he worked—no one was allowed to watch or assist in his experiments or compounding, and no one was allowed to glance at his journal or workbook where the details of his experiments were meticulously recorded. He perceived Herold as the ally of his chief rival, Stölzel—after all the two had worked together in Vienna. Sharing information with him would therefore be tantamount to handing it to the enemy, something he had no intention of doing.

Herold, however, had few scruples when it came to furthering his career. Hiding his feelings of irritation under a veneer of friendliness, he must have told himself that sooner or later his luck would turn. He had succeeded thus far in maneuvering himself into the inner sanctum of the Meissen factory. In such a position, an opportunity would eventually arise for him to

appropriate Köhler's formulas. It was now just a question of waiting.

In the meantime, Herold's progress and the fact that he was now working within the king's factory had whetted Augustus's voracious appetite for still more porcelain. He wanted vast numbers of ornamental pieces for his new porcelain palace and similarly gargantuan amounts of tableware for his lavish banquets. Flatware such as plates and dishes was only just beginning to be made in quantities, and Augustus put in orders for huge services in which every course would have its own specially designed dishes. He was also becoming progressively more hungry for imitations of yet another of his porcelain manias—Japanese kakiemon.

Arguably the most refined type of Oriental porcelain available at the time, and certainly the most expensive, kakiemon porcelain had been made in Japan from the late seventeenth century. Named after the legendary Sakaida Kakiemon, a brilliant Oriental artist from a large family of potters, who was believed to have invented colored enameling in Japan, kakiemon was produced in the Arita district of Japan—the country's porcelain-making center— where its other famous exports, such as rich, brocade-like Imari porcelain and delicate blue and white porcelain, were also made.

To Augustus's jaded eye kakiemon was a porcelain of potent and compelling contrasts. Jewel-like in its intense clear bright colors, it was nonetheless painted

in a severely limited palette of blue, turquoise, iron red, purple and black. Its decoration was supremely sophisticated, featuring asymmetrical scenes of prunus and pine through which tigers prowled and kimonoed beauties fluttered among birds and butterflies. Their delicacy was enhanced by their spareness and by the expanses of pure white porcelain against which they stood.

Augustus was enormously proud of his immense collection of carefully accumulated kakiemon treasures. But much as he admired their perfection he longed for his own factory's products to surpass them—and this majestic demand was now passed on to Herold.

But once again Herold found his progress barred by the problem of Köhler's refusal to cooperate on the colors.

As the winter gave way to the new year of 1723 and spring approached, Herold, struggling with the limited palette available, tried to urge Stölzel and Köhler to supply him with the new brighter shades he needed, and, probably out of sheer desperation, began his own experiments into color compounding based on what little he had learned so far.

Research of this kind was new to Herold and progress at first was slow. While he struggled long into the night in the laboratory to come to grips with the unfamiliar art, fate intervened to give his ambitions a helping hand.

Worn out by the constant demands that he share his

discoveries, and by the arduous working conditions, Köhler fell gravely ill. As with so many others who worked in the factory, his health was probably damaged by chemical poisoning from the toxic fumes to which he was constantly exposed. During his final three bedridden days, Stölzel and Herold, each desperate to be the first to get their hands on the secret book of recipes for colored enamels locked in the cupboard in his bedchamber, took turns keeping vigil over him as he tossed and fretted.

Neither man dared to take the key and unlock the secret cupboard while Köhler lived, perhaps fearing that he might recover enough to inform the Meissen authorities if they did so. Köhler's health was, however, beyond redemption. On April 30, 1723, a member of the Meissen administration received a message from Herold informing him that Köhler had died during the night. Herold was present at the deathbed and said that just before Köhler had breathed his last he had told Herold that he was entrusting him with a most valuable possession—his book of secret recipes. According to Herold, he had then been handed the key to the secret cupboard in the wall and instructed to take out the book.

Whether or not this conversation actually took place will never be known, but it seems highly probable that during the night, while the corpse of his obstructive colleague lay still warm beside him, Herold pored over the secret formulas, jotting down as many as he could in his own notebook and, perhaps, even re-

moving the pages on which the most important recipes were recorded.

Whatever the truth of the matter, the commissioner was highly suspicious of Herold's account and sickened at the thought that even death could not dampen his ambition. On behalf of the authorities he hastily removed the book from Herold's grasp and placed it in the factory's strong room for safekeeping—it remains in the archive to this day.

No one noticed that several pages on which the most important formulas had been written were missing, apparently cut from the book. The loss was only discovered fifteen years later, by which time Herold's position in the Meissen hierarchy was unassailable.

# Chapter Four

························································

## Crossed Swords

*To make red: its method of preparation. Take some English calamine, which is the best and to be had from any apothecary. Grind it small, and turn it into an earthenware bowl. Cover it with water and leave to stand for two or three days until it has dissolved. . . . Then you must put it into a crucible over a charcoal fire. Cover the crucible and leave it to glow for a quarter of an hour. It will then be a fine red.*

From J. G. HEROLD's notebooks

From the moment Herold plucked Köhler's secrets from his dying grip his progress was meteoric. In his cramped quarters in the Albrechtsburg he had dreamed of creating colors as vivid and as varied as

those which an artist might mix upon his palette. Now the notes he had so questionably commandeered gave his research a massive boost. He rapidly emerged as a supremely and, it appeared, an intuitively talented color compounder, effortlessly solving the problems that had baffled the factory for the last two decades.

With an energy fired by his still unbridled ambition, Herold frenetically ground, dissolved, crystallized, filtered and mixed his compounds. He mingled calamine with water to produce red as livid as the skins of cherries; he dissolved golden ducats in aqua regia (nitric and hydrochloric acids) to produce a blushing pink copper luster that Böttger had also made; he discovered compounds of iron that would create brown and, at certain temperatures, a delicate shade of green. All the while, with the eye of the true analyst, he scrutinized and logged every nuance of change in his notebooks.

As if by magic the elusive colors that Köhler and Stölzel had devoted a lifetime to inventing emerged in the crucibles and vials around him. Yet, as he triumphantly recorded the results in the burgeoning book of formulas, the exhilaration he felt remained secondary to his overriding aim. The knowledge he was gaining was merely a means to shake free of reliance on other color chemists, a potent weapon that might be used to intimidate the factory administrators—and ultimately gain sway over the king himself.

Over the decade that followed Herold conjured no fewer than sixteen new colored enamels, many of

which have never really been improved on and remain much prized secrets today, and also developed the muffle kiln—a cooler furnace better suited to firing colored enamels. With the ease of a master necromancer he created turquoise as delicate as the celadons in the king's collection, livid egg yolk yellow, a startlingly vivid pea green, intense aquamarine, a resplendent red, delicate lilac and claret as deep as garnet, a kaleidoscopic spectrum that infused the painting of his porcelain with newfound radiance.

A peerless array of colored enamel wares, many decorated with colors based on the unfortunate Köhler's recipes, was now made available for sale. In the meantime, the problem of making a pure white body had been gradually addressed by the use of a combination of feldspar and quartz rather than alabaster as a flux in the paste from 1724 on. One of the most abundant rocks in the earth's crust, feldspar is a less decomposed form of kaolin and is similarly comprised of alkaline aluminum oxide silicates. Apart from its ready availability the other big advantage of feldspar over alabaster was that when combined with quartz it created a more stable mixture during firing. When exposed to the heat of the kiln the feldspar not only melted and filled the pores in the kaolin, it also fused with the quartz, which lent support to the paste and stopped it from sagging during the high-temperature firing.

Although Stölzel and his fellow compounders who worked on the improvement could not have realized it, this mixture of kaolin, feldspar and quartz was in fact

identical to that used by potters in China and Japan. Thus by trial and error Meissen had at last overcome the problem of the porcelain's yellowish tinge that had plagued Böttger, and in so doing had discovered how to produce a paste that was more stable in firing and brilliantly white. By January 1725 Steinbrück was excitedly noting, "A large mantelpiece set of seven pieces also painted in red and Japanese colours was sent to the warehouse in Dresden on the 22nd of this month. It turned out so well that when it was shown to His Royal Majesty he was said to have shown great pleasure." At last the beauty and brilliance of Augustus's own porcelain factory was able to equal that of Japanese kakiemon.

Herold's work was inordinately costly. The authorities fretted over his exorbitant charges, and as early as 1720 the agent Chladni was asked "to see if it would be possible to have his painted porcelain at a lower price." Even though Meissen was far more expensive than most Oriental porcelain (except for kakiemon), Herold stood his ground and prices did not come down. But demand, far from wavering, was carried on the wings of the ascendant fashion for feminine frivolity and luxurious excess and spread inexorably throughout Europe. When ladies poured from a coffeepot decked with Meissen mandarins or fluttered flirtatious glances over the rims of tea bowls decked with exotic Indian flowers, these porcelain props became as invaluable an enhancement of their attractions as their fans, their scent bottles or their maquillage. Meissen, thanks to Herold, was high fashion indeed.

Its fame was fueled not only by its incredible and obvious beauty, but also by the mystery surrounding its manufacture. The eerily enclosed, prisonlike factory became the subject of much gossip in the letters of visitors to Dresden. Jonas Hanway, an Irish sea captain who went to Meissen in 1752, observed that, "in order to preserve this art as much as possible a secret, the fabric at Meissen . . . is rendered impenetrable to any but those who are immediately employed about the work."

The expense of Meissen was also much discussed. Hanway said skeptically: "They pretend they cannot execute fast enough the commissions which they receive even from Arita, as well as from all parts of Europe, and are consequently under no necessity of lowering the enormous prices." But one cannot help wondering if Hanway was not missing the point—and that, in fact, in sophisticated Vienna, in refined Augsburg and even in aristocratic England, buyers caught the craze for Meissen's elegantly painted porcelains in part because their outlandish cost gave them a chic exclusivity which magnified the frisson of owning them.

Realizing that Herold was the linchpin of their growing success, the Meissen authorities became increasingly concerned that he should remain happy and settled in the factory. If he should remove his studio and invaluable expertise elsewhere, the entire factory's profitability could be ruined. By 1724 Herold was twenty-seven years old and he was earning more than enough to support a wife and family. Why, wondered

the commission, had he not yet married? Was this a sign that he might move on if a better offer came along?

Herold had no intention of leaving such a profitable source of income, but he played his cards characteristically close to his chest. Although he would not have admitted it openly, he intended to pick a bride to advance his career. Love, affection and physical attraction were minor considerations in the great panorama of his impassioned ambition. Asked the reason for his reluctance to wed, he merely remarked that his lack of a proper role within the Meissen establishment gave him little to offer the sort of bride he had in mind. The authorities probably never even suspected that Herold had intended all along to use marriage as a weapon to maneuver them into a position where they would be forced to acknowledge his importance.

The coolly played ruse paid immediate dividends. Shortly afterward, in June 1724, he was formally appointed court painter—a title that marked an incredible achievement for a man who only four years earlier had run away from Vienna with nothing more than a handful of pots as a testimonial of his talents. He was now responsible for hiring and overseeing all the Meissen decorators, as well as having charge of the training of other members of the workforce and supervising the design of shapes and forms best suited to his decorations. A condition of the promotion was a royal order that he should get married as soon as possible.

Not only was his future now assured, he also had a

royal title under his belt and was well able to woo a wife of some social standing. Within a year he had made clear his intentions to Rahel Eleonore Keil, the daughter of a prosperous Meissen innkeeper and local councillor. In October of the following year the pair were married at Meissen with all the pomp and ceremony befitting the union of the only daughter of an important townsman and the king's brilliant and prosperous court painter.

His wedding gift to his carefully selected wife was a delicate porcelain beaker resplendently adorned with her name and the date of their union. It was a gift of considerable value. Porcelain was so expensive that most workers could never hope to possess any of the objects they so painstakingly made, but then neither could they hope to command Herold's fees.

The marriage, though long, was sadly ill fated. Herold's ambitions almost certainly included a desire to pass his already prosperous business on to an heir. This dream must have seemed about to be realized when his wife conceived easily after their marriage and nine months later Herold's first child, a boy, christened Johann Wilhelm, was born. But the infant was sickly and died a day later, and over the next decade the same tragedy was to be frequently repeated. Seven more children were born, of whom one survived until the age of seven, the rest dying within days of their birth.

As Herold grew ever more successful and powerful the deaths of so many children can hardly fail to have contributed to his embittered and unkind conduct

toward his employees. He continued to exploit their skills callously, paying them a fraction of the money he received from Meissen for their work. Ferociously ambitious as he was, he was also terrified that any of his most skilled assistants should develop their own artistic styles and then threaten to supersede him. By limiting apprentices to certain highly specialized subjects he actively discouraged blossoming talent and frowned on any burgeoning artistic individuality. Assistants were forbidden to sign their work (although some secretly hid their names in the designs). Underglaze blue designs were done by the least skilled decorators; others might specialize in landscapes, figures, harbor scenes, chinoiserie, Indian flowers or gilding, but novice artists were never encouraged to expand their repertoire and never properly trained.

Herold's own artistic style was rigorously imposed by making the artists copy designs he circulated in the decorating workshop as engravings and sketches. Even experienced decorators were forced to follow house style, and paper patterns with small pinpricks survive showing how designs were transferred to porcelain by sprinkling carbon dust through the holes—a similar transfer technique is still in use today. A degree of individual flair was permitted in adapting designs for wares of differing shapes, but for the most part Herold maintained absolute control over virtually every stroke of the brush.

As part of his new agreement with the factory Herold was paid a modest sum to instruct modelers and other

staff on Meissen's payroll in painting and drawing. This duty was perfunctorily and begrudgingly carried out. Why waste time and risk helping Meissen to coach decorators with painting skills, reasoned Herold, when it could only lead to his own business suffering? So training remained superficial and much latent talent was stifled.

Privately Herold justified his domineering attitude to his staff as being in the interests both of workshop efficiency and of security. Artists trained to paint a limited subject would be able to work more quickly. They would also, he argued, be less inclined to cause trouble by daring to leave, since restricted training would make them ill equipped to seek employment elsewhere.

It quickly became apparent that this thinking was fundamentally flawed. Mistreatment of his assistants not only caused profound misery and undoubted hardship; it also damaged the factory by directly resulting in the defections of many of them. Even though the training they were given was cursory and although guards watched all comings and goings at the factory, many of Herold's most talented painters were led, through desperation, shortage of money or the sheer unfairness of the way they were treated, to take their expertise elsewhere.

Among the lengthy roll call of those who fled Herold's tyrannical regime was his first apprentice, Johann Georg Heintze. Herold treated the unfortunate and talented decorator abysmally, failing to reward his hard work, never recognizing his increasingly accom-

plished designs, and paying him so poorly that he found it impossible to make ends meet and was forced to look for alternative ways to boost his income.

Meissen by the 1720s was producing far more porcelain than even Herold's studio could decorate, and surplus undecorated pieces "in the white" were often sold to *Hausmalerei,* independent decorators, who developed a lucrative trade in enameling in their own workshops and selling their wares privately outside Meissen's jurisdiction. The Meissen directorate was never entirely happy about the *Hausmalerei.* Quality controls were nonexistent, and while some pieces decorated by now famous names such as Aufenwerth, Seuter and Bottengruber were of a standard every bit as high as those produced internally, others were very inferior.

The authorities worried that this poor-quality output, often shoddy copies of designs produced by artists in Herold's studio, might damage the factory's hard-won reputation for artistic excellence. But the *Hausmalerei* neatly solved the problem of what to do with the surplus porcelain wares—especially pieces of poor quality that Meissen could not sell. The trade brought in extra cash, boosting the factory's profits, and so, reluctantly, it was allowed to continue.

But, to safeguard Meissen's reputation, in 1723 Steinbrück came up with the ingenious idea of identifying all genuine pieces with a mark painted in blue under the glaze. The idea was that such a device would act as a guarantee of quality, eliminating the possi-

bility of pieces of inferior standard being passed off as the genuine article. The mark eventually decided on was a pair of crossed swords taken from the Saxon coat of arms. For several years the crossed swords were only sporadically used, but as, gradually, they were applied to the bases of increasing numbers of factory-decorated wares—usually by the most junior apprentice—they became synonymous with the name of Meissen.

Little did anyone realize that in years to come Meissen's crossed swords were to become one of the most frequently faked marks ever invented.

For the poorly paid workers in Herold's employ the temptation to earn a few extra thalers by decorating wares at home was great, but they were expressly forbidden from dabbling in such trade. But Heintze, like many others in the factory, was acutely short of money and, doubtless disgruntled by the lack of recognition his skill had attracted, saw no reason not to join in the lucrative business on the quiet.

Little by little he began to take home white-fired pieces from the factory in order to decorate them in his own spare time and then sell them on the black market. As the clandestine trade grew he built his own muffle kiln and taught himself color compounding in order to make his own enamels. Heintze was a friend of Stölzel's, who must have helped him in this field.

But in the tightly knit workshop community it was virtually impossible to keep unauthorized work a secret. The factory still seethed with intrigue, and the risk of being incriminated by a fellow worker with a

grudge or who wanted to gain advantage with the head of the studio was very real, as Heintze was to discover to his cost. When Herold was tipped off that Heintze was illicitly decorating porcelain at his home he was at first reluctant to sacrifice such a hardworking and experienced decorator. Heintze received a stern reprimand, but, as usual, Herold did nothing to rectify the root of his discontent.

Either because he was so desperate for cash, or because he did not treat the warning seriously, Heintze continued undaunted to decorate porcelain on the side. On discovering this insubordination Herold was incandescent with rage and ordered his arrest and a search of his lodgings. As expected, a quantity of illicitly decorated porcelain was discovered. Heintze was sent for trial, found guilty of deception and sentenced to imprisonment in the fortress prison of Königstein—where, in a cruel irony, he was forced to paint porcelain for his subsistence. But this was not the end of his story.

Realizing that the only way to break free from Herold's tyranny was to leave Saxony, he managed somehow to escape. He fled, as the fugitive Böttger had done before him, toward Prague. Like the unfortunate alchemist, however, he too was quickly recaptured by Augustus's soldiers. But here the parallel ends, for his recapture seems not to have deterred Heintze from repeating the attempt, this time successfully. He went east to Breslau in Silesia, then south to Vienna and finally to Berlin. All these cities boasted

ceramic-making centers and in each he almost certainly offered his redoubtable services with a sense of profound relief that he had finally broken free of Herold's regime.

Heintze left behind him a legacy of porcelain arrayed with Arcadian landscapes and harbor scenes in which his favorite motif—an obelisk—provides as reliable a sign of authorship as the signature or initials so expressly forbidden by Herold. The only piece actually signed by the unfortunate Heintze is a plate now in the Landesmuseum in Stuttgart, painted, ironically, with a view of the Albrechtsburg, in which he was unhappily employed for so many years.

Heintze's crime of illicit home decoration was by no means unique. Numerous workers were spurred to engage in illegal private work in order to survive. Even Herold's house, when searched in 1731 after a tip-off to the authorities by his resentful housekeeper, was found to contain quantities of white porcelain that he too was presumably decorating on the side, in his case not out of necessity, but greed. But Herold's position made him invulnerable. Despite their misgivings, the authorities could do little but turn a blind eye to his misdemeanors. In this instance Herold was found to be slandered while the unfortunate informant was publicly derided for her untruthfulness and thrown into prison.

Not all those exploited by Herold successfully ran away. Some members of his staff, perhaps not realizing the value of their skills to rival establishments, put up

with almost incredible ill treatment rather than run the risk of losing their employment. Herold's despotic leadership is nowhere more clearly exemplified than in his dealings with Christian Friedrich Herold, a distant relation who came to work for him in 1724.

Christian Friedrich had trained in the art of enameling on copper in Berlin and, until his arrival in Meissen, had never decorated porcelain. But he quickly adapted his skills, becoming particularly engrossed with experiments into gilding. Noting his rapid progress, Herold became worried that his talented kinsman might get ideas above his station. To keep him in check he refused to pay him a regular salary, while at the same time forbidding him to conduct any private experiments into enameling, or to take on any other private work.

But Christian Friedrich was genuinely enthralled by his research and, ignoring Herold's constraints, he continued discreetly to work at home, painting copper panels for snuff boxes and experimenting diligently with new colors. When Herold heard rumors of this waywardness he ordered the Meissen guards to search Christian Friedrich's cramped lodgings in the town's market square. Enamels he had made at his own cost were impounded, the ingredients confiscated, and he, like Heintze, was arrested and tried for illegal decorating for his own profit.

Christian Friedrich however had a stronger defense. He justified his actions by pointing out that the ingredients the soldiers had found were for enameling on

copper, not porcelain, and as such they provided no competition for a porcelain factory. Unusually, in this instance, Herold's objections were overruled and the court found in Christian Friedrich's favor. But Herold never forgave his cousin for what he considered to be his subversive actions and exacted a lengthy revenge by continually taking advantage of him, working him unrelentingly and paying him poorly. Christian Friedrich was far from happy and made more than one attempt to leave, but somehow Herold always found out and put a stop to it.

The final injustice came four decades later, when Christian Friedrich politely requested a modest pay raise in recognition of his lengthy service. This quite reasonable demand Herold deemed to be a heinous crime tantamount to mutinous treachery, which should be dealt with by the courts. Incredibly, this time Herold won; Christian Friedrich was convicted of subversion and punished by four months' imprisonment, although even this mistreatment did not deter him from remaining at Meissen until he retired.

Already trained before he came to Meissen, Christian Friedrich's repertoire was more varied than that of many of his contemporaries. He was a master of action-packed battle scenes, serene landscapes, bustling harborside views and sensitive figure studies, as well as the chinoiseries that Herold still continued to favor long after public taste had moved on to newer, fresher subjects. He died aged seventy-nine in 1779, an unsung master to the end, little dreaming that in cen-

turies to come his underappreciated skills would be re-
garded as epitomizing Meissen's painterly decoration
at its best.

As Meissen's reputation grew, and Herold's mistreated
workforce expanded, so too did Meissen's profits. In
1724 the factory had a staff of around forty workers
while Herold had at his disposal twelve assistants. By
the start of the next decade Herold's business and
Meissen's turnover had escalated more than fourfold
and there were over ninety workers in the factory's em-
ploy.

Augustus was now reaping the rewards of his gold-
making fantasy. Gold poured into his coffers and,
equally important as far as the porcelain-hungry king
was concerned, porcelain of spectacular quality and
magnificence—outshining that of the Orient—now
flooded in to fill his palaces. Between the years of 1717
and 1732 Augustus received a total of 27,000 thalers
profit in gold and a staggering 880,000 thalers worth
of porcelain.

Hand in hand with the king's blossoming collec-
tion, Herold's enterprise prospered spectacularly too.
He was still employed as an independent artist on
highly favorable terms, but the cost of his lodgings,
his fuel, his horses and even his candles was met by
Meissen. His income was now vast—around 4,000
thalers, an enormous sum considering that his best-
paid employee was paid only a little over 300 thalers
and most workers were lucky to receive half that sum.

But perhaps the most surprising aspect of Herold's canniness was that no one on the commission fully appreciated the colossal sums he was raking in. His profiteering only came to light in the most unexpected way—as a result of an outrageous deception.

# Chapter Five

## Scandal and Rebirth

*Another of the Cabinet Ministers, who was also formerly Prime Minister to the late King of Poland, was the Count de Hoyhm. . . . I knew him intimately before he was advanced to the Ministry, at Paris and at Vienna, as well as here at Dresden. . . . There is not a Minister at this Court more civil, more learned, or a better friend to learned Men. During his long Residence at Paris as Ambassador from the King of Poland, his House was open to all Men of Learning as it is now at Dresden; and he had the splendid Title given him of the Maecenas of Saxony.*

BARON CARL LUDWIG VON POELLNITZ,
*Memoirs,* 1737

$\mathcal{T}$he scandal rocked both factory and court to its foundations. One of Augustus's most trusted ministers had been implicated in a web of disgraceful chicanery. His duplicity involved industrial and political espionage and he had come closer to endangering the security of the arcanum than anyone since Stölzel when he had fled to Vienna a decade earlier.

In the lax Dresden court, corruption, profiteering and unscrupulous dealing were endemic at virtually every level. It was almost expected that those in positions of power and privilege should profit from their status by whatever means was available. But the Lemaire de Hoyhm affair, as it became known, was different; it was a scandal of such monumental proportions that even the king could not sanction or ignore it.

In 1729 Augustus, still frequently called to attend to affairs of state in Poland, had appointed his prime minister, Count de Hoyhm, as senior director of the Meissen manufactory to represent his interests there. A member of one of the most powerful Saxon families, de Hoyhm was the brother of the unfortunate courtier whose wife had become Augustus's most infamous mistress, the Countess of Cozelle. As Saxon ambassador at the courts of Vienna and Paris he had become accustomed to a life of privilege—and loved nothing better than embroiling himself in the intrigues of court life.

During his tour of diplomatic duty at Versailles, de Hoyhm acquired an indispensable coterie of French ac-

quaintances, among them one Rudolph Lemaire, an entrepreneur with a keen eye for business opportunities, no matter how dubious. Soon after de Hoyhm returned to Saxony and took up residence in "the most considerable building in Dresden." Lemaire, hearing that his Saxon acquaintance was now in charge of Europe's most illustrious ceramics manufactory, arrived in Dresden and came to call on him. Together they hatched various schemes to make themselves rich beyond compare—all at the expense of the Meissen factory.

At de Hoyhm's instigation Augustus was prevailed upon to allow Lemaire exclusive rights to sell Meissen porcelain in both France and Holland. The wary king was persuaded that Lemaire was ideally placed, with his contacts in the French court and elsewhere, to develop Meissen's international market. Such an eminent representative would, promised de Hoyhm, bring Meissen greater recognition, which in turn would bring incalculable prestige to the royal owner of the factory.

Because Lemaire was familiar with the latest French fashions it was decided that he would be permitted to commission Meissen to make pieces to special order that would appeal to the refined Parisian taste. Among the chic clientele frequenting the shops in the boulevards of Paris, Lemaire had noticed that the appetite for Oriental porcelain, in particular kakiemon, was as yet unsatisfied. Kakiemon porcelain, Lemaire also realized, was far more costly even than Meissen.

De Hoyhm therefore arranged that the factory should supply Lemaire with large consignments of porcelain that directly copied kakiemon. With unbelievable audacity the pair decided that designs and shapes were to be meticulously duplicated from choice pieces in the king's own collection. To this end, more than 120 precious items from Augustus's prized displays at the Dutch Palace were carefully packed and transported the twelve miles along the perilously rutted roads to Meissen, there to be copied in large numbers. The payments received by the factory for these huge orders, confidentially agreed between the two conspirators, were little more than token sums, far below the usual market price for such intricate wares. Thus Meissen was rapidly being bled by the very agent whom everyone believed to be nurturing its interests.

The fraud might have gone unnoticed except that Lemaire induced de Hoyhm to order that the by now usual crossed swords mark of Meissen be left off. Facsimile Oriental marks would, he said, be acceptable; failing that, the porcelain should be left unmarked.

Almost immediately questions were asked about the wisdom of selling unmarked wares that so exactly imitated Oriental porcelain. Even if Lemaire were selling them honestly as Meissen copies, fraud could easily be perpetrated later on by other unscrupulous dealers and Meissen's reputation might be called into question. For his part Augustus was furious, not because of moral scruples, but because the lack of a

Meissen mark meant that he would receive no recognition for the accomplishment of the designs.

Nevertheless, through a mixture of coercion and bribery, de Hoyhm managed to slip quantities of unmarked pieces out of the factory. Others were marked in blue on top of the glaze in such a way that the mark would easily be scratched off. It is a testimony to the extraordinary skill of the Meissen decorators that even to the discerning eyes of today's collectors some of the unmarked pieces made at this time are virtually indistinguishable from the Japanese originals.

In the meantime, not content simply to earn a fortune from the sale of counterfeit Japanese porcelain, de Hoyhm and Lemaire began to cast their net of chicanery still wider, dreaming up an even more damaging plot: to discover and sell to France the precious arcanum for porcelain itself.

Louis XV, like every other luxury-loving European monarch, had acquired a dangerous fondness for porcelain. Ever since he had heard that Augustus had founded a factory making true porcelain he too yearned to join the race and sponsor a similar royal enterprise—one that would eclipse that of Saxony. Later in the decade he would invest in the Vincennes factory, a soft paste porcelain factory founded in 1738 and reborn in 1756 as the royal Sèvres manufactory, which like Meissen survives to this day. But in 1730, there was no royal manufactory, and French factories such as those at St. Cloud and Chantilly had still only managed to make *pâte tendre* or soft porcelain. Louis, the

treacherous Lemaire knew, would be frantic to get ahold of the arcanum—at almost any price.

So de Hoyhm granted his accomplice the extraordinary and unheard of privilege of wandering at liberty within the Albrechtsburg stronghold, allowing him to watch and observe the secret compounding and manufacturing processes that were forbidden to virtually every other outsider no matter how high-ranking. When, even with this privileged access, Lemaire proved incapable of finding out the secret, the pair decided that expert assistance was called for. Their choice was one of Meissen's most long-standing and vulnerable employees—the unfortunate Samuel Stölzel. Summoned with increasing regularity to grueling interviews with the factory director at his palatial house in Dresden, poor Stölzel was powerless to resist commands to divulge the secret, even though he must have realized what was going on.

Eventually, however, Lemaire and de Hoyhm grew careless, resorting to stealing porcelain clay for their own experiments. The tangle of conspiracy surfaced when the captain of the guards in charge of factory security noticed that firewood seemed to be disappearing from the castle precincts and ordered a specially vigilant watch to be kept. He did not have long to wait. One night the guards patrolling the lower ramparts around the fortress noticed a shadowy figure and went to investigate. They arrested a local girl employed as a maid in councillor Nohr's house. She was not, it turned out, stealing firewood but, even more worri-

some, a sack of porcelain clay. Her confession, extracted under lengthy interrogation, damningly incriminated de Hoyhm.

When the news of the illicit dealing reached the court, Augustus ordered de Hoyhm's arrest and the questioning of key workers at the Albrechtsburg. It transpired that Herold, as eagle-eyed supervisor of the decorating studio, had known all along what was going on. But, realizing that the more spectacularly de Hoyhm fell from grace the more he stood to profit, he had decided to steer clear of involvement in the deception, say nothing and wait for events to run their inevitable course. Now, questioned over the affair, he was quick to give testimony that conclusively proved de Hoyhm's guilt, after which he retreated to his workroom to wait patiently to reap his certain reward.

Augustus also ordered a search of the de Hoyhm palace. The guards did not take long to discover a cache containing nearly 1,600 pieces of porcelain—all presumably waiting to be illicitly sold at vast profit by Lemaire. In Lemaire's house, which was also searched, nearly three thousand more pieces were found. Many of them were unpainted and presumably intended for adornment in Oriental style by outside decorators in Saxony or elsewhere in Europe. Further investigations revealed that de Hoyhm had also been dabbling in political intrigue and passing important political information to the court in France.

As a result of this debacle Stölzel, a regular visitor to the de Hoyhm palace, was arrested and confessed

that he had been closely questioned concerning the arcanum. It appeared, however, that the information he had passed on had not been full enough to give Lemaire the key to the secret and eventually he was released and allowed to resume his work. The archvillain Lemaire seems never to have lost his sangfroid, and managed to evade severe punishment, suffering no worse a fate than immediate deportation.

But de Hoyhm did not escape so lightly. He was imprisoned in Waldheim Penitentiary, and two years later, depressed and desolate, after a failed attempt at shooting himself, succeeded in committing suicide by hanging. His demise was graphically recorded by von Poellnitz: "The said Count being stung by the remorse of his conscience, and vexed to see all his pranks laid open, chose to shorten the course of justice by putting an end to his own Life. . . . For this purpose he first pretended to be sick, and having order'd his Domestics not to disturb him, he hang'd himself the 21st of April last, at Night, with a handkerchief ty'd to a hook that supported his looking-glass."

The gravity of the Lemaire–de Hoyhm scandal forced Augustus to take radical action. On May 1, 1731, he paid a visit to the factory without his usual extensive retinue in order to assess the situation and decide how best to put right the pervasive rot of the last few years.

Resolving that he no longer would entrust the running of his factory to others, he personally took over its management, appointing a commission of three advi-

sors who would report directly to him. The commissioners were members of the court who had little practical experience of the intricacies of porcelain-making and the prime beneficiary of the restructuring was, as he had anticipated, Herold, whom Augustus now appointed to the role of artistic director of the factory, with the title of court commissioner.

The fringe benefits of such a rank were enormous. Herold was now entitled to be called "excellency," a privilege that must have given immense satisfaction to someone who was always obsessed with social status. He was given a sumptuous suite of rooms in the royal apartments on the first floor of the Albrechtsburg. In addition, he had the right to attend court, to be privy to its intrigues, even to demand the best seats at virtually any theatrical production or spectacle he cared to attend. Most significantly of all, however, he was to receive the ultimate signal of distinction and royal trust: he would be instructed in the secrets of the arcanum.

The new residence in the Albrechtsburg gave Herold a suitably grand backdrop for entertainment on a princely scale. He had the rooms redecorated at vast expense—all borne by Meissen—and, much to Augustus's annoyance, went so far as to remove the ancient stone bench around the walls of the grand hall in order to increase the space available for banqueting.

But along with the intrigues and skulduggery perpetrated by Lemaire, the investigations into the debacle also brought to light the fantastic sums of money

being paid to Herold. According to some reckonings he was believed to be earning some 4,000 thalers a year—a preposterously large sum even for a senior member of the factory. Herold, it was true, paid the wages and costs of his staff from the money he received, but these were still negligible compared with his income. A condition of Herold's newly elevated role was, therefore, that he should become a salaried employee of the factory. His pay was set first at 600 and later at 1,000 thalers a year, still a considerable sum, but far less than the profits he had been making until now. If he balked at such a reduction in his income, the important status and the royal apartment sweetened the pill. But his reduced income gave him no incentive to paint and decorate wares as prolifically as before, and from now on, aged only thirty-five, he hardly ever bothered to pick up his paintbrush again.

On June 1, 1731, Herold moved into his grand new residence and began enjoying the trappings of his new position. Two weeks later, on June 15, the Meissen workforce was joined by a new member of the staff, a man who would be the catalyst for events that would eventually challenge even Herold's apparently incontestable ascendancy.

# Chapter Six

........................................

❧✿❧

## *A Fantasy Universe*

*Anything can be made in porcelain; whatever one desires; if it is too big, make it in two pieces, which no-one can understand as well as he who makes the moulds. . . . In this way everything even the impossible can be done in its own way . . . and to this I candidly and truthfully attest.*

<div align="right">

Report by J. J. KAENDLER to the
Meissen commission, 1739

</div>

With every advance his factory made, Augustus's love affair with porcelain became more passionate and his schemes for his porcelain palace more fantastic. Even the damaging fracas with de Hoyhm did not distract him, and there are notes referring to the affair with drawings and sketches for the palace, annotated

in the king's scrawling hand on the other side detailing the theme and color scheme for each room. When the scandal was finally exposed Augustus still refused to be sidetracked, and all the wares confiscated from de Hoyhm and Lemaire went to swell his own collection.

The king had come to the conclusion that the Dutch Palace in its original form was not nearly big or exotic enough to do justice to his dream collection and a massive reconstruction was set under way. The palace formed three sides of an oblong with a central court. In its new incarnation it was to be reinvented as a Japanese Palace. The courtyard was to be enclosed by an extra wing. Instead of classical caryatids there would be gigantic laughing and grimacing sculpted Chinese to frame the doorways and support the entablature, and the building would be crowned by a crazily scalloped roof.

Inside, the very fabric of the building was, as far as possible, to be made of porcelain. There were to be porcelain surrounds on the doors and arches; the throne room would feature a glockenspiel of porcelain, while in the chapel the altar, the statues of the saints and even the organ would also be made of porcelain. The decor in this exotic edifice was to be equally extravagant. Augustus envisaged rooms with walls six meters high, covered with Oriental chinoiseries that would be encrusted with porcelain supported on frondlike gilded wall brackets. Every room would be filled with porcelain of a different color, each more

dazzling and breathtakingly beautiful than the last.

The intrepid traveler Johann Georg Keyssler must have been shown the plans on his visit to the city of Dresden in 1730, and he describes the arrangements with obvious astonishment. There was to be a chamber filled with "porcelain of celadon colour and gold and the walls lined with mirrors and other ornaments"; in another the porcelain would be yellow and the decorations gold; the next would feature dark blue porcelain, which in turn would lead to a room filled with purple porcelain. "It is almost impossible," wrote the porcelain-dazed Keyssler, "to enumerate the multitude of pieces of fine porcelain both foreign and home-made that are to be seen here. The culinary porcelain vessels alone are valued at a million thalers."

The furnishings he went on to describe were of matching opulence. "There is a state bed, with some chairs made of beautiful feathers of different colors, which cost thirty thousand thalers." But most amazing of all in this fabulous structure was its upper gallery, which was to be filled with a spectacular porcelain zoo. It was to be "of a hundred and seventy feet in length; which will be ornamented with all kinds of birds and beasts, both wild and tame, made entirely of porcelain, and in their natural colors and size. Some of these are already finished and cannot be sufficiently admired."

Augustus's demands for a menagerie of monumental porcelain animals presented Meissen with a thorny problem. Under Herold, painting ruled the day. The shapes of everything from tiny teacups to

massive vases and dishes had been simplified so that the impact of his painted decoration would be heightened. Herold had made sure that inventive modeling and unusual sculptural forms were virtually nonexistent. In short there was scarcely a handle of which Meissen could be proud, and furthermore there was no one in the factory capable of carrying out such complexities even if the king commanded them.

Until now Augustus had been content with Herold's brilliant painting and had not questioned the absence of new, more exciting designs. But as his plan for a porcelain zoo took more definite shape he impatiently demanded that a suitable expert modeler be found to create the massive beasts he had in mind as well as to increase the variety of Meissen's stock-in-trade. Clearly only a trained sculptor would be capable of such a challenging task, but the question was who?

First to be approached by Meissen was an exuberant twenty-one-year-old sculptor by the name of Johann Gottlieb Kirchner. An expert in stone carving, Kirchner could see no problem in adapting his skills to designing porcelain sculptures and sculptural objects either as drawings or as models of wood or clay. From these the modeling assistants would create molds from which the finished objects would be cast.

But Kirchner's initial confidence was drastically misplaced—he had fatally underestimated the complexity of the task in hand. By the time he realized the difficulties involved he had joined the Meissen staff on a good salary and it was too late to extricate himself

from the factory without severe embarrassment. Early trials were a disaster and progress was agonizingly slow. Kirchner was given a workspace in a corner of the modeling shop and his struggles and setbacks quickly became common knowledge. Within a few weeks the so-called master sculptor had become the object of scorn among the modelers and apprentices. He was ridiculed so mercilessly that work became unendurable until, after he complained to the authorities, his section of the workroom was enclosed by a screen to separate him from his tormentors.

Eventually, after a succession of embarrassing failures, he managed to make a handful of credibly inventive forms—a cup in the form of a shell, a clock case decorated with figures, a miniature temple with figures for a table centerpiece, as well as the first large animals and saints for the king's palace. But even then his troubles were not over. Augustus was far from pleased with the results. Kirchner's animals were too posed, too static and, above all, too dull. They were not what he had in mind at all.

As if the mounting friction between the hapless Kirchner, the factory workers and his royal patron were not enough, there were also huge technical problems to overcome. The porcelain paste in its usual form was ill suited to making such large objects, and cracks and faults were commonplace. Stölzel tried to help by modifying the composition and developed a more granular mixture, in which sand was added to the paste, but still it was usually riddled with firing faults

and, because of its instability, impossible to decorate with fired enamels.

Within months of Kirchner's arrival at Meissen the strain had taken its inevitable toll. Desperate to escape the constant barrage of criticism and scorn, he began to disappear from work and seek solace in local taverns and brothels. Before long he had contracted such severe venereal disease that he had to ask the authorities to allow him four weeks' leave. While treatment was still under way the commission decided that Kirchner's progress and his lifestyle were so unsatisfactory that he must be dismissed. The wretched sculptor, probably feeling a certain relief when informed of this decision, left Meissen as quickly as possible and found work as a stone carver at the court of the Duke of Weimar.

In February 1728, a month before Kirchner's ignominious departure, the commission had taken on another supremely self-assured sculptor by the name of Johann Christoph Lücke. Trained as a carver in ivory, Lücke came from a long line of specialist craftsmen, and had recently returned from travels through Europe. He was, he said, an expert at sculpting in all manner of different materials and the numerous studies and sketches he had made on his travels would provide him with a fertile source of innovative designs.

So impressed by his confidence were the commission that they immediately employed him as a master sculptor and set him to work. But the outcome was similarly disastrous. It soon became clear that Lücke

was no better than Kirchner when it came to modeling in clay or wood. Moreover, despite his claims to be an experienced designer, he had such difficulty in drawing designs that his assistants said they were impossible to work from. He also quickly became the butt of numerous workshop jokes and, realizing the hopelessness of the situation, a year after his arrival the commission unceremoniously sacked him.

Things were now so desperate that the factory supervisor, Reinhardt, began talks to secure the return of Kirchner, who was now happily settled in Weimar and, presumably having made a good recovery from his illness, newly married. Not surprisingly, when the first overtures were made Kirchner was reluctant to endure the ordeal of working at Meissen again. Eventually he was persuaded by a royal order demanding his return, coupled with the temptation of being appointed to the position of model master, in charge of all the Meissen modelers—a role in which he could exact revenge for the insults he had suffered a year before.

But while the negotiations for Kirchner's return were still under way the frustrated Augustus had noticed another possible candidate for the job of chief modeler closer to home.

One of the most spectacular suites in Augustus's primary residence, the Royal Castle in Dresden, was the so-called Green Vault, a treasure chamber originally created in the sixteenth century by Augustus's forebear, the Duke of Moritz. The duke had constructed a series of four rooms with meter-thick walls,

iron gates, vaulted ceilings and walls painted emerald green as a secure place in which to store his riches. Augustus had greatly added to this treasury and, in his perpetual quest for recognition as Europe's most splendid ruler, decided to expand the rooms, redecorate them and open them to visitors so that they could admire the extraordinary array of objects he had inherited or assembled. The rooms he planned were to be color-coordinated and the displays arranged according to the material from which the treasures were made. He would cram them with precious ivory and amber, silver, gold, lapis lazuli, agate, nautilus, shell, coc-de-mer, ostrich eggs and rock crystal. The final pièce de résistance was to be the jewel room, in which would be displayed the dazzling royal gems, together with Dinglinger's great cabinet masterpieces, including a massive solid gold coffee service studded with thousands of diamonds, and the extraordinary silver, gold and jeweled centerpiece known as *The Birthday of the Grand Mogul.*

The Green Vault was in effect intended to be the first ever museum of applied arts, but rather than adopt an academic approach to the display of his treasures, Augustus with typical ostentation decided to present them as a theatrical showpiece. Each room was decorated and arranged to look more spectacular than the next, so that by the end of their tour visitors would be utterly awestruck by the status and power of the monarch who owned the priceless contents. It is a mark of Augustus's extraordinary foresight that his

vault, at present on view in the Albertinium in Dresden, still dazzles and delights the thousands of visitors who troop through its reconstructed rooms every day.

During his regular tours of inspection to view the progress of the new decorations, Augustus's eye fell upon court sculptor Benjamin Thomae's young assistant, who was occupied with the task of carving console tables and show cabinets. The brilliance of his carving and the speed at which he worked was immediately outstanding.

Preoccupied by his need for a modeler at Meissen, Augustus began to make some inquiries about this unusually gifted young craftsman. His name was Johann Joachim Kaendler. Born on June 15, 1706, he came not from a family of artisans or craftsmen but, unexpectedly, from a well-educated clerical background. Kaendler's father, a pastor, had noticed that from an early age his son showed a marked aptitude for artistic pursuits and a fascination with the legends of antiquity. Young Johann Joachim was of pleasant appearance and demeanor, with a round intelligent face, a mischievous smile and an affable manner. When he professed a yearning for an artistic career rather than a desire to follow his father into the Church, his family did nothing to stand in his way. Kaendler's forebears had once worked as stonemasons, and when one considered the massive sums currently being spent by the king on buildings and artistic works in the capital it must have seemed a field ripe

with opportunity. So Kaendler's father apprenticed his talented son to the leading sculptor of the Dresden court, Benjamin Thomae, under whose watchful eye, as Augustus had seen, he progressed at a prodigious pace, quickly outstripping his peers in imaginative and technical skills.

But would he be talented enough to solve the modeling problems at Meissen? Augustus was eager to find out, and under royal command Kaendler was asked to work temporarily at Meissen, along with Kirchner. He reported to the Albrechtsburg as soon as his work on the Green Vault was completed, in June 1731.

In order to avoid conflict and petty jealousies between the two men, Kaendler was set to work in a completely separate part of the factory. The two were to tackle similar tasks but to remain as independent of one another as possible. Like Kirchner and Lücke, Kaendler had never worked with porcelain before, but in contrast with the difficulties they had encountered he took to the new medium with prodigious ease. His easy charm quickly won over Stölzel, who probably advised him about the fundamental technical constraints of the material. Within a matter of weeks he had his first success: a large eagle nearly two meters high with outspread wings for the king's porcelain menagerie. It was based on a heraldic design but filled with movement, naturalism and drama. Seeing it for the first time Augustus was enchanted. Here at last was someone who both understood his vision and had the skill to realize it.

On the king's order Kaendler was employed with the title of "model master" at a starting salary of 400 thalers a year. Both Kirchner and Kaendler now had the same title, but Kirchner was nominally senior. When, later, he found out that he was being paid nearly 100 thalers a year less than Kaendler he complained bitterly of the injustice to the authorities, who were forced to increase his pay. But the favoritism rankled, particularly as Kaendler proceeded at incredible speed to produce an amazing array of animals, objects and statues. Within the space of a year, apart from the eagle, he had successfully created two life-sized ospreys, a sea eagle, an owl, a hawk and a heron, as well as a statue of Saint Peter for the chapel.

Kirchner was left far behind. In 1733, disgruntled and embittered, he finally left the factory of his own accord. The authorities had no regrets. Kaendler had proved that he would easily be able to carry the responsibility of being modeler-in-chief alone, and to supervise the modelers working under his direction. Without Kirchner the problems of conflict and rivalry would be neatly eliminated.

Unfortunately they overlooked the fact that court commissioner Herold, ten years older than Kaendler and in overall charge of the entire factory, had also taken exception to the ease with which the sculptor had ingratiated himself with the king and the establishment. Kaendler's sculptural style threatened the importance of his paintings, and his novel ideas might call into question Herold's supremacy. In order to safe-

guard his own position Herold determined to thwart Kaendler whenever possible.

The two titans of the porcelain world were about to collide.

# Part Three

## The Porcelain Wars

# Chapter One

..................................................

## The Last Journey

The King found himself in a declining State several Years. During the last Dyet at Grodno, a Mortification seiz'd his Foot; for which reason, M. de Petit, a Surgeon at Paris, whom the King sent for on purpose, cut off two toes, and set his Majesty upon his Legs again, but told him withal, he must observe such a Regimen as he prescrib'd to him, or else it would break out again. But the King finding himself better, neglected Petit's Advice, and died of the Mortification, as the Surgeon had foretold.

BARON CARL LUDWIG VON POELLNITZ,
*Memoirs, 1737*

*I*n the autumn of 1732, Augustus left his royal castle in the heart of old Dresden to survey the building work

still in progress at the Japanese Palace. Now aged sixty-two, he was probably carried there in the comfort of a sedan chair padded with crimson velvet and chased with gold, for the excesses of his dissolute life had taken their inevitable toll.

Augustus was no longer the dynamic and athletic figure he had once been. His muscular physique had become bloated by an excess of wine and rich food, his legs were inflamed with abscesses and swollen by gout, and a hunting accident several years earlier had resulted in his surgeon having to amputate two of his toes. His demeanor nonetheless remained striking. His jawline might now be heavily jowled but he retained a "majestic presence," according to Wilhelmina, the nineteen-year-old Prussian princess who met him during a visit to Berlin in 1728—although one suspects she might have thought differently had she known that plans were secretly in hand to marry her to the aging roué. Her brother Frederick, heir to the Prussian throne (and later to be known as Frederick the Great) was also struck by the king—remarking not only his "very heavy eyebrows and a slight pug nose," but also that he was "polite to everybody and has considerable urbanity," even though he was "difficult to understand, particularly as he has lost so many teeth." (One wonders whether he ever ordered a false set from his porcelain-makers—they are known to have turned their hands to producing such oddities on occasion.)

Frederick also remarked that even at this advanced

stage in his life the king "dances and does other things, just like a young man." Augustus's sexual prowess, as well as his lust for the good things in life, was to remain with him to the last.

The short journey through the streets of his capital to the Japanese Palace would have taken him past the Zwinger—the "Tuileries of Dresden"—the magnificent Baroque pleasure pavilion next to his castle where musical extravaganzas, animal fights, military spectacles and operas were regularly performed to impress visiting dignitaries and entertain the court. He would then have crossed the grand stone bridge, 166 meters long and 11 meters broad, that linked the old city to the Neustadt on the Elbe's eastern bank and skirted a profusion of newly built grand stone facades. This part of the city had been devastated by fire early in his reign, but by waiving ten years' taxes for anyone who built there and introducing stringent building laws he had encouraged the construction of innumerable mansions in a coherent architectural style. He must have reflected with pride that during the course of his thirty-eight-year reign, he had seen Dresden change from an insignificant Renaissance town into one of the most beautiful cities in the world, a magnet for travelers of wealth and nobility. Even the King of Prussia had admitted that the luxuries of life here "could not have been greater at the court of Louis XIV."

Arriving at the Japanese Palace, Augustus surveyed the interior decorations and the new deliveries from Meissen with satisfaction. With Kaendler ensconced in

the factory and overseeing the design of commissions, his dream palace was at last taking shape.

Quantities of massive porcelain animals for the upper gallery had already arrived by boat from Meissen and he examined each with care. The king was fascinated by zoology and kept a menagerie of live animals at the nearby Jägerhof (a converted hunting lodge), many of which had been collected on a special expedition to Africa that he had sponsored. He had also built an aviary at Moritzburg for a vast collection of exotic birds, and he had another collection of stuffed animal specimens and various other natural curiosities. He was well able to recognize, therefore, the outstanding naturalism of Kaendler's work, the result of long hours spent watching and sketching the animals and birds from life. The base of the figure of a stork was woven with reeds and lily pads and enlivened with a frog and a cluster of snails. A huge pelican was shown with its head thrown dramatically back as, open-beaked, it swallowed a scaly fish. A scrawny-necked, rufflefeathered vulture was depicted consuming a sinewed strip of meat. Porcelain had never come so close to imitating the essence of life itself.

Soon after Augustus's inspection of the Japanese Palace urgent matters of state called him to Poland. The matter of who held the throne of Poland had traditionally been decided by election, but as he drew near to the end of his life Augustus longed to establish Saxony's hereditary right to it. Before leaving for Warsaw he decided to pay a brief, informal visit to the

Meissen factory. It was destined to be his last. Arriving at the Albrechtsburg castle on November 8, he could already see the effects of the changes he had made since taking charge of the factory.

The painting departments, the kilns and the stores had all been expanded to cope with the vast orders for the porcelain palace. A new firewood lift, an extraordinary horse-driven conveyor-belt contraption linking the cellars of the castle to the river landing stage below, had been constructed. This would save on the cost of bringing the vast quantities of wood needed to fire the new kilns into the castle precincts. A physician had been brought in to improve the workers' health. The fumes from the kilns were highly toxic, respiratory diseases were endemic, and it was rare for those constantly exposed to the belching smoke to live past middle age.

While the king was making his tour of inspection a trial firing of one of the newly constructed kilns was taking place. As the door of the kiln was opened and the wares, safely protected in their stone saggers, were expertly removed, Augustus could not have failed to draw a comparison between the now well-practiced routine and the highly charged moment, nearly a quarter of a century earlier, when Böttger, clad in soot-covered rags, had opened his primitive furnace to give him his first glimpse of true European porcelain.

The progress since then had been truly phenomenal. Böttger's porcelain had not only beautified his palaces, it was bringing in more money than any other

manufacturing industry in the country. Augustus's porcelain mania and Böttger's quest for gold had spawned an industrial showpiece, Europe's most highly specialized, productive and efficient corporation.

A few days after his visit to the Albrechtsburg, Augustus left Dresden for Poland. As he slowly and deliberately climbed into the royal carriage his attendants must have remarked that the king's lameness was more marked than ever. The old injury to his foot had become inflamed, his legs were more swollen. Royal physicians had treated him with various pills and by bloodletting, but had warned him that unless he curtailed his excesses the condition would not improve. Augustus, as usual, had chosen to ignore their advice. In fact, he was probably suffering from diabetes (unknown at the time), a symptom of which is foot ulcers that when not properly tended can cause blood poisoning.

Crossing Prussian territory en route to Warsaw, Augustus had a prearranged meeting with an advisor to the King of Prussia, General Friedrich Wilhelm Grumbkow, with the intention of discussing some of his political schemes. On hearing of the planned meeting, Frederick William I, the soldier king of Prussia, had given Grumbkow orders to try to extract as much useful *off-the-record* information as he could. Grumbkow decided that the best way to carry out this order was to get Augustus as drunk as possible and the two embarked on a gargantuan drinking spree with

Grumbkow plying Augustus with quantities of wine while secretly watering down his own intake. It was to be Augustus's last spree—his body could no longer cope with such continual overindulgence. Soon after his arrival in Warsaw he lapsed into delirium and, eventually, a coma from which he never recovered.

It was certainly not the sort of death he would have chosen for himself, for when he heard the story of the French regent, the Duc d'Orleans, who was rumored to have died in the midst of an epic lovemaking session with his mistress, Augustus was recorded to have declared, "Oh that I could die in such a way." His was to be a lingering, less pleasurable end. Despite the best efforts of the royal physicians, on February 1, 1733, having candidly confessed that "all my life has been one ceaseless sin," the ruler of Saxony and Poland finally breathed his last.

After lying in state in the cathedral in Warsaw he was buried in Kraców but his heart was brought back to Dresden encased in a metal casket and still lies in the crypt of the Catholic court church, the Hofkirche, built by his son. In Dresden some say that when a pretty girl walks by the king's heart may still be heard to beat.

Augustus the Strong, potent demolisher of women's virtue, was succeeded by his son, Augustus III, a man who, though said to be as physically powerful as his father, was as different in temperament, tastes and appearance as it was possible to imagine.

Since the lavish wedding celebrations of 1719 he had been contentedly married to Maria Josepha of Austria, by whom he had fourteen children; the attractions of mistresses seemed to hold little allure for him. Nicholas Wraxall, a visitor to the Dresden court, summed up prevailing opinions. The new king, he said, lacked "the activity, ambition, or address of his predecessor"; he was "mild, indolent and destitute of energy." Horace Walpole went further, waspishly describing the royal couple as "hideous and malicious beyond belief or description."

But the court of the new Augustus was not to be devoid of color—it would simply reflect quite different obsessions. Art, jewelry and opera, not porcelain and pretty women, were the passions of the new king and, like his father, he was not afraid to spend money on a grand scale to indulge them. He spent vast sums building up the royal collection of Dutch and Italian paintings, creating what one visitor considered was "by far the finest collection in the north of Europe." His most memorable acquisitions were the Duke of Modena's celebrated collection; sundry masterpieces by Raphael, Rubens and Correggio, for which he paid a princely 500,000 thalers; and the ravishing Sistine Madonna, a masterpiece by Raphael, which alone cost 20,000 thalers. Jewelry was another mania. Augustus spent 200,000 thalers on the only natural green diamond ever discovered—and then had the sparkling forty-one-carat stone mounted to wear on his hat.

Similarly outrageous sums were spent on the less enduring luxury of operatic spectacles. One of his musical extravaganzas cost 100,000 thalers, more money, commented the notoriously parsimonious Prussian king, Frederick William I, than was spent on feeding the entire court of Berlin for a year.

Busy indulging such pleasures, the cares of government were of little interest to Augustus III. He didn't share his father's political ambition to ensure Saxon supremacy in Germany, and the reins of power were handed over as quickly as possible to his favorites— and in particular to Count Heinrich von Brühl.

Porcelain also failed to captivate the new king. It was, he considered, an impressive adornment for gracing the banqueting table or for presenting as royal gifts, but beyond that held little interest. To the new Augustus the factory at Meissen became above all a means of earning revenue to pay for other luxuries and he was quite happy for others to take over its management. So along with the responsibility for running the country, the charge of running the country's most profitable business was speedily transferred to Count Brühl.

Brühl was an improvident politician—his foreign policy quickly cast Saxony into political turmoil—but his artistic tastes in many ways closely echoed those of the late king. He loved expensive clothes and his sartorial finery became legendary throughout Europe. A visitor to his palace recalled that he had "at least 300 different suits of clothes; each of these had a duplicate

as he always changed his clothes after dinner." A painting of each suit, with the particular cane and snuff box belonging to it, was "very accurately drawn in a large book, which was presented to his excellency every morning by his valet de chambre, that he might fix upon the dress in which he wished to appear for the day." Along with a mania for clothes, Brühl was possessed by a passion for porcelain. Once he took over as director of Meissen he saw his way clear to indulge his craving—and the orders for his palace began to pour in.

In deference to the memory of the late king, Augustus III and Brühl resolved that work on the still unfinished Japanese Palace would continue—as long as the factory kept up the production of pieces for sale, and, of course, maintained a steady stream of porcelain to the Brühl Palace.

For the next few years work on the fantasy palace dragged slowly on. Animals continued to be modeled by Kaendler and work also began on another porcelain tour de force—the amazing glockenspiel, a dual-keyboard instrument in a limewood case elaborately carved by Kaendler that played ranks of unglazed white porcelain bells. The finished instrument, assembled in 1737, miraculously survived the bombing of Dresden and today can still be seen in the city's porcelain museum.

But eventually even Augustus's good intentions began to fade and progress drew to a halt. The Japanese Palace was destined to remain an unfinished

porcelain chimera. In the end most of its priceless contents were heaped up in the basement while the building was used as a library. Today this monument to the excesses of Augustus the Strong somewhat incongruously houses a museum of anthropology and prehistory; the chinoiserie-painted walls are whitewashed and kayaks and oceanic outriggers fill the entrance hall. Only the bizarrely curved roof and the chuckling Chinese caryatids remain as a mocking but poignant memento of Augustus's exotic aspirations.

As progress at the Japanese Palace drew to a halt, the commissions for Count Brühl continued to grow. Brühl, it turned out, was a great admirer of the young Kaendler's work and enthusiastically encouraged his artistic development. The sculptor's ascending reputation increasingly rankled with Herold, whose ideas were beginning to look rather old-fashioned. Herold, however, had no intention of relinquishing his grip on design and realized that he needed urgently to reassert his authority, preferably by obstructing Kaendler's progress.

He saw his first chance by interfering in the production of the massive porcelain animals. Despite Stölzel's best efforts to modify the paste, the beasts were still peppered with firing flaws. Kaendler, however, was not too concerned, feeling that the vigor of his modeling more than compensated for such imperfections. Knowing full well that Kaendler intended his figures to remain white, as if carved from alabaster,

Herold ordered his painters to fill the cracks with gypsum paste and paint them in gaudily bright un-fired colors.

Kaendler was outraged. The effect was tasteless and detracted from the figures' delicacy and realism. But his protests were fruitless. Much to his annoyance, Herold, with the help of his allies on the commission, even managed to engineer royal support for his intervention.

The incident marked the beginning of a festering hatred between the two leading figures in the factory. From now on they barely spoke to one another and established entirely separate groups of friends and allies. As the tensions mounted the discrepancies in their treatment of their own staff became increasingly apparent.

Unlike Herold, Kaendler was always happy to encourage his assistants to develop their own ideas and designs and to help them overcome problems as their work became more ambitious. He made sure that all the apprentices, including Herold's, received a proper training in drawing and were helped and encouraged to develop their own styles, even giving drawing lessons in his own home, and offering a prize for the most promising pupil. He was not afraid, as Herold was, to employ well-trained assistants, and several talented modelers blossomed under his direction.

As Kaendler became more and more engrossed in his work new ideas poured out. Nothing was too difficult or too bizarre to be made from porcelain. He shat-

tered the conventions governing the design of tableware and decorative objects, replacing them with a repertoire of incredible novelty. On a visit to the factory showroom you might have seen teapots modeled in the form of monkeys or exotically plumed birds; sugar sifters cast as women astride cockerels; chandeliers like branched trees festooned with exotic birds as richly colored as tropical fruits. Alongside these eye-catching showpiece items there was an abundance of smaller standard objects made for less affluent buyers. A customer wanting a small trinket might purchase a key ring, an eye bath, a walking stick handle, a snuff box, a thimble, a needle case. One could even, if one so desired, buy a Meissen chamber pot.

While Kaendler and his talented team reinvented porcelain, Herold, as he had always feared, was increasingly relegated to the inferior job of ordering his decorators to produce run-of-the-mill items, endless services painted with blue and white patterns, flowers or classical landscapes, or to "color in" Kaendler's magnificently sculpted creations. Painting was no longer at the cutting edge of fashion—it was being replaced by sculpted form, just as Kaendler was replacing Herold as the factory's inspirational figurehead.

The rivalry between the two camps came to a head when Count Brühl ordered a massive dinner service to be designed by Kaendler. The so-called Swan Service he created took nearly four years to complete and is one of the largest ever made. It contained some 2,200 pieces, all of them in some way reflecting the theme of

water. The idea perhaps partly stemmed from the incredible grotto called the Bath of the Nymphs created by the sculptor Permoser at the Zwinger. Permoser's grotto is studded with figures of goddesses, satyrs and fish monsters and garlanded with swags of scallops, cockles, oysters and seaweed. Many of these same ornaments were now refashioned by Kaendler to form dishes for the great table of Count Brühl. Dinner plates were based on a printed design and ribbed with the striations of scallop shells and molded with nesting swans; tureens were crowned with nymphs, writhing dolphins, mermaids and infant tritons. Even the great dome-shaped meat covers suggest a beach at low tide, strewn with jewel-like shells and coral.

Herold's contribution to this massive and prestigious commission was to instruct his painters to do no more than paint the Brühl arms on each piece, to color in the sculpted figures, lightly sprinkle a few flowers here and there and finely gild the borders. For the most part, Kaendler had decreed, his design was so perfect that it needed virtually no paint to enhance it—the surface should be left pure white. Sculpture had won the day.

Feelings between the factory's two factions became even more tense when Kaendler and his supporters decided to make a formal complaint to the commission, pointing out the inefficiencies of Herold's supervision and the patently unfair discrepancies in pay. Modelers received far less than painters, even though their job was now far more important, but Herold had always

argued that this was because painters' eyesight was damaged by the detailed work they did and their working careers were shorter. The factory inspector, Reinhardt, tired of hearing the endless complaints about the arbitrary and unfair way in which Herold ran the factory, sided with Kaendler. Together they produced a list of grievances—presumably in the hope that such massive dissatisfaction would carry weight with the commission and Herold would lose his job. Herold, they said, squandered money and failed to organize the painters properly, and the lack of adequate artistic training was reflected in shoddy work. He was so envious of Kaendler that he had told his workers to run a sponge over the plates from the Swan Service so as to blur their crisply defined details. Even the old story of how Köhler's formulas had been stolen was resurrected as proof of Herold's corruption.

Herold retaliated by accusing Reinhardt of fraud and ordering his immediate arrest. Even though there was no evidence to support his allegations, Reinhardt was left to languish in prison for the next four years. The diversionary tactic had the desired effect: Reinhardt's reliability was called into question; the complaints against Herold were deemed too insubstantial for any concrete action to be taken against him; and Kaendler was reprimanded for his involvement in the whole affair.

But even if Herold's administrative domination was not yet over, artistically, he realized only too well, he had been roundly beaten. No one wanted to return to

the old painted chinoiseries. Kaendler's designs offered too many far more exciting ideas. As long as his rival's imaginative genius eclipsed his own talent, the defeat continued to haunt Herold and he would continue to do everything in his power to retaliate.

# Chapter Two

························································

❧✦❧

## *The Porcelain Soldiers*

*By slumbering and sluggarding, over their money-tills and flesh-pots; trying to take evil for good, and to say, "it will do," when it will not do, respectable Nations come at last to be governed by Brühls. . . . The gods are wiser!—It is now the 13th; Old Dessauer [Prince Leopold I] tramping forward, hour by hour, towards Dresden and some field of Fate.*

THOMAS CARLYLE, *The History of Frederick the Great,* 1865

*O*n the morning of July 20, 1736, as the Albrechtsburg's sentinel sounded the morning post, the duty guards stationed on the castle's gate were bewildered to hear the sound of marching footsteps drawing close. Minutes later the large courtyard in front of the factory

was filled by a body of soldiers in full regalia led by a Lieutenant Pupelle. His detachment, he explained self-importantly, had been drafted in to relieve the contingent of guards who had provided security for the castle for the past decades. The old guards were largely made up of invalided soldiers and had become, in the eyes of the commission, something of a token deterrent. In contrast, Pupelle's men, a highly trained regiment accustomed to active service, presented a far more intimidating appearance. They would, it was hoped, make anyone contemplating a breach of the factory's security measures think twice.

Over the weeks that followed Pupelle emerged as a far from sympathetic character who clearly enjoyed exploiting his authority to the full. Under his direction the new guardsmen quickly introduced a baffling list of regulations and enforced them so stringently that an atmosphere of fear and resentment descended on all those who worked at the factory.

Anyone who infringed a rule, no matter how trivial, was now routinely arrested and might be left to languish in prison for weeks. There was little apparent rationale behind many of the directives. Overtime, a necessity for many workers to supplement their meager wages, was strictly banned. Those caught working extra hours could expect the guards to snuff out their candles as they worked, and were thrown into jail. Outsiders, even good customers and royal courtiers, were treated like potential spies. In the old days the guards had escorted visitors to the door of the

rooms they were permitted to visit—usually the main showroom on the first floor—and waited discreetly outside until they were called to escort the visitor out again. Now they hovered malevolently over visitors even when they were in the presence of members of Meissen staff, never leaving the room. It was all highly intrusive—and more to the point, bad for business. But, argued the commission, as the factory grew, so too did the danger to the arcanum, and the only way to keep it safe was by taking even more rigorous precautions.

As matters turned out, however tyrannical Pupelle and his soldiers were, they were still not infallible. Those determined enough found ways to evade their control.

Eleven weeks after the arrival of Pupelle and his men, on the morning of October 7, 1736, the lieutenant had the unpleasant task of informing court commissioner Herold of a devastating piece of news. Adam von Löwenfinck, one of the ablest of Herold's painters, had apparently failed to report for work. Inquiries revealed that he had disappeared from his lodgings, and a horse belonging to a baker who lived nearby had also gone missing. The conclusion was inevitable—Löwenfinck had defected from Meissen.

Herold must immediately have realized that this was a potentially ruinous development. Adam von Löwenfinck was one of the few painters whose talents had blossomed despite his own erratic supervision of the decorating department. The young man had

learned all he knew under Herold, having joined him as a boy of thirteen, nine years earlier. But the question that must have been uppermost in Herold's mind when he heard the news was this: had Löwenfinck, in the process of acquiring such mastery, also gained knowledge of the arcanum?

Adam von Löwenfinck was the eldest of three brothers whose father, a soldier, had met an untimely death in one of Augustus the Strong's many ill-advised battles. Adam's widowed mother was forced to take work on a large estate near Meissen in order to provide for her sons until they were of an age to find employment. A sympathetic neighbor, who happened to be chairman of the Meissen commission, noticed the widow Löwenfinck's bright young boys and, hearing that she was looking for suitable careers for them, suggested that the porcelain factory might serve the purpose.

With this powerful introduction, but no proven talent, Adam was the first of the Löwenfinck brothers to be employed as an apprentice in Herold's studio. The two younger brothers later followed his lead. He was trained at first as a painter of underglaze blue decorations and by 1734, at the age of twenty, had displayed such outstanding skill that even Herold was impressed and let him try his hand at designing models for new porcelain wares.

Adam's skill emerged hand in hand with a hot-headed artistic temperament. As he rose through the Meissen ranks he became as famous for his aloof and

often abrasive manner as for his exquisitely painted Japanese subjects and weird imaginative beasts. He quarreled incessantly with fellow workers and was frequently reported to Herold over matters relating to workshop discipline. Money was a frequent bone of contention. Even after years of training Herold still paid him what Löwenfinck considered a paltry amount considering his obvious abilities.

Perhaps because he was trying to help his mother or support his two younger brothers Löwenfinck made the fatal mistake of borrowing money to make ends meet, believing, presumably, that it could not be long before Herold began to appreciate his talents properly and gave him an increase in salary. Herold, however, continued to behave with his customary meanness.

By 1736 the debts had mounted alarmingly and workshop differences had become insupportable. Failure to pay debts was an offense punishable by lengthy imprisonment, particularly now that Pupelle and his henchmen were in control, and Löwenfinck knew that with these new guards he stood little chance of talking his way out of trouble.

On October 6, believing that arrest must be imminent, he left his Meissen lodgings under cover of darkness. Somehow managing to evade the guards patrolling the town, he stole a horse from the stable of the unsuspecting baker and rode out of the city. He made his way to the ceramic center of Bayreuth, where before long he found a job as a decorator of faience pottery. It was not such prestigious work as being a deco-

rator at Meissen, but the working conditions were more congenial.

Although hot-tempered, Löwenfinck was certainly not unprincipled. Soon after he had settled in Bayreuth he wrote a revealing letter to the commission. In it he tried to explain the reasons for his actions and promised to repay his debts—a pledge he worked hard to honor and eventually fulfilled. His grievances nearly all relate to the way in which Herold treated his staff: that people with no aptitude, training or ambition were hired and promoted over those with real talent; that the limited subjects that artists were trained to paint made work unstimulating and discouraged the development of talent; and that payment was so arbitrary.

Hearing that the renegade Löwenfinck was daring to criticize his direction, Herold's mood of disbelief gave way to frenzied rage. It was essential that he should be memorably punished for such an act of defiance—as a lesson to others not to try anything similar. Officers of Pupelle's guard were speedily dispatched with orders to arrest him and bring him back to Meissen to face trial for desertion.

It was a dramatic but futile gesture. Before the guards were able to track him down, Löwenfinck heard rumors of the approaching danger and fled once again, this time farther south to Ansbach, where he again took up the offer to work as a decorator in a faience factory. The rest of his life was spent constantly on the run, to remain beyond Herold's reach, and to reap the rewards of his hard-earned expertise. Long after the

guards had given up the chase and returned to the Albrechtsburg, spies were still paid to keep a watch on his progress through the ceramic centers of central Europe. No one quite knew what the repercussions of his defection would be, and Herold lived in constant dread that he would prove himself able to make porcelain. For the next twelve years informants were still reporting back on his every venture.

In 1741 Löwenfinck was in Fulda, in the Hesse-Nassau province of Prussia, where he was joined by his brother Karl. Here his decision to abscond must have seemed finally vindicated when he was appointed to the important position of court painter. Five years later Herold's nightmare seemed about to come true when Löwenfinck moved to Höchst, having convinced the investors there that he knew the secret of the arcanum and could make porcelain as well as decorate it. At last feeling relatively secure and prosperous, he married. His wife was Maria Seraphia, the daughter of a porcelain painter and herself a decorator of great skill.

Like so many others, however, Löwenfinck underestimated the complexities of porcelain-making and was unable to deliver on his promises. In 1749, after an argument with the investors, he and his wife were on the move again. This final journey was to Strasbourg, where he stayed until his premature death in 1754 at the age of forty.

Back at Meissen, meanwhile, overzealous guards, draconian punishments and the stringent supervision of

outsiders could provide no defense against the larger dangers of mounting political unrest. As the new decade of the 1740s dawned, it was to be Prussia, the country that had brought Böttger to Saxony and set in motion the events that had led to the discovery of the porcelain arcanum, that now also threatened its safety most seriously.

The year 1740 had seen momentous changes in the delicate balance of European power. The Holy Roman Emperor Charles VI of Austria, who presided over the tapestry of independent German states, had died, to be succeeded, in the absence of any male heir, by his daughter, the Empress Maria Theresa. In the same year the ruler of one of the most powerful of these German states, Frederick William of Prussia (1688–1740), had also died and the mantle of power had fallen on his highly intelligent and rapaciously ambitious son, Frederick II, later to be known as Frederick the Great. From the outset Maria Theresa's accession to the Hapsburg territories was plagued by controversy, and her claim was challenged by a clutch of formidable opponents, including Frederick of Prussia and the Elector of Bavaria, not to mention the kings of Spain and Sardinia.

Of these adversaries by far the most threatening was Frederick. His father, known as the soldier king and "drill master of the Prussian nation," had expanded Prussia's professional army to 83,000 men, tailored his realm into a spartan militaristic state and brought his son up under a similarly stern regimen.

It was, of course, an approach to rulership in stark contrast with the excesses of the Saxon court, which the young Frederick had visited for a month, while a sixteen-year-old prince, in 1728. Dresden had come as a complete revelation to the austerely raised yet nonetheless artistic, sensual and romantically naive prince. He had mingled with Augustus the Strong's court beauties, and fallen prey to the seductive charms of at least two of them.

The first object of his affections was the stunning Countess Anna Orzelska, an ebony-haired beauty with a penchant for dressing up in men's riding clothes. Unfortunately for Frederick, Anna, though one of Augustus's many illegitimate daughters (by a French milliner), was also at the time his favorite mistress. Incest seems to have presented no moral dilemma at the hedonistic Saxon court; quite the reverse, for Augustus had been "presented" with his daughter by one of his illegitimate sons, Count Fredrich Rutowsky, who had also been her lover. The countess, however, appeared to prefer sharing her bed with the languid young Frederick of Prussia rather than with her rotten-toothed, gout-ridden, aged father, and Augustus, noticing the swing in her affections, became jealous. Rather than provoke a diplomatic incident he arranged that the prince be seduced one night after dinner by another specially provided beauty, a dusky opera singer named Formera, who was carried into his room tantalizingly reclining on a couch, totally naked.

Such decadence was to have unforeseen and unfor-

tunate repercussions. On his return to Berlin, Frederick's health, always frail, began to deteriorate. According to several biographers, he had caught "an attack of [a] dangerous, insidious disease," presumably a venereal infection. Whatever the true nature of the malady, it was to be many months before he was fully restored to health.

When, twelve years later, Frederick acceded to Prussia's throne, the elusive charms of Anna and her riding crop were long gone from his thoughts. Personal power and a strengthening of Prussia's position in the hierarchy of Europe were uppermost in his mind. Under his rule the already vast Prussian army was to more than double to 192,000—some 4 percent of the total Prussian population, at a cost of two thirds of the state revenue. But apart from his obsession with military strength Frederick was also conscious that his kingdom lagged behind Saxony and France in industrial production, which was needed to generate revenue for the royal purse—and to pay for its military might.

Along with the excitement of his first sexual liaisons, Frederick's visit to Saxony had also given him ample opportunity to become enthralled by porcelain, which he noticed everywhere splendidly decorating Augustus's royal palaces. Prussia's main industries were silk weaving and wool, but if Frederick were to make his kingdom not only the most powerful but also the most glorious in Europe a porcelain manufactory of his own would be essential.

Frederick rarely failed to grasp at opportunity when

it presented itself; "man is made to act" was to become one of the underlying tenets of his life. The death of the Austrian emperor and the question mark that loomed over his daughter's right to the throne gave Frederick the chance he had been waiting for to increase his territories. In the year of his accession he marched his vast and splendidly trained army into Silesia, the most fertile and abundant in natural resources of all Austria's lands. This act of unmitigated aggression marked the start of the Silesian Wars, which were to rage on and off for nearly twenty-five years.

In Dresden, meanwhile, the Saxon hold over Poland had become increasingly tenuous since the death of Augustus the Strong, who had died without managing to establish Saxony's hereditary right to the Polish crown. Stanislas Lesczynski, the father-in-law of Louis XV of France, had won the election to the throne and Augustus had only managed to regain his Polish territory through the support of Russia and Austria.

Brühl now persuaded Augustus that his hold over Poland would be more secure if Saxony could forge a land link with Poland—at present Prussian and Austrian dominions separated Saxony from the Polish kingdom. So when Frederick marched on Silesia, Augustus, rather than siding with Austria, to which he was bound by treaty, joined Prussia, along with Bavaria and France, in the hope that by so doing he would make territorial gain.

Frederick emerged victorious. His opportunistic war culminated in the Peace of Breslau, in which Aus-

tria was forced out of Silesia by Prussia. Charles Albert of Bavaria also prospered from the conflict, usurping the Austrian empress and having himself elected as Emperor Charles VII in her stead. Augustus, however, despite the vast sums expended and the backing he had given Frederick, reaped no rewards whatsoever.

Disgruntled at this humiliating failure, he made an abrupt about-face in his allegiance. Again following imprudent guidance from Brühl, he allied his kingdom with Austrian interests. A year later simmering tensions again yielded to open hostility. This time, Frederick, furious at Brühl's political vacillations, marched an army of sixty thousand Prussian troops southward into Saxony.

By August 19, 1744, Frederick's columns of soldiers were making serious incursions into the Saxon heartland. Saxon defenses were easily weakened to the point where Frederick, taking time off from the battlefield, was able to enter Meissen unopposed to visit the factory that he had long yearned to possess, and now planned to move in its entirety to Berlin. For virtually the first time in its existence, the Saxon guards found themselves powerless to resist an interloper. Frederick inspected the innermost sanctums of the factory. With the vast Prussian army camped within easy reach of the town's outskirts, no one dared stop him.

During the months that followed, Frederick's fortunes faltered when Bohemia, an ally of Saxony, forced his invading forces to retreat to Silesia. Undeterred, Frederick retaliated, and eventually triumphed over

the allied armies that opposed him. By 1745 he was again storming Saxon territory, and, while the situation on the battlefields deteriorated, the Meissen administrators were forced to acknowledge that Frederick had almost certainly set his inexorable sights on the town of Meissen as a strategic base from which to attack Dresden as well as a lucrative war trophy. By November 1745 the news reaching the Meissen commissioners had worsened still further—every report from the battlefield agreed that the Prussian invasion of Meissen was now imminent.

As the gravity of the impending situation struck home, orders were given to take the most drastic steps imaginable to prevent the secret of porcelain falling into enemy hands. The enameling kilns were to be destroyed, the grinding machines taken apart, and all the paste and compounded enamels concealed.

With all possible speed these instructions were carried out. The workers were sent home on full pay and production ground to a standstill. Meanwhile key members of the staff—the kiln workers, compounders and arcanists, among them Kaendler and Herold, who were deemed most vulnerable to Frederick's interest in porcelain—were moved to Dresden for safekeeping. Only a handful of officials remained in the castle to guard the stock and to wait in terror for the Prussians to arrive.

The precautions came not a moment too soon. Five days later, on December 12, a spearhead detachment of Prussians arrived bristling with weapons at the

Meissen bridge over the Elbe. There was nothing the helpless inhabitants could do to defend themselves. After the town's official surrender a solitary envoy and a guardsman were dispatched up the hill to officially take possession of the factory on behalf of the Prussian king. As dusk fell forty thousand troops flooded up the narrow Meissen streets, a large contingent swarming through the factory gates. Thirty guards were posted outside the storeroom and strict royal orders were given that there was to be no indiscriminate looting; the porcelain was to be saved for the king, or for authorized gifts to key military personnel.

Frederick himself set up headquarters in the town, taking up residence in the house of the town chamberlain, von Hachenberg. His stay gave him ample opportunity to examine the factory more closely, and though he must have been disappointed to find that production had stopped, this did not prevent him from trying to lure as many workers as he could to Berlin.

Three days later, on an exposed and swampy plain six miles southwest of Dresden, in piercingly cold conditions, the Saxon army's final annihilation took place at the battle of Kesseldorf. Ironically, among those opposing the Saxon soldiers on the battlefield were the porcelain soldiers—the regiment of dragoons that Augustus the Strong had so rashly traded with Frederick's father in return for the exquisite collection of Kangxi porcelain for his Japanese Palace.

Frederick's army came close to defeat, his first assault incurring huge losses. He emerged victorious late

in the day, when the Saxons' attack blocked their own artillery and exposed them to Frederick's still lethal army. The casualties on both sides were heavy. Some 1,700 Prussians were killed and 3,000 wounded, while on the Saxon side 3,800 were killed and wounded. The scene after the battle was one of utter devastation. The frozen ground was covered with trampled snow, and burying the bodies proved impossible. Many of the seriously wounded were taken to the Albrechtsburg, which was requisitioned as a military hospital. A stream of casualties was transported to the castle loaded on rough wooden carts. Harrowing cries reverberated through the vaulted halls as surgeons amputated shattered limbs with no anesthetics and only the most primitive of medical equipment.

In the battle's chaotic aftermath, the normally stringent guard on the stockroom was momentarily breached. A cluster of disaffected, battle-weary Prussian soldiers, finding their way to the stores and refusing to turn back empty-handed, took up arms against the guards at the door and managed to loot or destroy much of its valuable contents.

Fortunately, however, under orders from Frederick, Prussian officials had already set about examining, listing and packing the booty in the factory stockroom. Even before the battle's outcome was known, choice pieces had been commandeered by Frederick, who, desperately short of revenue to fund his army, fully realized the money they would bring. Plates, dishes, cups and vessels in a gratifyingly large range of designs were dis-

covered. There were wares decorated with landscape vignettes, others with molded decorations as well as a plethora of Kaendler's figures, animals and birds. The porcelain had begun to be carefully packed in wooden cases padded with wool, hay, moss and dried thistle flowers. The train of ox carts laden with porcelain began the long journey back to the palaces of Prussia in icy conditions on December 22.

Two days before the consignment was ready to leave, Frederick revealed his satisfaction at this prize, writing to his chamberlain in Berlin: "I send you six or eight carriages with porcelain addressed to you. Find out when they will arrive in the Garden Dresner Strasse with an escort of four *Jaegers;* and to avoid publicity, have them unloaded in Charlottenburg, but do not unpack before I come."

In all, Frederick was able to help himself to fifty-two cases of Meissen's finest wares. About half the acquisitions were destined for his own use; the rest were sold and raised a considerable sum. The porcelain that was left remained locked and guarded in the stockroom at Meissen, and one by one the pieces were distributed as gifts to Frederick's battle heroes.

To the vanquished citizens of Meissen it must have seemed that their porcelain factory was lost forever; all its past achievements had been obliterated along with the Saxon army.

Most poignant of all was the fact that the battle itself need never have been fought. On the very day it

took place, Frederick, in his headquarters at Meissen, received word from Prague that Augustus and the Austrian court were at last ready to agree to peace. All sides had finally been forced to face up to the fact that their countries had been nearly bankrupted by the prolonged conflict.

Eager to restore his kingdom's fortunes, Frederick accepted Austria's offer to cede the Silesian territories to Prussia, and Augustus's payment of one million crowns besides the porcelain that had already been seized as an eternal reminder of "the fragility of human fortunes." On Christmas Day, 1745, the Peace of Dresden was signed.

Frederick's hopes to possess the Meissen factory or to move it to Berlin had been temporarily suspended. But they were far from forgotten.

# Chapter Three

........................................

❧

## *Visions of Life*

*. . . jellies, biscuits, sugar-plumbs, and creams have long given way to harlequins, gondoliers, Turks, Chinese and shepherdesses of Saxon china. . . . By degrees whole meadows of cattle of the same brittle materials, spread themselves over the whole table; cottages rose in sugar, and temples in barley sugar; pygmy Neptunes in cars of cockle-shells triumphed over oceans of looking-glass or seas of silver tissue and at length the whole system of Ovid's metamorphosis succeeded to all the transformations. . . .*

HORACE WALPOLE, 1753

*P*icture the scene. Sir Charles Hanbury Williams, British ambassador to the court of Saxony, was at-

tending a banquet at Prime Minister Brühl's residence in Dresden in 1748. Arriving at the palace, one of the most richly furnished in the city, he was ushered into a vast mirrored hall. In its center, long tables draped in floor-length damask were ranged to form an open oblong around three sides of the room. Along their furthest sides were seated the invited guests: 206 dignitaries and members of the court, all clad in their most splendid finery.

The gentlemen of the court were dressed in velvet and brocade trimmed with gold and silver embroidery and gem-studded buttons. The ladies' costumes echoed French fashions, with tight-fitting jeweled bodices and plunging décolletage edged in gold and silver lace and strewn with silken flowers and ribbons. Copious brocaded skirts overflowed the chairs on which they sat, falling in billowing swags to the floor, and long trains, decorously arranged by their footmen, formed elegant cascades over the backs of their seats. The effect was completed by gravity-defying coiffures, liberally sprinkled with jewels, feathers and flowers, and by faces and breasts powdered white and strategically anointed with beauty spots and rouge.

Splendid though the effect of such concentrated magnificence undoubtedly was, Sir Charles's eye was riveted not by the garb of his fellow guests but by the quite incredible arrangement on the table at which they sat. "I thought it was the most wonderful thing I ever beheld. I fancy'd myself either in a garden or at an Opera, but I could not imagine that I was at dinner,"

he later wrote, still awestruck, to a friend in England. "In the middle of the Table was the Fountain of the Piazza Navona at Rome, at least eight foot high, which ran all the while with Rose-water, and 'tis said that Piece alone cost six thousand Dollars."

The table decorations that so bewitched Sir Charles stood out, not just because they were so staggeringly elaborate, but because they were all made from Meissen porcelain. These extraordinarily elaborate confections were to bring Johann Joachim Kaendler and the Meissen factory for which he worked worldwide fame—and their greatest success of all time.

Taking their seats at the fountain-adorned banquet, Brühl's privileged guests were comforted by the knowledge that war with Prussia now seemed little more than a memory, and that peace had ruled in Saxony for two years. During that time industry had prospered and revenue was once again flooding in to fill the royal coffers.

At Meissen, political stability had brought about a period of similar progress and productivity. As soon as the last column of Prussian troops had finally withdrawn and begun the long march back to Berlin, the Albrechtsburg had hastened to resume production. By January 1746, Kaendler and Herold had returned from their safe havens in Dresden to take up the reins of direction. The kilns were quickly rebuilt, the machinery reassembled, caches of porcelain paste and enamels re-

covered from their secret hiding places and, at considerable cost, vast quantities of pillaged firewood replaced.

Everything now seemed to return to normal. On the one hand Kaendler was able to reascend to his former imaginative heights. On the other Herold's obsession with status, indifference to his assistants and animosity to the modelers remained as unbending as ever. But the ongoing rivalry between the two seems to have done nothing to damage progress, as Sir Charles's comments testify. Kaendler was now at his most prolific, producing an astonishing range of designs to fuel the latest porcelain trend: the passion for Dresden figures.

The idea for porcelain fountains and the world-famous figurines came about as a direct result of the Saxon court's love of banqueting. Grand formal dinners like the one that Sir Charles attended were a regular feature of court life when the king was in residence in Dresden. To outsiders unaccustomed to the routine, these events must have seemed more like ordeals of endurance than bacchanalian entertainments; for a banquet might well last from midday until nine in the evening and dinners lasting four or five hours were commonplace. Travelers to the court were left utterly exhausted and baffled by it all. "The Germans drink and eat practically anything with pleasure. Their main object is to swallow instead of to taste," wrote Montesquieu with obvious disdain, while

J. B. S. Morrit, an English visitor, echoed his disapproval, describing a dinner that he attended at court as "a pretty awful ceremony . . . a great beastly party when you have nothing to say."

During the protracted feasting countless toasts would be drunk, and dishes were served with agonizing slowness. By the time a guest was able to eat a mouthful almost inevitably all the food was stone cold. No wonder then that novelties were needed to amuse and distract the assembled company between courses, if for no other reason than to stop them from falling asleep at the table.

Invariably a musical entertainment—perhaps an operatic performance, an orchestral recital or a display of dance—took place during banquets and its theme was often echoed in the ornaments on the table. Interspersed between the candelabra, you would see centerpieces in the form of miniature architectural models. At first these diminutive castles, temples, fountains and grottoes were sculpted from sugar, marzipan or wax by the court confectioner—one of the most eminent of the innumerable members of the staff who worked in the court kitchens. As the fashion took hold, whole landscapes and increasingly complex architectural structures were fabricated and the settings were populated by delicately modeled figurines.

As for some extraordinarily ambitious soufflé, realism and fantasy were whipped together in the apparently boundless imagination of the confectioners,

giving rise to intricate panoramas and vistas. Icing sugar buildings mimicked those of classical antiquity; some were lit internally with flickering candles, others discharged a display of fireworks to create a suitably memorable grand finale during dessert; and then there were the fountainlike concoctions filled with perfumed water that trickled artfully down the length of tables bordered with exquisitely modeled figures of gods or goddesses.

Though beautiful and imaginative, these miniature make-believes were ephemeral masterpieces, whose only purpose was to amuse for a few short hours before being swept away with the detritus of the table. The enterprising Kaendler, noting the vogue for such fripperies, realized that porcelain decorations would outlive a single function and therefore appeal to a far greater audience.

So, from around 1735, a cast of over a thousand porcelain figures, together with the appropriate architectural settings, was produced to adorn the tables of the privileged. Most of the subjects Kaendler dreamed up were based on the life that surrounded him, and in their astonishing variety they open a window onto the rarefied world of the Dresden court. He presents us with its star opera singers, its actors and actresses clad in the costumes of the *commedia dell'arte*. He shows us the favorite jesters of Augustus's court; the street sellers of Paris; exotic travelers from the Far East; idealized rustics—the shepherdesses of Dresden with which the city has ever since been associated.

Above all, he introduces the elegantly clad inhabitants of the city of Dresden.

Among them he unveils Count Brühl's pushy and well-patronized tailor, astride a bucking goat. Some believe that this figure was made because the count, in a moment of weakness and gratitude for some exquisitely embroidered piece of tailoring, promised to reward the man with any gift he chose to name. The impertinent tailor responded audaciously by asking Brühl to invite him to one of the king's court banquets—an unheard-of demand for someone of his lowly station. Tongue-in-cheek, Brühl promised to see what he could do, and then commissioned Kaendler to model the tailor in porcelain. Hearing of his foolish aspirations, Kaendler poked fun at him by dressing the figure in the costume of a grand aristocrat, but surrounding him with the humble tools of his trade and placing him incongruously astride a goat. Goats were considered the cattle of the poor, and there were various disparaging tales of relationships between goats and tailors in medieval folklore.

Placed upon the table in front of the king at a royal banquet, the completed figure caused riotous mirth among all those who understood its significance. The tailor had been present at a royal banquet—but not in the manner he had anticipated. Kaendler was so pleased at its reception that he made a second smaller version, and also modeled the tailor's wife.

Dressing up and role-playing were also royal diversions that Kaendler ingeniously mirrored. Since me-

dieval times there had been a tradition in Germany for *Wirtschaften*—day-long fetes when the king might don the clothes of a farmer and members of his court would dress up in albeit idealized versions of peasants' costumes. Each participant in the fete would assume a different character or profession and, in order to avoid duplication, roles were decided by drawing lots. So a grand countess might don the costume of a shepherdess, an ambassador deck himself in the robes of a peddler, while a privy councillor might assume the guise of a humble gardener. All these players Kaendler portrayed in porcelain, and one can imagine how a dinner table populated with diminutive fruit sellers, tinkers, gardeners and drunken peasants arranged around picturesque cottages and farm buildings would have amused the luxury-jaded courtiers who had recently dressed and made merry in such rustic garb.

Hunting was another passion of the Saxon court frequently interpreted by Kaendler. A highly exclusive occupation, in which only the king and his retinue were allowed to participate, hunting was as emblematic of royal privilege as an invitation to dine at court or to join the king in one of his rural fetes. Farmers whose lives depended on their crops were forbidden to protect them from marauding wild animals, no matter what damage they perpetrated. Killing an animal without royal consent was considered poaching and punishable by death. Jonas Hanway, a visitor to Saxony in the middle of the cen-

tury, recalled how "The wild boars are so great a nuisance to the country, that the Saxons would gladly compound to support a body of 8,000 soldiers extraordinary on condition that those animals should be reduced to half their present number. In every town of any note there are fifty of the inhabitants who watch, five every night, by rotation, and use belles to frighten the deer, and defend their corn from the incursions of this formidable enemy."

But despite frequent complaints by the local farmers and the outrage of occasional visitors such as Hanway, hunting remained an exclusively royal pastime for many decades to come. Meanwhile Kaendler's figures of virile huntsmen and their luckless quarry enjoyed enormous acclaim as potent reminders of the thrill of the chase and souvenirs of social status.

Most revealing of all Kaendler's figures were the so-called crinoline groups, which, like three-dimensional photographs, provide a snapshot of the intrigues, flirtations and fashions of court life. They represent court beauties of a type Augustus the Strong would have found irresistible, laden with movement and replete with imaginary confidences. As one gazes at these intimate creations one longs to know what exactly has led up to the moment that Kaendler has so evocatively frozen in time, and what will happen next.

Intriguingly, Kaendler often uses porcelain itself as a prop within these groups. As in a picture within a picture he shows us a gallant with his lady love, she

holding a painted porcelain beaker of chocolate to his lips in a gesture filled with seductive familiarity. Often these figures were inspired by the paintings of Watteau, but they have been embroidered with extra romantic meaning. Many are said to show Augustus the Strong and one or other of his mistresses. In one he offers a lady (perhaps the unfortunate Countess of Cozelle) a heart-shaped box, while she mirrors his affection by holding a heart to him.

Kaendler's detailed knowledge of court life is also implicit in the numerous figure groups in which a pug dog also features. This endearing creature was much more than just a charming pet. Those familiar with the intrigues of the day would have been well aware that they obliquely referred to the "Order of the Pug Dogs" or "Mopsorden," a fashionable and frivolous offshoot of the order of Freemasons of which the electors of Saxony were grand masters.

But the beauty of Kaendler's figures lay in the fact that one did not need to understand their significance to enjoy them. Their endless variety, their color and their movement were captivating enough to attract an ever-increasing circle of international collectors. One might not be able to afford the entire cast of the *commedia dell'arte* or a complete set of Parisian street sellers, but even a pair of figures invested their owners' homes with a certain refinement, and at every level among well-to-do society the fashion for collecting them grew.

In the wealthiest royal quarters the sums spent on such luxuries could reach phenomenal proportions. Sir Charles Hanbury Williams boasted to his relative Henry Fox that he had already been presented by the king with a "set of china for a table of thirty covers, which would have cost here fifteen hundred pounds." The service, said Sir Charles proudly, contained, apart from 350 pieces of tableware, 166 figures "to adorn the middle of the dessert." This expenditure seems outrageously high, bearing in mind that in China one would have been able to buy ten thousand blue and white porcelain plates for a little over £100.

Perhaps Augustus would have thought twice about offering such a generous gift had he known that Sir Charles was a bosom friend of Sir Everard Fawkener, a key investor in the newly formed Chelsea soft paste porcelain factory. Soon after he had been dazzled by the dinner at Count Brühl's, Sir Charles lent many of his own Meissen porcelains to the modelers at Chelsea. They took molds from them and began to make extremely accurate copies in soft paste porcelain.

Chelsea figures might have lacked the perfection of Meissen, but in porcelain-hungry Britain, as elsewhere, there was a ready audience for such novelties, even if they were of less sophisticated quality. Chelsea was only one among a number of British and European ceramic manufactories that made a handsome living from peddling pirated versions of Kaendler's ideas. Soon even humble cottage potters in Stafford-

shire were producing their own simplified earthen-
ware versions of Dresden courtiers and shepherdesses
for an audience even further removed from the so-
phistication of the king's table than Count Brühl's
unfortunate tailor.

# Chapter Four

........................................

❧

## *The Final Defeat*

*I wish the Empress, the King of Poland, Count
Harach, and Count Brühl could better conceal
their Enmity to his Prussian Majesty. . . . It
cannot long remain secret, and may at last give
Jealousies very prejudicial to the Affairs of Europe,
but particularly to the Austrian and Saxon do-
minions.*

Report by THOMAS VILLIERS, January 1756

*E*ven if superficially everything appeared to be the
same, Meissen had been changed by its Prussian expe-
rience. Long after the last bloodstains had been
cleansed, the walls whitewashed and the tiled floors
scrubbed clean, an atmosphere of unrest lingered in
the vaulted halls of the Albrechtsburg.

It was only in the aftermath of Prussia's retreat that several key factory workers were found to have been enlisted into the Prussian army or compelled to move to Berlin to help Frederick realize his porcelain ambitions. Others, spurred by greed, necessity and despair, and above all by indifference to the loyalty demanded by Meissen's coldhearted director, Herold, had used the opportunity offered by the chaotic conditions of the time to abscond and find employment elsewhere.

Frederick the Great was not alone in craving a porcelain factory. Princelings and entrepreneurs all over Europe wanted factories of their own more urgently than ever, with the result that in the town of Meissen there was a seemingly endless stream of outsiders with more than a casual interest in what went on in the fortress up the hill.

In the aftermath of the war salaries rose with production, but the increases were not enough to stop a number of poorly paid Meissen workers from choosing to boost their incomes further by passing on a few tips about how the paste was compounded, the glaze made or the porcelain fired. The information they gave was often vague and inaccurate—but this scarcely seems to have mattered. There were many who were willing to part with quantities of gold or silver in return for inside information, no matter how dubious its origins.

Everyone in the upper echelons of the factory knew that the arcanum could not remain inviolate in the face of such threats forever. But despite the pervasive unease, work in the modeling rooms progressed unremit-

tingly. As if defying others to match him, Kaendler made ever more massive and breathtaking architectural centerpieces, some so huge that a grown man could have sat in them. As emblems of wealth and dynastic power their message was clear: the larger the centerpiece, the more significant the dining table, the more potent its owner.

For Augustus III, Kaendler produced a porcelain temple of honor nearly four meters high containing 127 individual pieces. The stunning effect of the now lost original can still be appreciated from a later version at the Meissen factory museum. It completely dwarfs the modest table on which it loftily towers.

Such grandiose objects also made startlingly impressive dynastic gifts and several were graciously bestowed by the king—visible proof, if proof were needed, of Saxony's reestablished ceramic preeminence. The marriage of the Dauphin of France to Augustus's daughter Maria Josepha was marked by the gift of a porcelain console table and a vast oval porcelain mirror, over three meters high, made by Kaendler. The mirror's frame was festooned with figures of Apollo, classical muses, garlands of flowers and shells. Such was the prestige and importance of the object that Kaendler was privileged to be allowed to leave Saxony—his only trip abroad—to deliver the mirror personally to the French court in 1750.

Kaendler was dazzled by Paris and Versailles. He noted, perhaps with some trepidation, that the royal French porcelain manufactory of Vincennes, though

still making only soft paste porcelain and deriving its designs largely from Meissen's, was now beginning to break new ground. Nonetheless he must have quickly assured himself that French porcelain was still only made in very limited quantities and could not yet hope to match Meissen's domination of the European market.

Having installed his mirror and table in the dauphin's palace, Kaendler returned to Dresden feeling secure in the knowledge that his creations would remain there forever as testimony to the un-challengeable superiority of Meissen porcelain over that of France. Both these assumptions were soon to be proved hopelessly wrong. As archetypal emblems of royal privilege and excess the mirror and table were to be smashed to annihilation by revolutionaries. Saxony's porcelain supremacy was to suffer a similar fate.

Left behind to watch over the factory, Herold could hardly fail to realize that he was more sidelined than ever by Kaendler's virtuoso genius. But even a porce-lain maestro may eventually overstretch himself, and in the case of Kaendler the setback was to be as mon-umental as the masterpieces he strove to create.

Kaendler had set his heart on making the largest figure from porcelain the world has ever known: a giant equestrian statue of the king that would measure in its final form an incredible nine meters or more high.

The idea had begun in 1731 when he had been summoned to sketch Augustus the Strong on horseback. Three years later, on the accession of the new monarch, Kaendler heard that a new life-sized gilded copper equestrian statue of the king had recently been commissioned and the notion of a large porcelain statue of Augustus III began to dawn. The copper figure was impressive but, proposed Kaendler, why not also mark the new king's accession with a porcelain version? It would be a far more spectacular and appropriate way in which to glorify the king of the porcelain capital of the world.

Immersed in buying jewels and fine paintings for his burgeoning royal collection, the king remained ambivalent and Herold was not slow to take advantage of his indecision. Such a figure was far larger than anything even Kaendler had attempted so far—it must be impossible to make. Furthermore, he whispered convincingly, there was no room at the castle for such a bulky object to be stored. To Augustus, always easily swayed by his advisors, such a risky and contentious scheme suddenly seemed pointless. Despite Kaendler's protestations and reassurances, he adamantly declined to commission it.

But Kaendler's dream monument refused to die. With the persistence for which he was already famed, he continued to carry out his usual day-to-day duties, but in secret sketched innumerable designs for the massive figure. The fervor continued while he was in hiding during Frederick the Great's occupation of

Meissen. He started work on a clay model for the porcelain statue, paying for the materials and the help of an assistant from his own pocket, and at the same time incessantly pestering Count Brühl to persuade the king to change his mind.

To start with, even the count's recommendations failed to break the king's resolve. Augustus was still stubbornly unconvinced that such a grandiose scheme was either worthwhile or technically viable. Finally, in 1751, the pressure paid off; the king relented and Kaendler was at last officially commissioned to proceed on the project and paid 15,000 thalers for the cost of making a small and a large version of the figure.

Even then Herold raised objections. But with royal backing Kaendler now had the upper hand. New space was rented in the cathedral courtyard and a wooden shed specially constructed. Kaendler would work with numerous assistants, all of whom he would house and feed in his nearby home in the square.

Over the next two years the final design took shape. There would be a rock-framed base, around which a vast procession of figures symbolizing justice, peace, the arts and sciences and the rivers Elbe and Vistula would gesture theatrically upward—leading the eye to the majestic figure of the king astride his rearing Lipizzaner.

Almost as soon as the design was approved the small version was successfully fired—it remains one of the most spectacular exhibits in the Dresden porcelain museum to this day. The molds for the final large ver-

sion, Kaendler promised, would be ready by 1755, then it would just be a matter of firing the pieces before the final object was finished.

Even at this late stage the progress of this massive scheme in which Kaendler had invested so much of his time, money and talent did not run smoothly. Herold refused to cooperate with Kaendler's requests for more paste, and complained that the molds were already taking up precious storage space. Eventually Kaendler had to evict fellow workers who were lodging in his house in order to store the molds.

Ultimately, however, Herold was no match for Kaendler at his most determined and it was to be political events rather than Herold's animosity that would prove the fatal stumbling block. By 1756 danger in the form of Frederick the Great once again loomed, and with the specter of impending invasion marking the advent of the Seven Years' War, all funds for Kaendler's monumental project immediately dried up.

Since the end of the Second Silesian War and his retreat from Saxony some ten years earlier, Frederick had felt increasingly isolated by an unexpected coalition between Austria and France, both of which wanted to crush the "evil man of Sans Souci." Frederick had used the years of peace to rebuild his country and develop its industries and agriculture. Now once again his position was threatened.

Having formed an alliance with England, he de-

cided with his usual incisiveness to avert the threat of an imminent attack by his enemies and keep hold of the territory he had gained ten years earlier by once again invading the weak and hapless Saxony. On August 27, 1756, a Prussian army of some seventy thousand troops marched into Saxony. A fortnight later Frederick's troops had stormed through the bountiful plains of the Elbe and taken possession of Dresden.

At the first sign of trouble the king and Count Brühl, together with other key members of the royal entourage, fled to Warsaw, leaving Augustus's doughty queen, Maria Josepha, the Countess Brühl and various other aristocratic ladies behind to confront the Prussian invaders. In what must have seemed the final humiliation, Frederick himself moved into the splendid Brühl palace.

Incensed at Frederick's overbearing manner, even high-born Saxon ladies were tempted to dabble in espionage. One was caught smuggling secret papers to her husband inside sausages. The Countess Brühl herself, forced to live cheek by jowl with her husband's archenemy, was noted one day to have received from Warsaw an unexpected present of a barrel of wine. Frederick allowed her to drain the wine but orders were given that she should give the cask to him. On examination it was found to have a false base in which various secret documents were concealed. Upon this discovery Frederick coolly suggested to the countess, "Madam, it is better that you go and join your husband."

While Frederick's armies marched on Dresden, desperate messages had been sent by the fleeing Brühl to Meissen, once again ordering the demolition of the kilns and the removal of all materials. For the second time the factory was indefinitely closed and Augustus issued a further command ordering the arcanists Herold and Kaendler to escape to Frankfurt am Main. Herold and several of his colleagues obeyed the order promptly, escaping in Herold's carriage. Kaendler refused to go and remained resolutely in Meissen to guard his massive porcelain project against the predations of the Prussian king. Over the years of turbulent strife that followed, Herold, hearing of Kaendler's sufferings, must have been highly relieved at his own decision to flee. He still received his generous salary while in exile, could afford to keep his carriage, and generally lived a life of ease and relative luxury. For Kaendler, left in Meissen, it was a very different story.

With the occupation of Dresden all Saxon assets were now diverted to Prussian coffers in order to fund the massive armies of Frederick the Great. The stocks of the porcelain showrooms in Meissen, Dresden and Leipzig were summarily confiscated by Frederick, who sold them on to a privy councillor named Schimmelmann for 120,000 thalers in order to raise money quickly. These vast quantities of porcelain were mostly sold at auction, and Schimmelmann's profits were substantial enough to allow him to buy a grand city palace, a country castle and a large estate in Denmark, where he later settled for a time.

Frederick, despite his military preoccupations, had never forgotten his dream of possessing the Meissen factory. In the years of peace before the advent of the Seven Years' War he had encouraged a textile manufacturer called Wilhelm Kaspar Wegely to establish a porcelain factory in Berlin and provided him with financial backing. The result of this investment had been disappointing. Accustomed to the sophistication of Kaendler figurines and Herold's delicate painting, Frederick found Wegely's attempts crude and uninspired and rapidly lost interest in the venture. But now, with the occupation of Meissen, Frederick saw a new ray of hope. Wegely was summoned to Saxony, with the idea that he would take charge of moving the factory with all its workers to Berlin.

Berlin was only a good day's travel away—some one hundred miles from Meissen—but by the time Wegely arrived the factory was already deserted, all the equipment had been hidden, and the arcanists and even the workers had disappeared. There was nothing to remove and nothing to learn and Wegely was forced to return empty-handed. His own factory foundered soon afterward.

For his part Frederick still refused to give up hope. In the light of Wegely's failure he was more keen than ever to place commissions with the Meissen factory, and to do that he would have to bring it back to life. With this in mind, and realizing that the workers would cooperate more readily under Saxon direction, he therefore leased the Albrechtsburg to a Saxon offi-

cial, Georg Michael Helbig, who, seeing the chance to profit from collaborating with the enemy, slowly managed to rebuild the kilns, obtain the necessary raw materials—no easy matter in war-torn Saxony—and entice back enough workers to begin manufacturing again.

As the factory slowly returned to production, Frederick exploited it mercilessly. He kept increasing both the rent he expected for use of the premises, which he now deemed Prussian property, and the quantities of porcelain he demanded be supplied free of charge for his own use. Eventually Helbig could no longer meet Frederick's requirements and a Polish commissioner by the name of Lorenz stepped in to save the factory and workers from further Prussian intervention and the renewed menace of forcible transfer to Berlin.

Frederick was a frequent visitor to the factory and during his tours of inspection he constantly plagued Kaendler with offers of work in Berlin. Terrified of being forcibly extradited, Kaendler was forced to cooperate to some degree. By suggesting ideas for new commissions to the Prussian king he kept the threat of removal to Berlin at bay, and thus helped ensure the factory's survival. But when Frederick's back was turned, his giant statue of Augustus continued to obsess him. By 1761, eight hundred molds for the base were complete, but only the face of the king had as yet been fired in porcelain. It was years since he had received any payment for this work, and the strain of the project threatened to break him both financially and physically.

Kaendler was not alone in suffering the indignity of having to work for the enemy. The people of Meissen not only endured acute shortages of necessities such as food and fuel; those who still worked in the factory had their wages reduced by a third and many others were forced into Prussian service. Some had to build fortifications against their own army; others were impressed into the Prussian armies "to carry destruction into the bosom of their native country"; defenseless women were "carried off by violence from their paternal cottages . . . sent into the remotest provinces of the Prussian Monarchy, and their {sic} matched with husbands provided for them by the State." Many skilled former workers in the porcelain factory were "forcibly sent to Berlin . . . there compelled, during life, to continue their labours, and to exert their talents, for the profit of a Sovereign, the inveterate enemy of their country." Even in war-hardened Europe, such treatment, said Nicholas Wraxall, an eighteenth-century traveler, was an outrage: "Neither the laws of nations, nor those of modern war, allow of transporting the male and female manufacturers of a conquered state, into the dominions of the invader. This infraction of natural justice was nevertheless committed at Meissen in Saxony. . . ."

But worse was to come. In July 1760 Frederick retaliated against Austrian resistance in Saxony in his most ruthless manner. In a massive bombardment of the city of Dresden that eerily presaged the events of February 1945, many of the most beautiful buildings

of Dresden were destroyed. The Turkish Palace, one of the settings for Augustus's memorable wedding celebrations, was reduced to a heap of rubble; so too were some of Dresden's most beautiful churches, the exquisite Brühl Palace and many others of its grandest houses.

The Seven Years' War in Europe drew to its close in 1763 with the signing of the Treaty of Hubertusburg. Before taking his final leave of Saxony, which once again he agreed to relinquish, Frederick celebrated his victory by holding a musical concert at Meissen, and by emptying the factory's stockrooms of a hundred more crates of porcelain.

Behind him he left a devastated kingdom in which 100,000 people had perished and the artistic achievements of an era had been laid waste. "The royal palaces lay in ruins, Brühl's glories were destroyed and all that remained was a splendid and severely ravaged countryside," Goethe later wrote with impassioned anger. Even the Saxon king and his profligate prime minister, Count Brühl, who had lived in exiled comfort in Warsaw throughout the war, were utterly overcome by the evidence of Frederick's aggression; both died within months of their return to Dresden.

Only the Meissen factory, it seemed, against all odds had survived.

# Chapter Five

••••••••••••••••••••••••••••••••••

❧

## *The Arcanum*

*I believe I neglected to mention in any of my let-*
*ters from Berlin, that when I visited the manufac-*
*tory of Porcelain, I was so much struck with the*
*beauty of some of it, that I ordered a small box for*
*you. . . . I did not imagine that this manufactory*
*had arrived at such a degree of perfection as in*
*several places in Germany. . . . The parcel I have*
*ordered for you is though equal to the finest made*
*at Dresden.*

JOHN MOORE, *A View of Society and Manners*
*in France, Switzerland and Germany,* 1779

The year was 1750. Seated in a Meissen alehouse, Jo-
hann Gottlieb Ehder, one of Kaendler's most talented
modelers, was enjoying himself.

The company was congenial, the tankards of ale and pipes of tobacco plentiful, and so engrossed was Ehder in the boisterous revelries that he failed to notice the chimes of the cathedral bell tower. It was only when groups of his fellow drinkers began to spill onto the cobbled street and stagger unsteadily homeward that he realized that the hour at which he was supposed to have returned to his lodgings had long passed.

As he drained his *Walzenkrug* of beer, Ehder must have cursed the fact that unlike most of Meissen's workers, who lived in the jumble of medieval houses nestling on the slopes of the Elbe, he had accommodations within the cathedral courtyard, inside the castle's walls. This meant that while his companions could enjoy some measure of freedom after the long working day was over, he was still bound to observe the strict regime introduced by the castle's guards. Their rules included a rigorously enforced curfew hour—one that he had now missed.

Ehder knew that if he was caught trying to reenter the guarded courtyard after hours he was liable to be punished with several weeks' imprisonment. A jail sentence would not only involve considerable physical hardship, it would also cost him his salary for the time he was incarcerated, a punishment he could ill afford; he might even lose his job. Obviously he had to get back to his lodgings undetected.

Avoiding the main approach to the castle, he must have climbed the steep footpath up the hill. Looming at the summit he could make out the castle's Gothic

pinnacles and ramparts silhouetted against the night sky. To avoid detection he decided to wait in the shadows by the outer wall; when the soldiers guarding the main gate were distracted, or left their posts to patrol the courtyard, he would steal in undetected.

Unfortunately the plan miscarried. Perhaps a guard turned unexpectedly and, glimpsing a shadowy movement, called out to his fellow soldiers and came to investigate. What is certain is that Ehder, realizing he had been seen, panicked. Perhaps instilled with false courage from the alcohol he had consumed, he must have decided that the only way to avoid imminent arrest was to jump from the ramparts. It was a suicidal misjudgment.

He plummeted some ten meters and landed heavily on the sheer slope below, so severely crippled by the fall that he could do nothing but lie helpless in agony while the guards descended the rocky path and recovered his broken body. He died a few days later as a result of the appalling injuries he had sustained.

Ehder's tragic leap to his death in 1750 seems doubly pitiful considering that by then the tyrannical guards' efforts to protect the arcanum were utterly futile. Elsewhere in Europe at least half a dozen other factories had discovered the secret of hard paste porcelain. Within the next decade a dozen or more others were to follow suit.

The damage had been done three decades earlier, in 1719, when Samuel Stölzel had absconded from

Meissen to help du Paquier and Hunger begin pro-
duction of porcelain in Vienna. Struck with remorse
for his disloyalty, Stölzel had memorably tried to de-
stroy the factory's stock of paste, smashed its molds
and stolen its enamels, assuming that such sabotage
would put it out of business almost before it had
begun.

But that was not what happened. Du Paquier re-
fused to see the life of his prized Vienna factory so
easily extinguished. Faced with the scene of over-
whelming destruction that confronted him in the
workshop, he became grimly determined to resume
production. Du Paquier had secretly observed Stölzel
at work and, with his already considerable knowledge
of chemistry, felt confident that he now knew enough
to replicate the mixture and compound the paste on
his own.

Trial firings proved him right. Within a few
months of Stölzel's flight, the factory had moved to a
new, larger building in a street now called the Porzel-
langasse, where improved kilns were quickly built. A
year later du Paquier was back in business; twenty
workers were on his payroll and production was in full
swing. Stölzel's efforts to destroy the factory had failed.
Furthermore the Meissen monopoly on the arcanum
was irretrievably lost.

The resurrection of the Vienna works had not gone
unnoticed in Dresden. Ever since du Paquier had re-
built his factory, concerns had been voiced about the
threat he posed. But what could be done about it? The

officials in Meissen might be able to take steps to assure the security of the arcanum in their factory, but in Vienna they were powerless to do any more than watch events unfold.

Christian Anacker, the Saxon ambassador at the Austrian court, who had played a key role in encouraging Stölzel to return to Meissen, was instructed to keep a close eye on the progress of the factory. His reports hinted at a degree of disorganization that was in stark contrast with the tight ship run at Meissen since Böttger's demise. Every letter he dispatched fueled fears that the safety of the arcanum was in serious jeopardy.

Money, a problem from the early days of du Paquier's venture, was never easy. For much of its early life the factory was fraught with worries over mounting debts and a chronic inability to pay staff, who quickly became disgruntled. Soon after Stölzel had repented and returned to Meissen, Christoph Konrad Hunger, Stölzel's co-founder of the factory, became similarly disenchanted. But Hunger had an altogether different temperament from that of the vulnerable and guilt-torn Stölzel. A hard-bitten and devious profiteer, he was willing to make money in whatever way presented itself. Loyalty and integrity were low on his list of priorities; he would happily stoop to intimidation, threats and all manner of chicanery if it would help to fill his purse.

According to Anacker, Hunger's craving for money led him to tarnish his reputation so severely in various

shady financial deals in Vienna that he had little alternative but to follow Stölzel's example and run away. In his case the chosen route was not straight back to Meissen but to Italy, where he joined forces with the brothers Francesco and Giuseppe Vezzi, goldsmiths and would-be porcelain manufacturers of Venice, convincing them that he knew the secret of the arcanum.

Hunger was no arcanist, but he knew enough after working with Stölzel to realize that the right type of clay was critical to production. With his contacts in Saxony he managed to persuade the unscrupulous mine owner Schnorr to supply the Vezzi brothers with a consignment of kaolin. This was an outright breach of Saxon law, since Schnorr had agreed to give Meissen exclusive rights to his clay, but Schnorr, an inveterate wheeler-dealer, could not bear to turn away good business. He promised to get the consignment over the border to Italy without detection.

Two years after the clay arrived, with Hunger's assistance the Vezzi factory managed to establish production of porcelain. Hunger, however, quickly grew weary of life on the Venetian canals and hankered to return to Saxony. He wrote an apologetic letter to the authorities in Meissen in which he attempted to exonerate himself from any blame for the theft of the arcanum.

Meissen must have viewed his audacious request for work with astonishment, but rather than leaving him free to wander Europe and help hatch further factories it seemed more expedient to take him back into the

fold. Thus he was given leave to return to Meissen and offered work as a gilder.

But this occupation was not enough to satisfy Hunger's still voracious ambitions. Three years later he decided to leave Saxony again and offer his now considerable expertise to the highest bidder. Without permission he deserted the factory, traveling first to Stockholm, then to Copenhagen, then back to Vienna and finally to St. Petersburg. In all these cities he tried, with little success, to make porcelain.

Throughout his escapades Hunger remained unabashedly defiant of Meissen officaldom. Writing at one stage for leave to return to Saxony after his unauthorized defection, he threatened that, if his demands were not met, "I will not only manufacture porcelain here in Sweden but through the book which I shall have published, I shall render the science of porcelain a matter of such common knowledge, that not only will many other noble persons undertake its production, but every potter will be able to copy it."

If threats like these seemed to echo Meissen's worst nightmares, they had not yet imagined the havoc to be wrought by another roaming arcanist from Vienna, one Joseph Jakob Ringler.

In Vienna the Saxon ambassador reported that disarray still ruled and finances were far from improved. By 1744 things had become so bad that even du Paquier had grown tired of the constant financial problems and decided to sell out to the state. Maria Theresa of Aus-

tria now became the factory's official sponsor, and with the much needed new investment more workers could at last be employed.

Among the new apprentices was the fourteen-year-old son of a local schoolteacher by the name of Joseph Jakob Ringler. The young apprentice was outgoing, extremely intelligent and, it later emerged, unusually observant. He made rapid progress as a porcelain decorator, but also became so popular with co-workers specializing in other areas of production that they happily shared their expertise with him.

While Ringler was steadily accumulating a formidable knowledge of porcelain-making, the factory was at last enjoying a period of prosperity. With royal patronage Viennese porcelain had become the essential adornment for every fashionable breakfast table and boudoir, and as demand grew the business expanded to employ around two hundred workers.

But the problems brought about by an overly lax administration were still far from solved. Pilfering of the porcelain was rife. Everyone recognized that the workers were taking wares home "in the white," decorating them privately and selling them on the sly, but still no effective security measures were introduced. In the workshop itself the scene was equally chaotic. Wives and girlfriends were reported to congregate in the workshop drinking and gossiping with their partners and preventing the smooth progress of work, and much more porcelain was lost in the general confusion.

The chaotic ambience must have helped the ambi-

tious and sharp-eyed Ringler to gain access to even the most secret parts of the manufacturing process, but once he had enjoyed the carefree atmosphere and learned all he could, the allure of the place began to pall. Enterprising and ambitious, he had always yearned for travel and adventure and he became increasingly impatient to put his expertise to the test. The whole of Europe was crying out for porcelain; he was not going to spend the rest of his life as a mere decorator—his intention was to direct a factory of his own.

By 1747 Ringler had matured into a young man of seductive and apparently irresistible sexual attraction. Among his many female conquests was the impressionable young daughter of the Vienna factory's director. She became so completely besotted by the young Ringler that, so the story goes, he managed to persuade her to steal from her father's desk the secret arcanum for porcelain and, equally important, a design for a porcelain kiln. With these precious documents he now had all that was needed to make porcelain anywhere he chose, for whoever would pay. At the age of seventeen this was an astonishingly powerful position in which to find himself.

Soon after the lovelorn young director's daughter had passed the secret documents to Ringler she awoke, in the manner of all tragic heroines, to find her lover gone. Ringler had packed a large black bag and deserted her to embark on the precarious and uncertain career of a wandering arcanist. It was the life of danger, adventure and travel he had always craved.

He went first to Künersberg in Bavaria, where he managed to produce one or two rare pieces of porcelain. A year later he was in Höchst, the factory near Mainz where a year earlier the renegade Adam von Löwenfinck had encountered such unsurmountable problems that he had been forced to leave and seek work in Strasbourg. Since Löwenfinck's departure, a new arcanist, Johann Benckgraff, had been taken on, but he too was encountering difficulties. Benckgraff was some ten years older than the dashing young Ringler, but the two had already met and worked alongside one another in Vienna. Within two years of Ringler's arrival porcelain production was under way and Benckgraff knew nearly as much about its manufacture as the talented Ringler. Both now embarked on separate journeys through Europe's ceramic centers, leaving a trail of nascent porcelain factories in their wake.

Ringler followed Löwenfinck's trail to France's easternmost border with Germany and the city of Strasbourg. Löwenfinck was busy refining painting techniques on faience there, but Ringler was able to show the factory owner, Paul Hannong, how to make porcelain. The factory's output was soon good enough to compete with Louis XV's royal manufactory at Vincennes and Louis became so worried by Strasbourg's progress that he announced by royal decree that no factory other than his own was allowed to produce multicolored porcelain. Forced to close, Hannong moved his factory outside the jurisdiction of France to the Palati-

nate of Frankenthal, where he was given exclusive rights to produce porcelain in the region.

Ringler meanwhile moved on, finding a niche for himself nearby at Neudeck. This factory belonged to the Elector Max Joseph III, who had married Maria Anna Sophia, one of Augustus the Strong's granddaughters. Like her grandfather, Maria Anna Sophia was a porcelain fanatic. She longed to encrust her royal palace with porcelain in an echo of Augustus's Japanese Palace and persuaded her new husband to become involved in a porcelain venture. With Ringler in their employ the royal couple were soon able to realize their dream. The factory later moved to a nearby building at Nymphenburg, where it remains in production today.

Meanwhile, hearing of Ringler's reputation as a brilliant arcanist, Duke Karl Eugen of Württemberg summoned him to Ludwigsburg in southwest Germany. A porcelain factory, the duke decreed by royal proclamation, was a "necessary attribute of splendour and dignity." Ringler was able to provide this necessary attribute with consummate ease, and his Ludwigsburg porcelain factory was founded in 1759. So pleased was the duke with Ringler's progress that within a month of his arrival he was appointed director. Having realized his ambition of running his own factory, Ringler at last settled down and remained there until his death in 1802.

In Berlin, after his withdrawal from Saxony in 1763, Frederick the Great was not to be without his own

porcelain for long. In the same year he made peace with Europe, he bought a porcelain factory that had been started two years earlier by an entrepreneurial financier by the name of Gotzkowsky, who now found himself in financial distress. Gotzkowsky had bought the secret arcanum from an associate of Benckgraff's. Frederick still had at his disposal a cache of highly skilled Meissen craftsmen whom he had forced to come to Berlin during the war. They were now refused leave to return, and the success of Frederick's venture was at last assured.

While throughout Europe havoc was thus wrought on the security of the arcanum, a momentous upheaval was also afoot in Meissen. Once all possibility of danger from Prussia was safely past, Herold had returned from his life of comfortable exile in Frankfurt. The first thing he did on his return was submit a hefty bill of 8,200 thalers for the expenses he had incurred during his exile in addition to the salary he had already received. By now an old man of sixty-six, he still officially held the title of inspector of the factory, but in practice his authority was now negligible and he was furious to find how effortlessly Kaendler had stepped into his shoes and managed to steer the factory through the traumatic events of the war. A report of a meeting held a year after his return reveals the extent of his animosity; he is recorded as grumbling about "the laxity, the negligence, and the dishonesty of most of the officials, among whom he specially mentioned the court commissioner, Kaendler."

But Herold's days of power and influence had

passed, and since a new supervisor of the painting department had been brought in his complaints were largely ignored. Two years later, unable to tolerate working under someone else's rule and following the death of his wife, he requested permission to leave his rooms in the Albrechtsburg and live quietly in retirement. The large country estate at nearby Plossen, bought by his wife in 1741, was sold, and Herold moved back to Meissen where he bought a spacious house on the corner of Fleischergasse (the building is still standing). Before he was allowed to leave Meissen's employ, he was forced to agree never to leave Saxony and ordered to write an account of his entire knowledge of the arcanum and color compoundings and to hand it over to the authorities. Herold's hostility to Kaendler had, finally, ceased to be a threat.

But for Kaendler the reprieve came too late. His fortune too was in decline. The furious battles that had raged within Europe had not been able to hold back the tide of changing fashion. Kaendler's Rococo shepherdesses and amorous courtiers now seemed as passé as Herold's chinoiseries once had done. A new look, noble and simple Neoclassicism, had taken over.

Meissen's failure to move with the times in the aftermath of war resulted in a slump in profits. Realizing that survival depended on its ability to keep pace with new artistic developments, the commissioners frantically looked to France, where the new style had first taken hold, for inspiration. A young Parisian modeler by the name of Michael Victor Acier was

found and lured to Meissen with the promise of a generous salary (50 percent more than Meissen had expected to pay), a free house and the same title as Kaendler—that of modeler-in-chief.

Shattered by his experiences of Prussian occupation, wounded by the accusations of cooperation with the enemy that had been leveled against him since their withdrawal, and above all embittered by the failure of his long and obsessive quest to make the massive equestrian statue—for which he had still not been fully reimbursed—Kaendler now had to suffer the further ignominy of having his opinions and past achievements brushed aside. Acier, thirty years his junior, represented new ideas and new hope for the dying factory and orders were given straight to him. Kaendler was completely cold-shouldered.

As his relationship with Acier deteriorated, Kaendler's once exuberant, extrovert personality became increasingly withdrawn and aloof. Disillusionment was reflected in his work, which lacked its former flair, and in his treatment of his assistants, with whom he became increasingly short-tempered. He was badgered to adapt his animated, lively style to the cold, static poses of the classical subjects that were now in vogue. It was not an easy adjustment.

On January 26, 1775, Kaendler must have shuddered to hear the news that Johann Gregor Herold, his archrival, had died, aged seventy-eight. His own health was also failing but he continued to work, producing new models and suggesting reforms to improve

the factory's efficiency. He died on May 18, 1775, aged sixty-eight, having worked unrelentingly at Meissen for forty-four years.

The deaths of these great porcelain masters, though poignant, did not really mark the end of an era. Meissen had already been toppled from its preeminent position two decades earlier. The efforts of discontented employees and wandering arcanists had demolished its monopoly and spread the secret arcanum for porcelain far and wide. But it was the might of Frederick the Great's army that had unwittingly exacted the final revenge for stealing Böttger from Prussia's grasp half a century before. By so severely interrupting Meissen's prodigious output it had allowed young rival German factories, as well as Louis XV's porcelain factory (which in 1756 moved from Vincennes to Sèvres), to gain a foothold in the marketplace. Frederick had achieved his ambition to own a porcelain factory of which he could be proud, but it was not he but Louis of France who conquered the European porcelain market. Soon it was Louis's interlaced initials, representing Sèvres, that replaced the crossed swords of Meissen as the world's most exclusive mark.

But if Meissen porcelain no longer dominated the dining tables of the wealthy in quite the same way, its name still held celebrity status. The impact of Böttger, Herold and Kaendler, who between them found the formula for the substance for which all Europe clam-

ored and then created an entirely new art form with it, spread inexorably. As time passed and manufacturing processes improved, porcelain became less exclusive and costly, and the influence of this unlikely trio was echoed in the products of almost every ceramic manufactory throughout the Western world. Even today, their shadowy presence is reflected in the forms and designs of countless mass-produced objects made from myriad different materials. Technology and taste have moved on, but the pioneering achievements of these three trailblazers remain as formidable as they ever were.

# Postscript

·····················

*If this were so: if to the eighteenth-century imagi-
nation, porcelain was not just another exotic, but
a magical and talismanic substance—the sub-
stance of longevity, of potency, of invulnera-
bility—then it was easier to understand why the
King would stuff a palace with forty thousand
pieces. Or guard the "arcanum" like a secret
weapon. Or swap the six hundred giants.*

*Porcelain, Utz concluded, was the antidote to
decay.*

BRUCE CHATWIN, *Utz,* 1988

$\mathcal{T}$he Albrechtsburg castle, now painted a rather in-
congruous shade of gray, still towers with imposing
authority above the muddled clusters of medieval

Meissen rooftops. Its guards have long since disappeared, along with the modelers and painters of Meissen's fragile wares. The barren halls where once Herold and Kaendler vied with one another were given an overhaul in 1863, when the factory's management decided it had outgrown the castle and moved to larger premises down the hill.

Now the walls are frescoed with pastiche medieval tapestries relating the town's illustrious history, and the only obvious reminders of the castle's porcelain past are two theatrical nineteenth-century murals painted by Paul Kiessling. In one, Böttger drinks wine as he works in his laboratory, in the other he initiates Augustus the Strong in the art of porcelain-making.

At the new factory down the hill there are no soldiers at the gate and you no longer need special permission to visit. Meissen has given up the perpetual struggle against outside interest and realized its potential as a serious tourist attraction. Visitors arrive by shuttle bus from the market square to be ushered into neon-lit rooms in which the age-old techniques of paste compounding, molding, glazing and decorating are proudly demonstrated and explained to the culture-hungry crowd. Times have certainly changed.

For its part, Dresden, city of Augustus the horseshoe crusher and his ravishing mistresses, still bears the scars of the fateful nights in February 1945, when almost the entire center of the old city and 75,000 of its inhabitants, plus inestimable numbers of refugees fleeing the advancing Soviet army, were annihilated in

vengeful Allied bombing raids. The bombs were so many and so lethally concentrated that they created a firestorm, an oxygen-consuming inferno suffocating most of the unfortunates who were not burned or crushed to death. A massive column of heated air rose and produced suction of such intensity that roofs and the core fabric of buildings were swallowed by the raging heat. Afterward there was scarcely a building or a person left standing.

Since then, like some monumental phoenix, Augustus's triumphal city and its shattered buildings have one by one been gradually reborn. The process is ongoing; his royal castle is still clad in scaffolding, but the covered bridge connecting it to the Taschenberg Palace where once he cavorted with the beautiful Countess of Cozelle remains intact—and her grand residence has been turned into one of Dresden's most luxurious hotels.

Incredibly, most of Augustus's prized porcelain collection managed to survive the bombs. In the months before the final devastation it was taken by rescue teams, along with many of the priceless works of art bought by Augustus III, to various country estates, so-called places of safekeeping deep inside Saxony. The porcelain treasures were later removed to the Soviet Union before being finally restored to Dresden in 1958.

Today Augustus's richly patterned Chinese and Japanese porcelains are displayed along the gently curving walls of the long, airy, light-filled galleries of

the Zwinger that surround the vast courtyard where once his extravagant entertainments were staged. These are some of the surviving treasures from his fantastical Japanese Palace. Dishes, bowls and vases are arranged much as he would have liked them—in radiating mosaiclike patterns on the walls. In their midst stands a resplendent centerpiece, the ultimate memento of the monarch's porcelain madness—a clutch of the massive blue and white vases for which he paid a regiment of dragoons.

Here too are Böttger's first tentative trial cups and bowls; cases of Herold's painterly masterpieces, Kirchner's and Kaendler's animals for the Japanese Palace, some still bearing traces of the paint that so incensed Kaendler; here is also his equestrian model and the massive face of Augustus—all that remain of his dream. Vast though the collection is, what you can see is less than a tenth of what remains. Stored in inaccessible vaults beneath the floor are further quantities of porcelain collected by the king, along with diminutive nuggets of gold magicked by the unfortunate Böttger.

But the most potent reminder of this extraordinary story is to be found not here but beneath the nearby Brühlsche Terrace, the elegant part known as the Balcony of Europe that now surmounts part of the old city walls bordering the river Elbe. Underneath this fashionable strolling ground, the ancient fortifications where Böttger's first successful firings took place have recently been excavated. Nowadays the Jungfernbastei no longer arouses frissons of horror but of fascination

as troops of German schoolchildren and parties of wide-eyed tourists are regularly escorted on a route that leads through the cavernous subterranean halls that once witnessed the extraordinary discovery.

As you follow the dimly lit passages leading from one bleakly echoing chamber to the next you cannot but help wondering if Böttger ever imagined, as he toiled in such an inhospitable place, that nearly three hundred years later people would still visit the spot where it all happened, or that the fruits of his struggles would feature in countless museums and collectors' vitrines all over the world.

In discovering the arcanum for porcelain, did he realize that his immortality was guaranteed—that no one would forget that it was he who concocted the means for his king to earn the golden fortune he craved? Or that in making white gold, and earning a place in the history books, he had come so close to the true arcanum after all?

# Sources

My intention in writing this account of the invention of European porcelain is to bring this incredible story of discovery and intrigue to the attention of the general reader. In order to research these events I have gratefully relied on the vast body of scholarly and expert insights published in studies of Meissen porcelain. I have also drawn on eighteenth-century travelers' accounts of Dresden to provide a picture of the color and intrigue of court life, as well as general works on eighteenth-century German history to outline as simply as possible the complex political panorama of the time. The following list provides the main sources on which I have relied for each chapter. Full details of these and other related publications to which I have referred are given in the bibliography that follows.

## PART ONE

### Chapter One

Böttger's escape: Röntgen, *Book of Meissen*

Fashion for alchemy: Fauchier Magnan, *Small German Courts*

Alchemy: Sherwood Taylor, *Alchemists;* Holmyard, *Alchemy;* Szydlo and Brzezinski, "A New Light on Alchemy"

Pabst von Ohain quote contained in Menzhausen, *Early Meissen Porcelain*

### Chapter Two

Epigraph and letters regarding experiments quoted from Hoffmann, *Von Alchimistengold*

Böttger's early life and gold-making experiments: Hoffmann, *Böttger* and *Von Alchimistengold;* Doberer, *Goldmakers;* Röntgen, *Book of Meissen*

### Chapter Three

Augustus the Strong: Poellnitz, *Saxe Galante*

Relationship with the Countess of Cozelle: Montagu, *Travels*

Political ambitions: Treasure, *Making of Modern Europe;* Bruford, *Germany in the 18th Century*

Interest in Oriental porcelain: Honour, *Visions of Cathay;* Schmidt, *Porcelain as an Art and Mirror*

### Chapter Four

Alchemical experiments: Doberer, *Goldmakers;* Hoffmann, *Von Alchimistengold*

# Sources →

Oriental porcelain: Honour, *Visions of Cathay;* Impey, *Impact of Oriental Styles;* Jacobson, *Chinoiserie*

Early porcelain experiments: Walcha, *Meissen Porcelain;* Ducret, *German Porcelain and Faience*

History of early European ceramics: Honey, *European Ceramic Art*

Friendship with Tschirnhaus: Röntgen, *Book of Meissen;* Walcha, *Meissen Porcelain*

## Chapter Five

Manufacture of ceramics: Honey, *European Ceramic Art*

Imprisonment in the Albrechtsburg and Königstein: Menzhausen, *Early Meissen Porcelain*

Experiments: Walcha, *Meissen Porcelain*

Wildenstein's account quoted in Menzhausen, *Early Meissen Porcelain* and in Walcha, *Meissen Porcelain*

Composition and manufacture of porcelain: Sterba, *Meissen Domestic Porcelain*

## Chapter Six

Experiments in Dresden based on Wildenstein's contemporary account quoted in Walcha, *Meissen Porcelain,* and in Hoffmann, *Böttger*

Böttger's statement and poem quoted in Menzhausen, *Early Meissen Porcelain*

Career of D. M. Caetano: Holmyard, *Alchemy*

Proclamation of the invention of porcelain: Röntgen, *Book of Meissen*

Early production of porcelain and stoneware: Walcha, *Meissen Porcelain*

# Chapter Seven

Financial problems and working conditions: Walcha, *Meissen Porcelain*

Arguments with cathedral, kiln designs: Ducret, *German Porcelain and Faience*

Problems with Nehmitz: Savage, *18th Century German Porcelain;* Walcha, *Meissen Porcelain*

Tea: Hobhouse, *Seeds of Change*

Tea drinking in China: Purchas, *Pilgrimage*

Augustus's collection of stoneware: Honey, *Dresden China;* Sterba, *Meissen Domestic Porcelain*

# Chapter Eight

Commission's inquiry: Walcha, *Meissen Porcelain*

Porcelain manufacture: Danckert, *Directory of European Porcelain;* Röntgen, *Book of Meissen;* Honey, *Dresden China;* Sterba, *Meissen Domestic Porcelain*

# Chapter Nine

Last alchemical experiments: Hoffmann, *Böttger*

Böttger's health and private life: Engelhardt, *Böttger;* Röntgen, *Book of Meissen;* Hoffmann, *Von Alchimistengold*

Financial problems at the factory: Walcha, *Meissen Porcelain*

Purchase of the dragoon vases: Pauls-Eissenbeiss, *German Porcelain*

Böttger's letter to Augustus quoted in Menzhausen, *Early Meissen Porcelain*

Köhler and the quest for underglaze blue: Walcha, *Meissen Porcelain*

# PART TWO

## Chapter One

Death of Böttger: Walcha, *Meissen Porcelain;* Menzhausen, *Early Meissen Porcelain;* Hoffmann, *Von Alchimistengold;* Rückert, *Meissener Manufakturisten*

Klettenberg's death: Hoffmann, *Böttger*

Description of Vienna: Nugent, *Grand Tour*

Early history of Vienna factory: Hayward, *Viennese Porcelain;* Tasnadine, *Porcelaine de Vienne*

Stölzel's departure from Meissen: Röntgen, *Book of Meissen*

## Chapter Two

Marriage of Augustus Frederick and Maria Josepha: Weber, *Planetenfeste;* Schlechte, *Solemnite du Mariages;* Poellnitz, *Memoirs*

Fashion for porcelain rooms: Impey, *Impact of Oriental Styles;* Pauls-Eissenbeiss, *German Porcelain;* Berges, *Gold to Porcelain*

Herold's early career: Seyffarth, *Höroldt;* Walcha, *Meissen Porcelain;* Pietsch, *Höroldt*

## Chapter Three

Herold's progress: Menzhausen, *Early Meissen Porcelain;* Walcha, *Meissen Porcelain;* Morley-Fletcher, *Meissen Porcelain in Color*

Interest in kakiemon: Pietsch, *Meissener Porzellan;* Ayers, et al., *Porcelain for Palaces*

Death of Köhler: Walcha, *Meissen Porcelain*

## Chapter Four

Epigraph quoted in Ducret, *Meissen Procelain*

Herold's development of color: Ducret, *Meissen Porcelain;* Sterba, *Meissen Domestic Porcelain*

Cost of Herold's work: Seyffarth, *Höroldt;* Pietsch, *Höroldt*

Popularity of Meissen porcelain: Hanway, *British Trade*

Herold's marriage and working practices: Behrends, *Meissenger Masterbuch*

Careers of Heintze and Herold: Walcha, *Meissen Porcelain;* Danckert, *Directory of European Porcelain*

## Chapter Five

Lemaire de Hoyhm scandal: Boltz, "Hoym, Le Maire und Meissen"; Ayers, et al., *Porcelain for Palaces;* Seyffarth, *Höroldt;* Röntgen, *Book of Meissen;* Walcha, *Meissen Porcelain;* Poellnitz, *Memoirs;* Pietsch, *Höroldt*

## Chapter Six

Japanese Palace: Menzhausen, *Early Meissen Porcelain;* Berges, *Gold to Porcelain;* Keyssler, *Travels*

Kirchner and Kaendler: Walcha, *Meissen Porcelain;* Savage, *18th Century German Porcelain*

Green Vault in Dresden: Syndram, *Green Vault;* Arnold, et al., *Green Vault of Dresden*

## PART THREE

### Chapter One

Augustus in later life and journey to Warsaw: Asprey, *Frederick the Great;* Schreiber, *August der Starke;* Fellman, *Heinrich Graf Brühl*

Last visits to Japanese Palace and Meissen: Menzhausen, *Early Meissen Porcelain;* Walcha, *Meissen Porcelain*

Augustus III: Wraxall, *Memoirs*

Count Brühl: Moore, *View of Society*

End of work on Japanese Palace: Menzhausen, *Early Meissen Porcelain*

Swan Service and dissension between Herold and Kaendler: Seyffarth, *Höroldt;* Walcha, *Meissen Porcelain;* Pietsch, *Höroldt*

### Chapter Two

New security arrangements and Lowenfinck's escape: Walcha, *Meissen Porcelain;* Savage, *18th Century German Porcelain;* Danckert, *Directory of European Porcelain;* Honey, *Dresden China*

Frederick the Great: Asprey, *Frederick the Great;* Kitchen, *Germany*

Invasion of Meissen: Walcha, *Meissen Porcelain;* Pauls-Eissenbeiss, *German Porcelain*

### Chapter Three

Hanbury-Williams: Charleston, *European Porcelain*

Saxon banquet costumes and hunting: Fauchier Magnan, *Small German Courts;* Bruford, *Germany in the 18th Century*

Table decorations and Meissen figures: Honey, *German Porcelain;* Adams, *Meissen Portrait Figures;* Hackenbroch, *Continental Porcelain*

# Chapter Four

Epigraph quoted in Asprey, *Frederick the Great*

Kaendler's trip to France and large centerpiece: Walcha, *Meissen Porcelain*

Equestrian statue: Menzhausen, *Early Meissen Porcelain;* Röntgen, *Book of Meissen;* Savage, *18th Century German Porcelain;* Walcha, *Meissen Porcelain*

Seven Years' War: Pauls-Eissenbeiss, *German Porcelain;* Asprey, *Frederick the Great;* Carlyle, *History of Frederick the Great;* Wraxall, *Memoirs*

# Chapter Five

Ehder's death: Adams, *Meissen Portrait Figures;* Walcha, *Meissen Porcelain*

Vienna factory's development: Savage, *18th Century German Porcelain;* Ducret, *Meissen Porcelain*

J. J. Ringler's career: Honey, *European Ceramic Art;* Pauls-Eissenbeiss, *German Porcelain;* Ducret, *Colour Treasury*

Later careers of Herold and Kaendler: Seyffarth, *Höroldt;* Menzhausen, *Early Meissen Porcelain;* Walcha, *Meissen Porcelain;* Röntgen, *Book of Meissen*

# Bibliography

......................................

## PORCELAIN

Adams, Len, and Yvonne Adams, *Meissen Portrait Figures,* 1987

Atterbury, P., *History of Porcelain,* 1982

Ayers, J. O. Impey, and J. V. G. Mallet, *Porcelain for Palaces: The Fashion for Japan in Europe,* 1990

Battie, David, ed., *Sotheby's Concise Encyclopedia of Porcelain,* 1990

Behrends, R., *Das Meissener Masterbuch* (Schultz Codex), 1978

Berges, Ruth, *From Gold to Porcelain,* 1963

Berling, K., *Das Meissen Porzellan und Seine Geschiche 1900* (Festive Publication to Commemorate the 200th Jubilee of the Oldest European China Factory), 1911

Bolz, Clause, "Hoym, Le Maire und Meissen," *Keramos,* April 1980

Charleston, R. J., *Meissen and Other European Porcelain* (The James A. de Rothschild Collection at Waddesdon Manor), 1971

Danckert, L., *Directory of European Porcelain,* 1981

Ducret, Siegfried, *Meissen Porcelain,* 1964; *German Porcelain and Faience,* 1962; *Colour Treasury of 18th Century Porcelain*

Engelhardt, Carl August, *J. F. Böttger: Erfinder des Europaischen Porzellans,* 1982

Freestone, I., and D. Gaimster, eds., *Pottery in the Making,* 1997

Garnier, P., *Porcelain of the du Paquier Period,* 1952

Goder, W., et al., *Johann Friedrich Böttger: Die Erfindung des Europaischen Porzellans,* 1982

Hackenbroch, Yvonne, *Meissen and Other Continental Porcelain, Faience and Enamel in the Irwin Untermeyer Collection,* 1956

Hayward, J. F., *Viennese Porcelain of the du Paquier Period,* 1952

Hoffmann, Klaus, *Johann Friedrich Böttger: Vom Alchimistengold zum Weissen Porzellan,* 1985

Honey, W. B., *European Ceramic Art from the End of the Middle Ages to 1815,* 1949; *Dresden China,* 1954; *German Porcelain,* 1947

Honour, Hugh, *Chinoiserie: the Vision of Cathay,* 1961

Impey, Oliver, *Chinoiserie: The Impact of Oriental Styles on Western Art and Decoration,* 1977

Jacobson, Dawn, *Chinoiserie,* 1996

Menzhausen, Ingelore, *Early Meissen Porcelain in Dresden,* 1990; *Staatliche Porzellan Manufaktur Meissen,* 1960

Morley-Fletcher, Hugo, *Meissen Porcelain in Colour,* 1971

Neuwirth, Waltraud, *Wiener Porzellan,* 1979

Pauls-Eissenbeiss, Dr. Erika, *German Porcelain of the 18th Century,* 1972

Pietsch, U., *J. G. Höroldt,* 1996; *Meissener Porzellan und Seine Ostasiatischen Vorbilder,* 1996

Röntgen, Robert E., *The Book of Meissen,* 1984

Rückert, R., *Meissener Porcelain Exhibition Catalogue* (Munich Bayerisches National Museum), 1966; *Biographische Daten der Meissener Manufakturisten des 18 Jahrhunderts,* 1990

Savage, George, *18th Century German Porcelain,* 1958

Schärer, Jürgen, *Vierschiedene Auberordentlich Feine Mahlery und Vergodete Geschirre,* 1996

Schlechte, Monika, *Recueil des Dessins et Gravures Representent les Solemnite du Mariages, Image et Spectacle,* ed. P. Behar, 1989

Schmidt, Robert, *Porcelain as an Art and Mirror of Fashion,* 1932

Seyffarth, Richard, *J. G. Höroldt,* 1981

Sonntag, Hans, *Meissener Porzellan,* 1994

Staatliche Kunstsammlungen Dresden, *Johann Friedrich Böttger zum 300 Geburtstag Meissen,* 1982

Steinbrück, J. M., *1710-1712 Bericht aus der Staatlichen Porzellan Manufactur Meissen über das Jahr 1919,* 1982

Sterba, Gunther, *Meissen Domestic Porcelain,* 1991

Tasnadine, Marik, *La Porcelaine de Vienne,* 1975

Verlag, R. V., *Meissen & Meissen, Europe's Oldest Porcelain Manufactory,* 1991

Walcha, Otto, *Meissen Porcelain,* 1981

Willsberger, J., and R. Rückert, *Meissen,* 1989

Zimmermann, Ernst, *Die Erfindung und Frühzeit des Meissener Porzellans,* 1908

## CONTEMPORARY TRAVEL REPORTS

Boswell, J., *Boswell on the Grand Tour,* ed. F. A. Pottle, 1952

Browne, Sir Thomas, *Pseudoxia Epidemica, or Enquiries into Very Many Received Tenets,* 1646 (Vulgar Errors)

Hall, John, *Paradoxes of Nature,* 1650

Hanway, Jonas, *An Historical Account of the British Trade over the Caspian Sea,* 1752

Keyssler, Johann Georg, *Travels through Germany,* 1740

Marco Polo, *Travels,* trans. R. Latham, 1959

Montagu, Lady Mary Wortley, *Travels*, 1763

Moore, J., *A View of Society and Manners in France, Switzerland and Germany*, 1779

Morrit, J. B. S., *A Grand Tour: Letters and Journeys*, 1794

Nugent, Thomas, *The Grand Tour*, 1749

Platt, Sir Hugh, *The Jewell House of Art and Nature*, 1594

Poellnitz, Baron Carl Ludwig von, *La Saxe Galante, the Amourous Adventures of August of Saxony*, 1734; *Memoirs*, 1737

Pratt, S. J., *Present State of Germany*, 1738

Purchas, Samuel, *A Pilgrimage*, 1614

Wraxall, N., *Memoirs of the Courts of Berlin, Dresden, Warsaw and Vienna*, 1777

## HISTORY

Asprey, Robert B., *Frederick the Great: The Magnificent Enigma*, 1986

Bac, F., *La Ville de Porcelaine*, 1934

Black, Jeremy, *The British Abroad: The Grand Tour in the 18th Century*, 1992

Boswell, A. B., ed., and A. Goodwin, *European Nobility in the 18th Century*, 1953

Bruford, W., *Germany in the 18th Century*, 1965

Carlyle, Thomas, *The History of Frederick the Great*, 1865

Davis, Norman, *God's Playground: A History of Poland*, 1982

Fauchier Magnan, A., *The Small German Courts in the 18th Century*, 1958

Fellman, Walter, *Heinrich Graf Brühl*, 1990

Hibbert, Christopher, *The Grand Tour*, 1987

Kitchen, M., *Cambridge Illustrated History: Germany*, 1996

Rosenberg, H., *Bureaucracy, Aristocracy, Autocracy,* 1966

Schreiber, Herrmann, *August der Starke,* 1986

Treasure, Geoffrey, *The Making of Modern Europe: 1648-1780,* 1985

Vierhaus, R., *Germany in the Age of Absolutism,* 1988

Volker, T., *Porcelain and the Dutch East India Company,* 1954

Weber, Ingrid S., *Planetenfeste August des Starken,* 1985

## ALCHEMY

Doberer, K. K., *The Goldmakers,* 1948

Holmyard, E. J., *Alchemy,* 1957

Sherwood Taylor, F., *The Alchemists,* 1951

Szydio, Z., and R. Brzezinski, "A New Light on Alchemy," in *History Today,* 1997

## MISCELLANEOUS

Arnold, U., et al., *The Green Vault of Dresden,* 1993

Hobhouse, H., *Seeds of Change: Five Plants that Transformed Mankind,* 1987

Schnell, *Art Guide No. 1848: Albrechtsburg Meissen,* 1995

Syndram, D., *The Green Vault,* 1994

# Acknowledgments

........................................

Apart from the wealth of scholars on whose published research I have relied, I am deeply indebted to a host of individuals, among them many experts of international renown, who have generously offered me their assistance and advice. I am enormously grateful to Gordon Lang of Sotheby's—with whom I was privileged to collaborate on a Miller's collector's guide to ceramics, when the idea for this book was born—for reading my manuscript and guiding my research. I would also like to thank Dr. Friedrich Reichel of the Dresden Porcelain Museum, who responded so patiently to all my queries and escorted me around the collection; thank you also to Dr. Ulrich Pietsch of the Dresden Porcelain Museum; Dr. Hans Sonntag of the Meissen Manufactory; Jurgen Schärer, Meissen archivist; Robin Hillyard of the Victoria and Albert Museum, London; Sebastian Kuhn of Sotheby's; Christine Battle; Inge Heckmann-

Walther, one of J. F. Böttger's direct descendants; Leticia Roberts; translators Eva Roth, Jane Ennis, Hannelore Woolnough, Gisela Parker, Barney Perkins and staff at the National Art Library; and the endlessly patient Philip Stokes of the British Library, who helped trace innumerable obscure German texts. Above all, I should like to thank my agent, Christopher Little, for his inspiring enthusiasm and unfailing support.

# Index